Wisdom With
Understanding
is Better
Than Rubies

Laurine Karon Greenberg
Fine Arts Collection

ETHAN WAGNER &
THEA WESTREICH WAGNER

Collecting Art for Love, Money and More

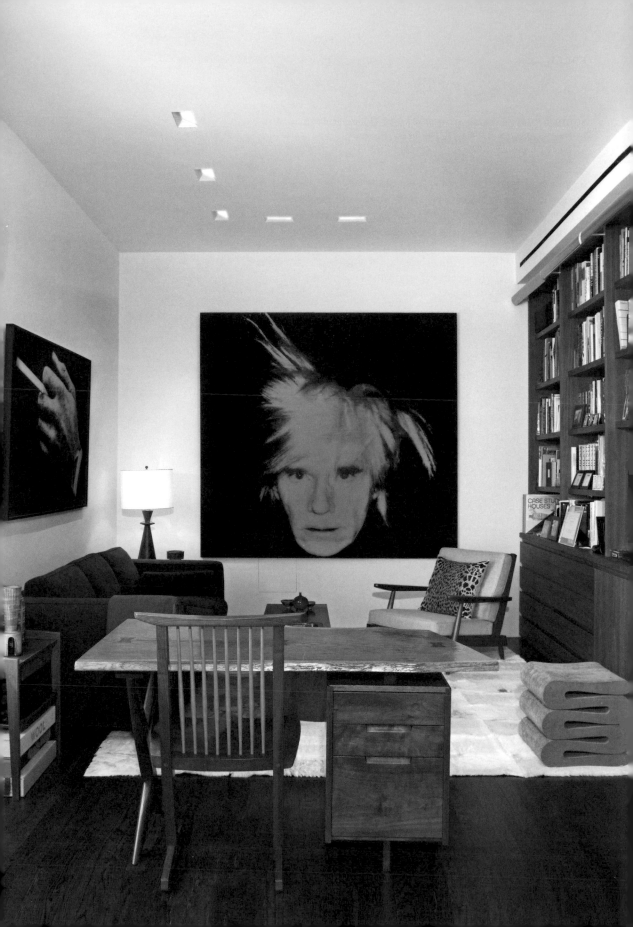

Collecting art has enticed and compelled its enthusiasts for centuries; for most it's a fascinating avocation, for some an all-consuming passion. The motivations for collecting vary, but no matter what they may be for each collector, ample rewards can be had. Though collecting by its nature is reliant on the creative output of artists, its pursuit by collectors conversely provides artists with essential encouragement and support. As such, art making and art collecting are vitally intertwined and mutually dependent. Yet, collecting has its own splendid history, rich with captivating stories: of artworks coveted and acquired, and sometimes sold for enormous sums of money; of great experiences and inspiring art world relationships; and of collections donated to museums or made available to the public at an increasing number of collector-owned exhibition spaces worldwide.

The tales of exceptional collectors – those wealthy and famous and those not so – are presented throughout. Our intention is not only to characterize these accomplishments, but moreover to exemplify and bring to life for the reader the abundant gratifications and joys of collecting, particularly collecting contemporary art. As well, in *Collecting Art for Love, Money and More* we offer insights and advice by which initiates and experienced collectors alike can derive the most from their efforts and collecting experience, and can help make collections singular and noteworthy, maybe even historically important. The book's ten chapters revolve around the themes of taste, knowledge, money and navigating the art world.

We present art collecting as we know it – an activity or pursuit that can provide its adherents with emotional stimulation, intellectual satisfaction, opportunity for creativity and self- expression, life-enhancing relationships, interesting travel, financial gain…and with all that, inevitable disappointments and frustrations. We come at the subject with thirty years of experience as professional art advisors and curators for private collectors, publishers of artists' books and inveterate collectors. And with, as well, an abiding love of art and admiration for the people who make it. Hopefully, our enthusiasm is contagious.

Authors' residence, SoHo, New York, summer 2012: Richard Prince, *Untitled (Hand with cigarette and watch)*, 1980 (above sofa); and Andy Warhol, *Self-Portrait*, 1986 (centre)

The thrills
of collecting art

To gain a sense of the anticipation and excitement that collectors exude on their hunt for art, one need only mix with the crowds at gallery openings, art fairs, auction sales and international exhibitions. At these art world events, flung far and wide, the passion, seriousness of purpose and desire of art collectors fill the air.

The aspiration to own art – to possess it – sets collectors apart, placing them in a small subset of a much larger audience of people who describe themselves as art lovers. In our definition of collector we speak of those who are passionate about the activity; those who are out in the art world regularly, looking, learning, socializing, engaging with artists and art dealers, and excitedly buying works they find compelling. We also include those who, although more sporadic in their pursuit of art, buy works now and again because they are affected by art's aesthetic values. Our definition of art collector also encompasses those just starting out, for history is replete with outstanding collectors who began buying art tentatively but, in due course, become inexorably drawn to the thrills of collecting.

For those who populate this relatively small but ever-expanding community of art collectors, the act of buying, or, as they say in the trade, 'acquiring a work of art', is relished like no other. As art collectors have described it, buying art provides a rush, an adventure, a feeling of being alive and a chance to express individuality. The notable twentieth-century sculpture collector Raymond D. Nasher (1921–2007), from Dallas, Texas, summed it up this way: 'There's nothing like the discovery, the chase and the capture.'[1]

What drives the art collector?

In choosing which artists to collect and which works to buy – the core activities of collecting – collectors can demonstrate their knowledge, perspicacity and intellectual heft. Likewise, in making such decisions there are collectors who display, to their peers and other art world players, shallow understanding, herd instinct and susceptibility to what's fashionable. Since collecting art is an activity predicated on a personal belief in one's choices, it's understandable that collectors in the latter category aren't often willing to countenance such negative descriptions of their collecting, even though others may think them quite apt.

From an almost infinite set of possibilities – of artworks available – a collector's choices are inevitably narrowed and defined by a matrix of factors, including personal motives, likes and dislikes, collecting strategy, financial wherewithal, aesthetic acumen and art historical knowledge. But no matter what drives the collector,

the art world is expansive and highly democratic in granting its manifold rewards. They are available to collectors who are discerning enough to spot critically important artists before the rest of the pack does; who are driven to buy the best; who are quintessentially interested in seeing the art they buy increase in economic value; who want to fill their homes with prestigious works by famous artists in order to impress their friends; who use the activity to gain entrée to desirable social circles; who want to engage with interesting personalities; who seek to connect more profoundly with their time and culture; and who aim to be part of a scene that garners widespread media attention. Finally, these rewards are available to collectors who wish to share their collections with future generations – to leave a legacy.

The rewards of collecting art

People who buy art are apt to receive approbation and encouragement not only from the dealers who have sold them the art but also, on occasion, from the artists themselves. Words of admiration and nods of approval may also come from fellow collectors who share enthusiasm for the same artist or appreciate the desirability of an acquisition, or just from friends who admire what they see in a collector's home.

Collectors may derive additional gratification if an artist they have chosen becomes the subject of a monographic catalogue, a glowing review in an industry publication or other media attention, or a museum or *Kunsthalle* exhibition, or if that artist's prices increase dramatically in the art market. Indeed, confirmation by the market, and the approval of others, can certainly be financially rewarding and ego-boosting. Many collectors naturally enough enjoy these outcomes – it feeds net worth and self-worth.

Nevertheless, for many collectors the most profound experiences that art has to offer come not from the world outside but from within themselves – from those highly personal, ineffable moments when they respond viscerally to objects that engage them. The renowned French filmmaker and art collector Claude Berri (1934–2009) expressed this kind of reaction upon seeing, at the age of seventeen, a Van Gogh exhibition at the Musée de l'Orangerie in Paris. He said, 'I was stunned. I couldn't even move from one painting to the next. It was too intense. I had never seen anything like it.'[2] Another notable collector, creator of the Colección Jumex in Mexico City, Eugenio López, gushed, 'To see a great painting! I have goose bumps.'

During experiences such as these – the sort of moments collectors and art lovers live for – millions of

'For many collectors the most profound experiences come from within.'

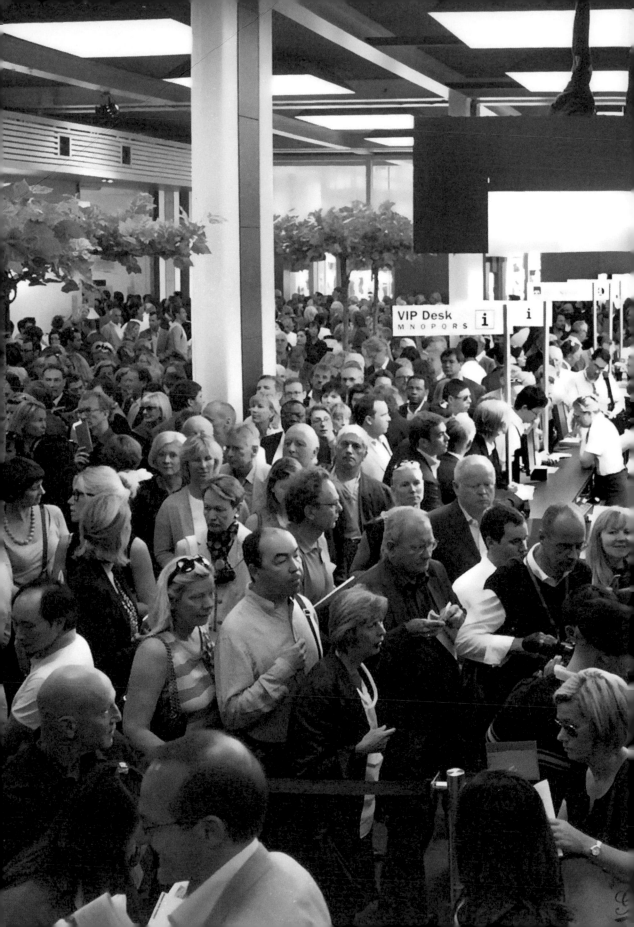

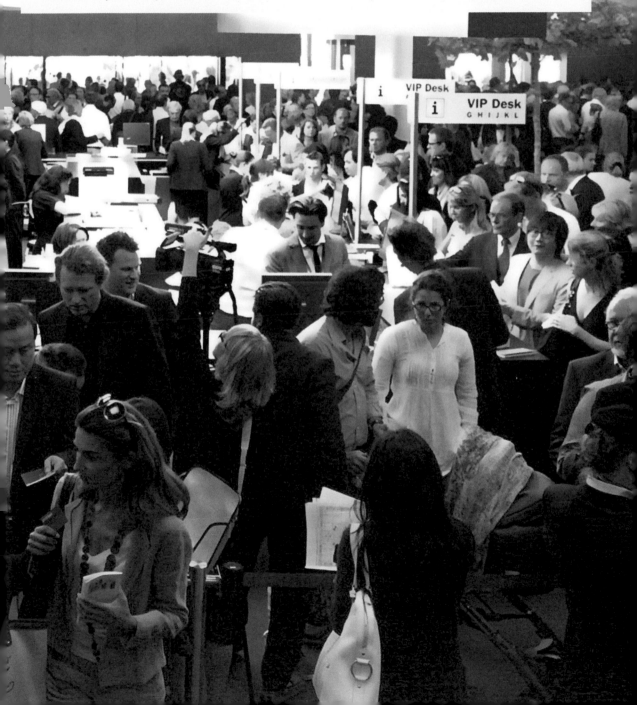

Scene at the opening of the Art Basel art fair, 2011

Eager to see what's on view and available for acquisition, large crowds with chequebooks at the ready regularly press the entry point on the opening of important art fairs. With competition for the best works usually fierce, as it's mostly been in recent decades, a few avid collectors and art world professionals always seem to try to beat the multitudes to the punch. In the early 2000s, Sam Keller, then the director of Art Basel, declared emphatically that no one was to be allowed entry to the fair prior to the VIP opening. To get around Keller's edict, a well-known art advisor – dealer, Philippe Ségalot, disguised himself – or so he thought – with workers' overalls and a wig. Ségalot was soon found out and told to leave until the fair officially opened. We confess to having once used an exhibitor's pass, though no disguise, to gain early entry to Art Basel. Our ruse also failed, and we, too, were asked to depart until the fair opened.

VIP Desk

i VIP Desk
GHIJKL

'WHAT STARTS AS A
PASTIME EVOLVES INTO
A HOBBY AND THEN IT
BECOMES AN OBSESSION,
AND THEN A DISEASE...'

Howard Rachofsky

neural connectors are set off and information, impressions and feelings flow through the brain in fractions of a second. It's then that something between conscious and unconscious thought is experienced and all else suddenly ceases to exist. These are especially thrilling moments, when the desire to possess can be overwhelming for passionate collectors.

Indeed, there are art collectors all over the world for whom the impulse to possess evolves into an all-consuming, nearly obsessive drive to own artworks they love and desire, sometimes even when they cannot realistically afford these works and do not have enough room to display them. As collectors we readily acknowledge being in this category.

When collecting becomes an obsession

The phenomenon of obsessive acquisitiveness seems endemic to the activity of collecting. Those who buy art often start out with modest ambitions and limited objectives, such as to buy only enough art to decorate their homes, to buy a few objects but not to spend too much money, or not to buy anything that will offend or be found controversial. But when they are beset by the elusive charge that comes from meaningful art, when they experience its intellectual and emotional rewards, and if they also have a deep-seated urge to possess objects and to assert their taste, then the art buyer may well evolve into a passionate collector. When this occurs, those original modest instigators we mentioned are soon forgotten and grander ambitions take over.

In his book, *Collecting: An Unruly Passion*, psychoanalyst Werner Muensterberger writes about some of the more prominent and obsessive collectors throughout history, and the various psychological conditions that compelled them to collect. Of collectors in general, he said, 'The roots of their passion can almost always be traced back to their formative years.'[5] Muensterberger delves into causal reasons and antecedent mental experiences that can lead to the making of a collector. Other psychoanalysts, including Sigmund Freud, have written on this subject, and many volumes on art collecting touch on early childhood experiences and the various psychological conditions that activate the urge to possess and collect. Our focus, however, is not those early psychological conditions – which are beyond our ken – but rather on the circumstances that drive people specifically to art, and on certain behaviour that accompanies art collecting as the pursuit develops and grows, over time, into a passion – as it so frequently does.

Howard Rachofsky, a well-known American art collector, told us, 'What starts as a pastime evolves into a

Art storage, Bronx, New York

Art storage is a way of life for inveterate collectors who continue to buy long after their walls are covered. Pictured here is the largest of several storage facilities, amounting to over 280 square metres (3,000 square feet), in which the authors keep works in their collection whilst they are not installed where they live and work. Today, inventories of large art collections are usually tracked on computer database systems. Pictures of the artworks are accompanied by information that includes purchase price, provenance, condition, artists' instructions, exhibition history and location. Without such computer programs to help them, it's all but impossible for collectors who own hundreds of works, or even more, to keep them all in their mind's eye. The extraordinarily wealthy, voraciously acquisitive American financier John Pierpont Morgan once enquired about the location of a sculpture in his collection that was attributed to none other than Michelangelo. His librarian responded in writing, 'This bronze Bust is in your library and faces you when sitting in your chair. It has been there for about a year.'

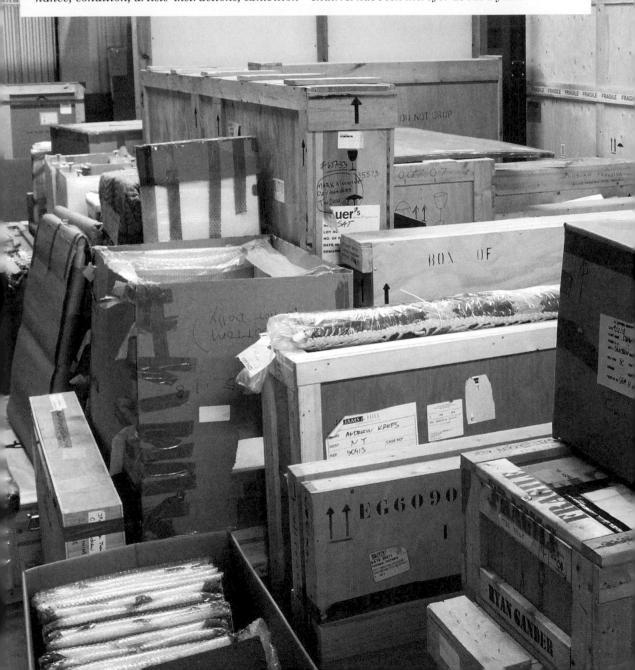

hobby and then it becomes an obsession, and then a disease. For me it reached a disease where everything was all-consuming. Art became the centre not only in our personal lives [speaking also of his wife, Cindy] and in our public lives, but in our social lives and cultural lives as well.'[4] The ever-enthusiastic Rachofsky turned his 929 square metre (10,000 square foot) house in Dallas, designed by Richard Meier, into a public exhibition space for art not long after it was built.

The pleasure of possessing art

'Making the deal – actually purchasing the work of art – provides a unique thrill for passionate collectors.'

After many years of observing collectors buy art and in listening to them talk about their collections, it's apparent that a state of excitement, even exhilaration, regularly accompanies the activity, and that this state of mind continuously nourishes the collectors' passions. Collectors may at times try to hold a display of such emotions in check in order to better position themselves to negotiate a good price with a selling agent, or simply to appear cool. However, after all the looking, thinking, conversing and research that is regularly part of the acquisition process, making the deal – actually purchasing the work of art – provides a unique kind of thrill for passionate collectors.

Essayist Walter Benjamin's insight into the pleasure of possession helps explain why soon after making an acquisition, a passionate collector typically turns his or her attention to the next object to be bought, and then the next, and the next. Benjamin said, 'For inside him there are spirits, or at least little genii, which have seen to it that for a collector – and I mean a real collector, a collector as he ought to be – ownership is the most intimate relationship one can have to objects. Not that they come alive in him, it is he who lives in them.'[5]

Oddly enough, in the very moment of deciding on an acquisition, collectors can also experience conflicting emotions, feelings of doubt about their choice, distress and even guilt about the expenditure. In other words, this dialectic tension between rational thought and the grip of passion can be agitating and exciting at the same time. In his autobiography, *The Passionate Collector*, Roy R. Neuberger (1903–2010), benefactor of the Neuberger Museum of Art in Purchase, New York, speaks plainly about this sort of conflict: 'Much of the time when I went out on Saturday, I would say to myself: Roy, try not to buy. Then I would see a particularly lovely work of art, and I would be smitten. My smitten self would win out over my don't buy self.'[6]

As collectors, this conflict is quite familiar to us. In June 2011, on our way by train from Zürich to Basel to attend Art Basel, widely considered the world's best

annual art fair, we faced the fact that after accounting for purchases made earlier in the year we simply did not have ready cash for new acquisitions. Along the way we admonished each other not to buy anything. 'Not a single artwork,' the two of us agreed. We arrived in Basel somewhat confident that reason and financial realities would prevail.

When the fair opened TW had a few clients in tow. Before joining the group EW went off to get an early first look at the work of a few artists of interest to us. An hour or so later, palpably agitated and feeling quite guilty, EW called TW to say that he had put reserves on five works by Klara Lidén at Reena Spaulings Fine Art, and had also reserved a Matias Faldbakken sculpture at the Simon Lee Gallery. For her part, TW could not have been more thrilled, financial concerns and mutual admonitions notwithstanding. By the end of the Basel fair, after completing our work with clients, we had not only turned every one of these reserves into a purchase, but had also bought several other works – by Josephine Pryde, Annette Kelm, Danh Vo, Melvin Moti and James Beckett. What's more, all of these artists, except Moti, were already represented in our collection with multiple works! We flew home anxious about money but far more exhilarated by the works we acquired and how they would amplify our collection.

Integral to the excitement that collectors experience when they identify and acquire art of deep interest and assert their likes and desires are feelings of mastery, magical escape and states of transport and renewal. They may also gain a sense of control, potency and conquest. These kinds of intoxicating feelings reside mostly at the subconscious or unconscious level; nonetheless, they are powerful sensations that impassion collectors everywhere and make collecting personally and psychologically indispensable to many. As Muensterberger said, 'Even a very serious and reflective collector is hard put to offer a clear, convincing explanation of his inclination or the intense emotion that occasionally occurs in the process of obtaining an object.'[7]

The desire to share

Apart from their inner passions, collectors are plainly motivated by external factors associated with collecting, notably the desire to share one's collection with friends, fellow collectors, the art community at large and even the general public. It's not unusual for collectors to seek recognition, approbation and applause, and we don't mean this pejoratively. All but the most reticent collectors like to show people what they've collected, how they've installed their works and what they've recently

'Collectors are motivated by the desire to share.'

Installation of works by Klara Lidén, including *Untitled (Trashcan)*, 2010 (far left), at Reena Spaulings Fine Art, Art Basel, 2011

Biennials and similar international exhibitions offer collectors excellent opportunities to see artists' work they may wish to acquire. At the 2011 Venice Biennale, Klara Lidén installed several tatty, graffitied, purloined trashcans in a small room in the vast Arsenale space. This installation was beautiful and affecting, earning her a well-deserved Special Mention award from the Biennale jury. A year later, we recalled to friends that immediately after seeing Lidén's trashcans in Venice we were on the phone to her dealer, Reena Spaulings Fine Art, who was showing Lidén at Art Basel. Upon hearing our comment, Berlin gallerist Johann König laughed and said that he had done the same thing. Then Erling Kagge, also a long-time Lidén collector, chimed in that he, too, had made a similar call. Also on view at the 2011 Venice Biennale was a group of Annette Kelm's singularly intriguing photographs. We had seen images of these same works months earlier but wanted to see them in person in Venice before deciding on any acquisition. It was almost too late when we approached Kelm's dealers in Basel a week later, as the entire edition of a particular image we were interested in was already spoken for. However, Kelm's Berlin gallerist, the same Johann König, was eventually able to spring one free for our collection.

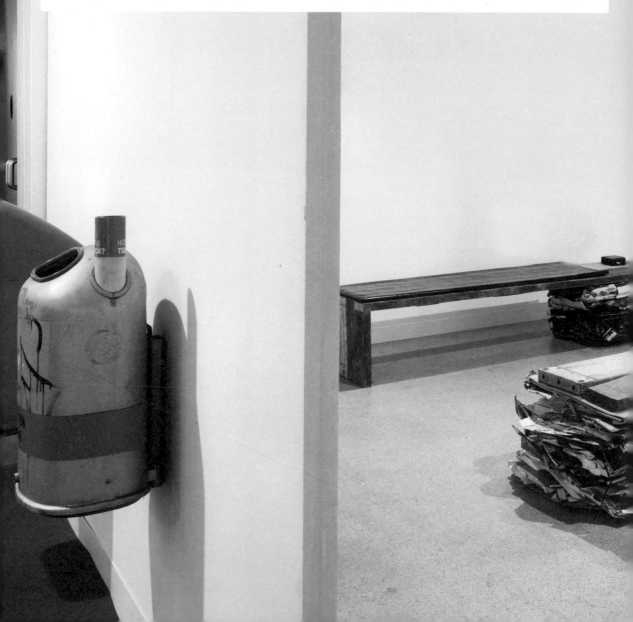

acquired. So, it's quite ordinary, almost de rigueur, for collectors to open their homes to friends, fellow collectors, museum groups, artists, dealers and curators. In doing so they seek to affirm (and project to others) their self-image: the constellation of traits they hold dear to their collecting, such as knowledge, individuality, discernment, perspicacity, personal taste and sensibilities, courage and prescience. Collecting is also a competitive activity, so collectors may relish the opportunity to establish that what they have acquired is the best, the ultimate, the most hard-to-get and the most valuable – both critically and financially.

Among the great collectors who enjoyed opening their collections to friends and interested visitors were Leo (1872–1947) and Gertrude Stein (1874–1936), an American brother and sister living in Paris in the early twentieth century. Their Saturday night 'at homes' attracted a fascinated – and fascinating – crowd: collectors, dealers, literary figures and artists who came to see, discuss and marvel at the works that filled the Steins' Left Bank apartment, among them the latest Picassos, Matisses and Renoirs.

In New York, Henry Osborne (1847–1907) and Louisine Havemeyer (1855–1929), early twentieth-century collectors of considerable note, had a similar disposition. Louisine Havemeyer said, '[A]ny stranger that came to our city, if properly recommended, was sure of a welcome and an opportunity of seeing the pictures.'[8] The H. O. Havemeyer Collection, which has been called 'a museum within a museum', includes works by Frans Hals, Rembrandt van Rijn, Lucas Cranach, Édouard Manet, Paul Cézanne and the Havemeyers' good friend and advisor, Mary Cassatt. Most of their collection was bequeathed to the Metropolitan Museum of Art (Met) after Mrs Havemeyer's death in 1929.

In his book *Great Private Collections* (1963), Douglas Cooper tells the story of another pair of collectors who wanted to share their collection with friends: Samuel A. Marx (1885–1964), a Chicago architect and noted designer, and his then wife, Florene (1903–95). After marrying and moving into their new Chicago apartment in the early 1930s, the Marxes hung their first work of art: a reproduction of an oil painting by Georges Rouault. Thinking it to be a genuine Rouault, their friends were greatly impressed, and this favourable response seems to have prompted the Marxes to up the ante to start collecting original works of art. While the couple didn't acquire a great number of objects, their collection grew to include works by Georges Braque, Pierre Bonnard, Giorgio de Chirico, Amedeo Modigliani, Fernand Léger, Henri Matisse and Pablo Picasso. Many of the works they owned are now in the

collection of the Met and the Museum of Modern Art (MOMA) in New York.[9]

One might ask, what collector wouldn't proudly open his or her home to display a collection as spectacular as those of the Steins, the Havemeyers and the Marxes? The point is that the impulses of these historically important collectors are likely no different than those of prominent collectors today. In fact the inclination to show and talk about one's art collection applies, at least to some degree, to most art collectors. After all, the entire activity of collecting art is built on belief – the collector's belief – in art's special qualities and in the perspicacity of his or her own acquisitions.

This dual belief compels some collectors to want to open up their personal collections beyond their social circle to the general public – to enable as large an audience as possible to be thrilled by art's special qualities and values. The legendary oil tycoon and collector J. Paul Getty (1892–1976) once said, referring to a later stage in his collecting, 'I realized that my collection had grown important enough for the public to have an interest in viewing it.' He added, 'The shift in my thinking was natural. It is a phenomenon familiar to many private collectors. After acquiring a large number of examples of fine art, one develops conscience pangs about keeping them to oneself.'[10, 11]

François Pinault, a high-profile French collector and businessman with a large and impressive collection ranging from late-twentieth-century works to the most recent contemporary art, has expressed a similar view. 'The desire to possess – born at the moment I first came in contact with art – has been transformed into a profound need to share,'[12] he once declared. In recent years

'The inclination to talk about one's collection applies to most art collectors.'

Willem van Haecht, *The Archdukes Visiting the Home of Cornelis van der Geest*, 1628, oil on panel

Collectors the world over are beset with a desire to display and discuss their art; it's a fundamental reason why the art world's social scene is always vibrant. In fact, art collecting has served as a status symbol and centrepiece of social interaction for centuries, certainly since the early 1600s, when increasing numbers of Europeans from the Low Countries – mostly businessmen with surplus capital – began collecting pictures. This painting portrays a prosperous Antwerp spice trader (at lower left, pointing to one of his works) surrounded by art world luminaries, including royals and other nobles, merchant–collectors and artists. Gatherings of this sort (absent the royals, in most cases) have taken place ever since in collectors' homes around the globe. ↦

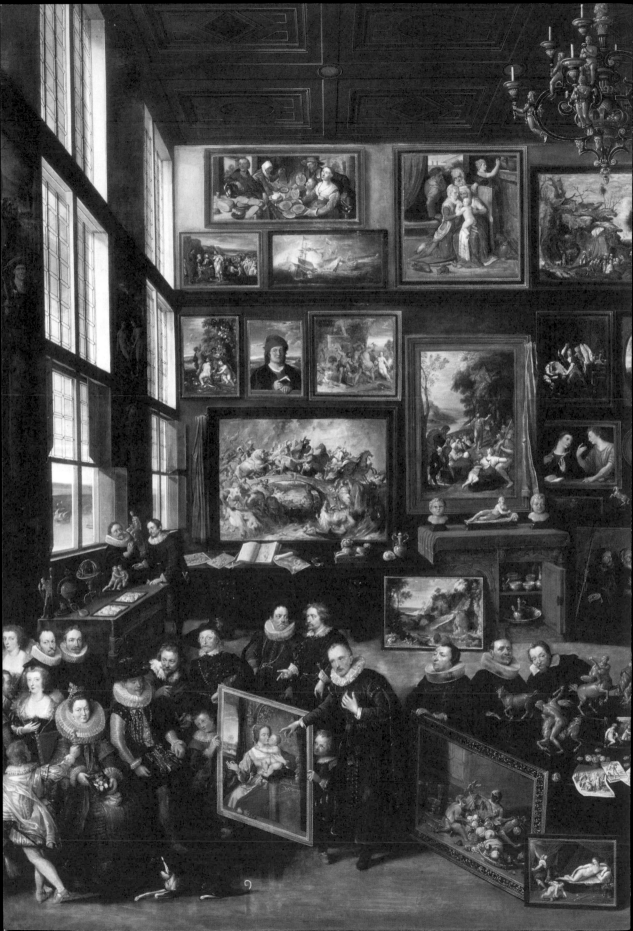

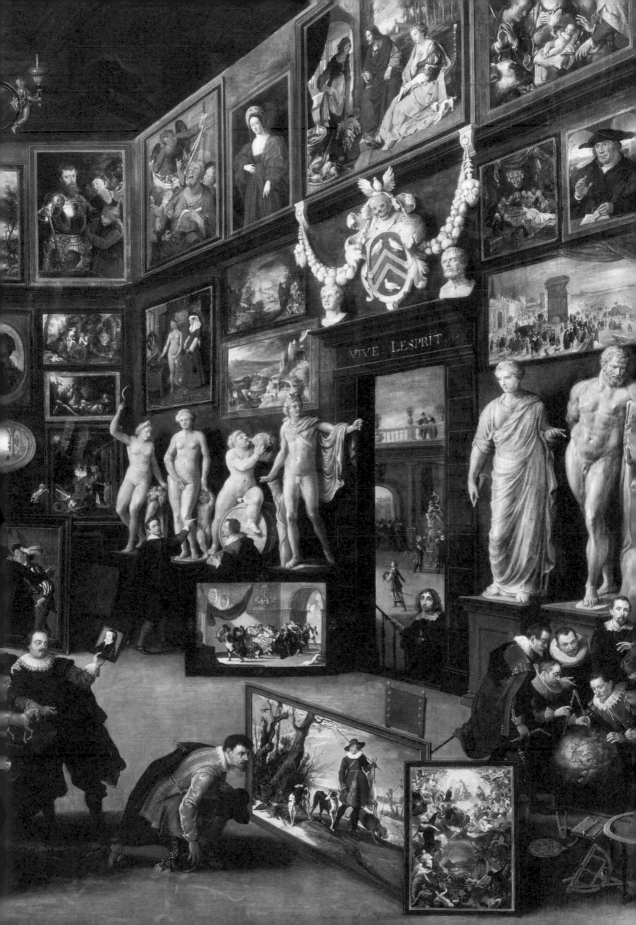

VIVE L'ESPRIT

Pinault has opened two immense spaces in Venice, Italy, to exhibit works from his collection.

Another very prolific collector of contemporary art, Ukrainian businessman Victor Pinchuk, established a private museum in the centre of Kiev with the intention of educating young Ukrainians in the thinking and expressions of international artists. Pinchuk has said, 'I absolutely believe that contemporary art is one of the most revolutionary forces in the world and it works. I am sure of that.'[13] Since it opened in 2006, more than one million people have visited his facility, the Pinchuk Art Centre.[14]

The rise of private exhibition spaces

In recent years there has been a surge in the number of collector-owned, quasi-institutional exhibition spaces – mostly dedicated to showing contemporary art – in cities around the world, from Russia to Brazil, and from Mexico to Germany. In the United States alone such new spaces have opened in many far-flung small towns, including Calistoga, California; Vail, Colorado; Hartford, Connecticut; and Potomac, Maryland; as well as in large cities such as Dallas, Miami, Los Angeles and New York.

Anna Somers Cocks, the founding editor of *The Art Newspaper*, traces this recent rise in the number of privately owned exhibition spaces to the 1990s art market boom. She says, 'During the ascending speculative market people put their money into art and began to buy more than they could house.' Indeed, many collectors wind up having to place much of what they collect in storage – they simply cannot display all that they own in their residence(s). Those who can afford it have found the solution in building exhibition spaces that enable them to see what they've collected, curate what they own and show it all to others.

Many collectors have gone this route because they feel that if they had given their collection to a public institution it would not have been presented in a way that reflects their curatorial disposition. A more prevalent feeling is that many of the works would be relegated to museum basements and not be seen by the public. Explaining his decision not to make an outright gift of his vast and highly regarded collection, Los Angeles mega-collector Eli Broad said, 'We were concerned that if we gave our collection to one or several museums, ninety per cent or so would be in storage all the time. Our goal was to have the broadest possible public view of what we have.'[15] With a slightly different but hardly less significant concern in mind, Chinese collector Wang Wei said, 'I won't donate my art to public museums. I don't trust their management. Many pieces are rotting there.'[16]

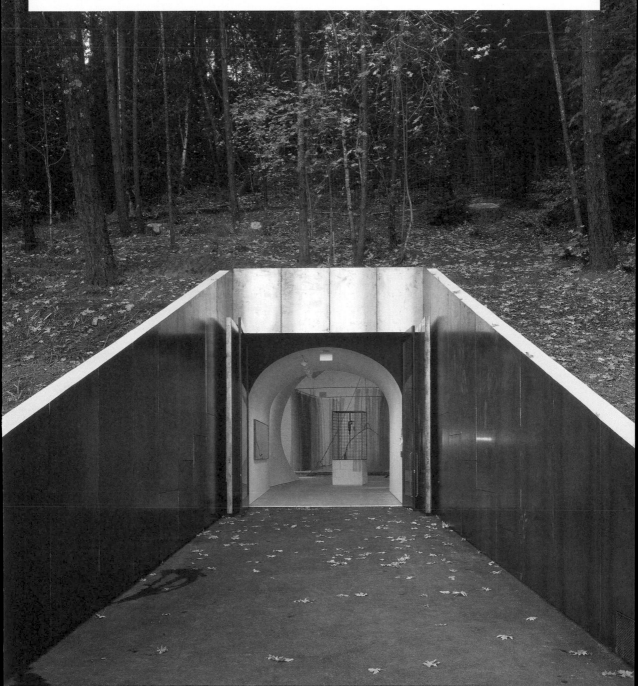

Entrance to the 'art cave', an exhibition space for contemporary art in Calistoga, California

Contemporary art collecting couple Norman and Norah Stone are among a growing number of collectors who, since the turn of this century, have built private exhibition spaces to curate and exhibit their collections. The Stones' 'art cave', designed by the architectural firm Bade Stageberg Cox and opened in 2007, is an innovative 534 square metre (5,750 square foot) space dug into a mountain on the Stones' vineyard property in the Napa Valley. Stonescape, as the entire property is named, also includes a farm-house built in 1877, a pool and pavilion designed by James Turrell, an outdoor sculpture by Cady Noland and also a sound installation by Alex Waterman, in addition to a vineyard and a magnificent stand of redwood trees. On the other side of the United States in Greenwich, Connecticut, another collecting couple that way inclined – Peter M. Brant and his wife, model Stephanie Seymour – converted a 1902 apple barn into a 910 square metre (9,800 square foot) showplace for their contemporary art collection.

'These [quasi-public] spaces are often large in scale...and favour the display of works that are scaled to fit.'

For the collecting community this trend toward privately owned, quasi-public spaces, no matter what prompts it, is not without consequences. Among the more problematic is that because these spaces are often large in scale, their owners have a tendency to favour the display of works that are scaled to fit or that otherwise convey a strong visual presence. Certain artists can produce large-scale works that 'work', while others, as is often plain to see in these venues, are simply not up to the task. This collecting approach, often favouring the bombastic, can lead impressionable visiting collectors awry – away from the significance and relevance of works of art that are more quiet, intimate and visually subtle.

Another concern is that these quasi-institutional spaces will become static when their owners are no longer around to keep the collections vital. Even more important, this trend may be cutting off the flow of art that traditionally finds its way to permanent museums that are established destination points for the museum-going, art-loving public. As Neal Benezra, director of the San Francisco Museum of Modern Art (SFMOMA), said, 'We can make [art] accessible on a scale that private collectors can't.'[17] Furthermore, there is widespread feeling in the museum world and beyond that unless collectors gift contemporary art, much of which has become incredibly expensive in recent decades, public institutions will have a difficult time keeping their permanent collections current and relevant.

On the benefits side of the ledger, private exhibition spaces can expose collectors to unique and creative visions and provide opportunities to meet new artists and exchange ideas with other, perhaps more experienced collectors. The development of these often-ample spaces has also allowed artists to realize unique and grand visions, works of a scale that would not otherwise find a buyer or a home. Collectors benefit from these kinds of works as well. As the London art dealer Pilar Corrias told us:

> There is a point in art buying where acquiring an artwork is about investment and the higher value of the artwork. However, there is a threshold that goes beyond that – where the work is so important, rare and unique that one cannot put a value on it. This kind of work goes beyond art fairs, it cannot be placed in a booth, it's about the search for the 'true' experience of art outside the mainstream market.[18]

Budi Tek, an Indonesian-Chinese businessman, is a collector who fits Corrias' description, at least in so far as he regularly seeks to acquire large-scale works 'outside the mainstream market'. Tek has a staged plan to build a museum complex in Shanghai, with the 7,900 square metre (85,000 square foot) De Museum

scheduled to open in 2013. Tek said, 'Now is the time for me to have a serious space, because I have so many big things that maybe a lot of people can't imagine.' His description would apply, for example, to very large-scale works he owns by Ai Weiwei, Yoshitomo Nara, Wim Delvoye and Fred Sandback, to name a few.

Not to be missed, private exhibition spaces offer viewing opportunities that can enliven the discourse on art-making practices and curating. Indeed, as history shows, the better, more astute private collectors can provide unique perspectives, showing what they deem important to great effect. Fondazione Prada's Ca' Corner della Regina in Venice, for instance, makes a strong argument for the private exhibition space approach. At the opening exhibition in June 2011, the art-going public, many collectors included, was treated to an intelligently curated display of postwar and contemporary art that included many important Arte Povera works, all of which were installed with extraordinary sensitivity in this historic palazzo on the Grand Canal. It would be hard to ask for more from a space, whether public or private.

Two other privately endowed exhibition spaces are noteworthy: one in Japan for its outstanding architecture, the other in Brazil for its astounding ambition, and both of them for their unique locations. In the late 1980s, Tetsuhiko Fukutake, founder of a large publishing company, formed an agreement with the local government to develop cultural sites on Naoshima island. They commissioned Tadao Ando to design two facilities: the Chichu Art Museum, whose underground buildings house permanent works by Walter De Maria, James Turrell and Claude Monet (five *Water Lily* paintings); and the beautiful Benesse House Museum, which incorporates a hotel and contains works by Dan Graham, Yves Klein, Hiroshi Sugimoto, Frank Stella, Andy Warhol and Kan Yasuda, among others.

Across the globe, in a remote area of Brazil, mining magnate Bernardo Paz opened his Inhotim complex to the public in 2006. Considered by many to be the most ambitious private exhibition space ever conceived for contemporary art, it already contains close to twenty galleries spread over some 120 hectares (300 acres), most devoted to single-artist works commissioned for these very spaces. According to Paz, there's much more to come, including (as of this writing) the nearly completed Great Gallery, which will add another 4,000 square metres (43,000 square foot) of exhibition space. According to the *New York Times*, all of this is only a fraction of the area of the Inhotim property, which, although largely undeveloped, covers almost 2,000 hectares (5,000 acres).

'Private exhibition spaces offer viewing opportunities that can enliven the discourse on art-making practices and curating.'

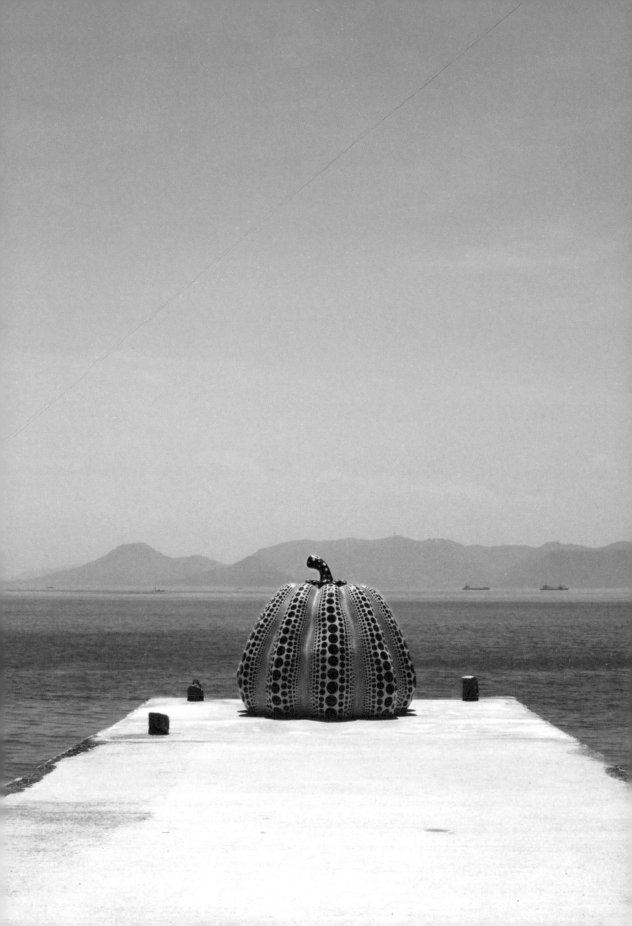

Naoshima island's iconic sculpture; Yayoi Kusama,
***Pumpkin*, 1994**

Japan's Naoshima island is one of the art world's most spectacular and remote destinations. It is home to the Benesse House Museum, the Chichu Art Museum, the Art House Project, the Lee Ufan Museum (opened in 2010) and a museum dedicated to Agent 007 – 'The name's Bond, James Bond'. Raymond Benson, the author of six James Bond novels (following the death of original Bond author Ian Fleming), made Naoshima a primary locale for the last book in his series, The Man with the Red Tattoo, *published in 2002. The vision of the founder of the art spaces on Naoshima, Soichiro Fukutake, was to create a 'rejuvenating haven', and by accounts of visitors who have been there he has done just that. Fukutake's ambition may be a bit loftier than that of most collectors with private exhibition spaces, but not by much. Most of these spaces evidence pride in what the collectors own, serve to express their curatorial viewpoints and manifest their love of art.* ↤

There's a lot to see at Inhotim, even for its creator. Paz is quoted as saying, 'There are works of art here which I haven't entered yet which everyone told me were spectacular, but why should I go in there? I don't consider myself passionate for art. But gardens, that's what I like.'[19] Whether the statement expresses bravura or Paz's true feelings is hard for us to say, but Inhotim is nonetheless quite remarkable. Writing in *The Art Newspaper*, Christina Ruiz described Inhotim this way: 'There is a place in the Brazilian jungle where artists are told to make their dreams come true. This is a place where the usual institutional limitations do not apply: where there is endless space to realize projects, no time limits in which to make them, and plenty of money to pay for them.'[20] Inhotim is already drawing hundreds of thousands of visitors yearly, despite its far-off location.

Having worked as professional art advisors with many different collectors – those who have their own quasi-public spaces, those with grand homes and those with modest residences – it's clear to us that collecting asserts itself powerfully in the lives of collectors who are open to what art has to offer. As a general rule, art collectors recognize and appreciate that art provides intellectual and emotional satisfactions that cannot be calculated in economic terms. At its best, art embodies values – originality, uniqueness, intellectual achievement, higher principle and epistemological gain chief among them – that confirm a simple truth for art collectors and art lovers: art stands apart.

Personal taste and knowledge

A number of years ago we were invited by a client to his grand new home in the far reaches of Maine to discuss what kind of art he and his new wife might collect together. It took a flight and a long car ride to get there, but soon after arriving we were fully into the subject.

We asked the wife what she was interested in. After an interminable pause and what appeared to be a lot of soul-searching, she replied, 'I like flowers.' Another long pause and then, 'Yes, that's what I like, flowers.' Over the next year or so, with the husband's encouragement, we tried valiantly to source credible works that both of them would find interesting and worth buying, but to no avail. The wife liked prosaic flower paintings and nothing else. And without being able to agree, the couple couldn't move ahead with their collection. As an aside, the couple later divorced.

The respected New York art dealer Ronald Feldman told a similar story about a New York businessman who wanted to 'get some culture' but, like our client, was locked into a set notion of what he liked. Feldman said:

He came to the gallery with a list of pretty, Fifty-Seventh Street/Palm Beach artists, the ones who look like Impressionists but aren't. I told him he could have a much finer collection, and arranged for a private lecturer to take him and his wife to all the museums. First his wife dropped out. She had made all her beauty parlour appointments to coincide with the museum visits. Finally, he too had enough. I asked him what his thoughts were. He pondered my question, and then told me he wanted to buy second- and third-rate Impressionists. He still liked them and just hadn't known what to call them before. The last time I saw him he was headed toward Parke-Bernet [the auction house later acquired by Sotheby's], catalogue in hand, to one of those afternoon auctions where they try to sell everything that no one wants.[1]

We heard an art collecting disposition of an altogether different nature expressed when we asked the noted New York collector and museum benefactor Leonard Lauder what drew him to Cubism. He answered, 'I just liked them [the Cubists].' But what he added makes all the difference: 'I made sure that I would be as good, if not better, than anyone around in being able to understand it, because there was the thrill of being able to learn.'[2]

The importance of personal taste

An art collector's personal taste – their likes and dislikes – is a large part of what makes a collection individual. Particular as it is to each collector, taste differentiates – it allows for the creation of something unique. It's a

characteristic to be embraced, not denied. We say this knowing full well that the word 'taste' is disparaged by many in the art world as being too coarse or capricious; as an obsolete word to be avoided because it does not fully convey the interpretation, sensibility and analysis that are integral to considered value judgements about art. This may be so, but we're using the word 'taste' as a synonym for 'like': a simple, handy way for us to describe the collector's responsive chord and to make two important points.

The first is, as Lauder suggests in speaking of 'the thrill of being able to learn', that taste is not something that should remain static, perpetually mired in whatever initial conception the collector may have of what she or he likes and finds beautiful. And it matters not whether that initial conception came about through visits to museums or commercial galleries or collectors' homes, or what a decorator brought in to place above the couch.

In our experience observing clients and scores of other collectors over about thirty years, the rewards of collecting and the chances of building a unique collection are much more likely to be realized by developing and refining one's taste than by staying wed to what's familiar. When it comes to art, remaining permanently moored in a safe, familiar harbour and never daring to sail outside the break delimits the collecting experience and surely the collection. When the two of us started collecting together as a couple in 1991, one of us (TW) gave the other (EW) a good piece of collecting advice: 'Sometimes you just have to walk up to the edge of the cliff, close your eyes and jump.'

As we relived this conversation it brought to mind, albeit with a contemporary slant, Charles Baudelaire's insight: 'The Beautiful is always strange...it always contains a touch of strangeness, of simple, unpremeditated and unconscious strangeness, and it is that touch of strangeness that gives it its particular quality of Beauty.'[3] What propels art collectors from the familiar to the unknown – to the 'strange', if you will – and ultimately to the possibility of assembling a unique and compelling collection, is largely curiosity – a desire or willingness to explore and learn.

For a short time in the early 1990s one of our clients was American businessman–investor Mitchell Rales. In 2006, years after our professional relationship ended, Rales opened his own museum in a 2,044 square metre (22,000 square foot) building in Potomac, Maryland. His personal art collection is vast and exceptional: it includes European and American modern masters such as Henri Matisse, Alberto Giacometti, Willem de Kooning, Jasper Johns, Andy Warhol and Donald Judd, as well as more contemporary artists of considerable

'THE BEAUTIFUL IS ALWAYS STRANGE...IT ALWAYS CONTAINS A TOUCH OF STRANGENESS, OF SIMPLE, UNPREMEDITATED AND UNCONSCIOUS STRANGENESS, AND IT IS THAT TOUCH OF STRANGENESS THAT GIVES IT ITS PARTICULAR QUALITY OF BEAUTY.'

Charles Baudelaire

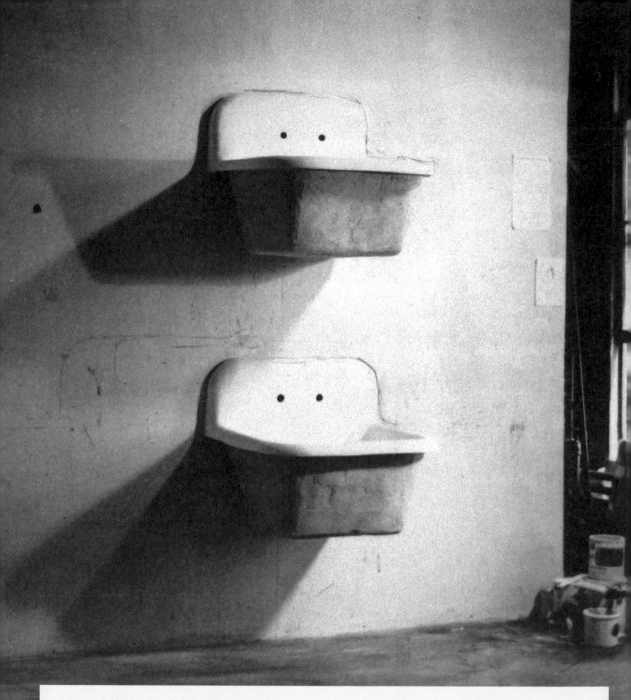

Robert Gober, *The Ascending Sink*, 1985, as seen in the artist's studio; plaster, wood, steel, wire lath and semi-gloss enamel paint

Truly innovative art, almost by definition, generally doesn't look anything like art which is already familiar. Actually, when first seen by the public, innovative art can appear downright strange. In 1985, on a visit to the Paula Cooper Gallery in New York, TW learned about a young artist named Robert Gober and was encouraged to visit his studio by a mutual friend, the artist Christopher Wool. Mounted on the walls were various permutations of his sink sculptures. TW purchased the piece pictured for her collection and recommended two others to a client. Upon seeing these works the collector–client said to TW, 'Now I know you're crazy' – a response not much different, at least for a few years, from many of those who viewed the work in TW's home. Since that time, Gober's sinks and urinal sculptures have come to be considered iconic.

stature, including Ellsworth Kelly, Richard Serra, Brice Marden and Jeff Koons.

Rales started buying art to decorate his home; in fact, it was his decorator that referred him to our advisory practice. At the beginning of our collaboration he had scant knowledge, no particular preferences and even little understanding of his own taste. As is the case with most beginning collectors, wherever he was to venture as a novice, the terrain was most likely to be new and unknown. But he rapidly became an astute collector.

Rales approached the activity of collecting with the same dedication to knowledge, empirical information and incisive analysis that seemed to define the way he conducted his businesses. For example, he bought his first Franz Kline only after he had learned where every black-and-white Kline painting from the mid- to late 1950s, generally considered the artist's most desirable period, was located and how each was evaluated critically. Together, we also conferred regularly with David Anfam, a noted scholar of Abstract Expressionism, and once we even flew to Barcelona for twenty-four hours to see a monographic exhibition of Kline's work. Only then was Rales prepared to make his acquisition.

Many history-making collectors begin with modest ambitions. 'It was very late before we would admit we were collectors,' said none other than Dominique de Menil (1908–97), who, with her husband John (1904–73), built one of the greatest collections of the twentieth century. The de Menils began acquiring art in the 1940s, ultimately amassing more than 15,000 objects ranging from the arts of ancient and indigenous cultures to early and mid-twentieth-century Modernism and contemporary art.

Jane (1924–2004) and Robert Meyerhoff, natives of Baltimore, Maryland, who began collecting about a decade after the de Menils, held a similarly modest view of their beginnings as collectors. 'We never intended to be collectors, it sort of just happened by accident,'[4] said Jane Meyerhoff. Their collection, much of which they donated to the National Gallery of Art in Washington, DC, contains works by Jasper Johns, Ellsworth Kelly, Roy Lichtenstein, Brice Marden, Barnet Newman, Robert Rauschenberg and Clyfford Still, among many others.

But whether collectors begin with modest or grand collecting ambitions, or for that matter a small or large budget, if they become serious, purposeful and passionate – in other words, if they catch the collecting bug – they'll soon begin expanding their interests, and their likes and dislikes will evolve. Aaron and Barbara Levine, collectors from Washington, DC, spoke with us about how personal taste in art develops over time. Barbara said, 'I look at things I hate, and then I like

'Many history-making collectors begin with modest ambitions.'

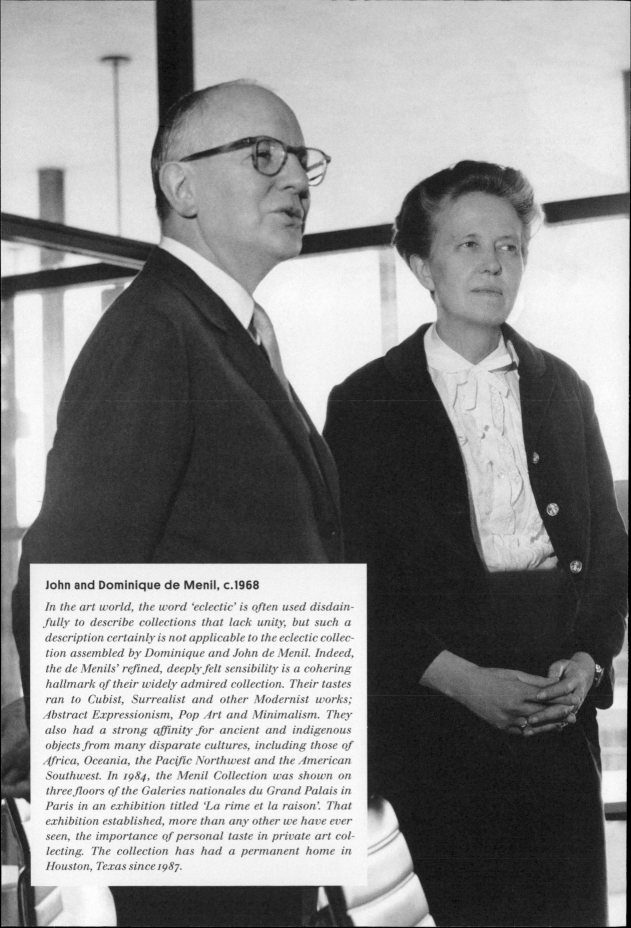

John and Dominique de Menil, c.1968

In the art world, the word 'eclectic' is often used disdain-
fully to describe collections that lack unity, but such a
description certainly is not applicable to the eclectic collec-
tion assembled by Dominique and John de Menil. Indeed,
the de Menils' refined, deeply felt sensibility is a cohering
hallmark of their widely admired collection. Their tastes
ran to Cubist, Surrealist and other Modernist works;
Abstract Expressionism, Pop Art and Minimalism. They
also had a strong affinity for ancient and indigenous
objects from many disparate cultures, including those of
Africa, Oceania, the Pacific Northwest and the American
Southwest. In 1984, the Menil Collection was shown on
three floors of the Galeries nationales du Grand Palais in
Paris in an exhibition titled 'La rime et la raison'. That
exhibition established, more than any other we have ever
seen, the importance of personal taste in private art col-
lecting. The collection has had a permanent home in
Houston, Texas since 1987.

them.'[5] In the early 1980s Aaron's legal practice often took them to Holland, where they visited museum shows in their spare time. Soon, their friend and early mentor Neal Benezra, then a curator at the Hirshhorn Museum of Art in Washington, DC, began recommending specific exhibitions to see while they were in Europe. 'It was a relief from legal work to get on a train and travel from one exhibition to another,' Aaron said.[6]

The Levines saw shows, met artists and began making acquisitions. They also regularly frequented the bookstore in Cologne, Germany, owned by Walther König – a special place then and now for artists, book lovers and art collectors from around the world. A key moment for the couple came when the New York art dealer Sean Kelly introduced them to the work (and thinking) of Marcel Duchamp, which they believe has influenced them ever since. As Barbara put it, they are aligned to art that's 'Reverberating and challenging, aesthetically and intellectually.'[7] With a growing library and greater exposure and knowledge, the Levines' passion grew. 'I will put a federal judge on hold for a good dealer or artist,'[8] said Aaron.

The act of looking

As with the Levines, every collector has to find his or her own direction. For serious collectors, that search is in large part about processing information; and foremost in that pursuit is the act of looking.

The approach followed by *New York Times* art critic Roberta Smith has much to recommend it. In her words:

My main activity is looking, looking and more looking, and trying to listen to my subjective reactions as objectively or neutrally as possible. I learn from everything I look at, good, bad or indifferent. I follow my eye reflexively; if it is drawn toward something, I pay attention and try to find out why. You train your eye, build up a mental image bank, and constantly try to pinpoint why some things are convincing and others aren't. When I look at a new work, my image bank goes into action. I pay careful attention to the names of other artists that flash in my brain as I look at the work. How many other artists exactly come to mind? [...] Obviously, the fewer names that come to mind, the greater the odds that you are looking at something fresh that you haven't quite seen before.[9]

Of course, few collectors work with such an 'image bank'. But for every collector, Smith's process – or something akin to it – is well worth the effort.

Not to be overlooked is the effect a work of art may have on the viewer – the 'subjective reactions' that

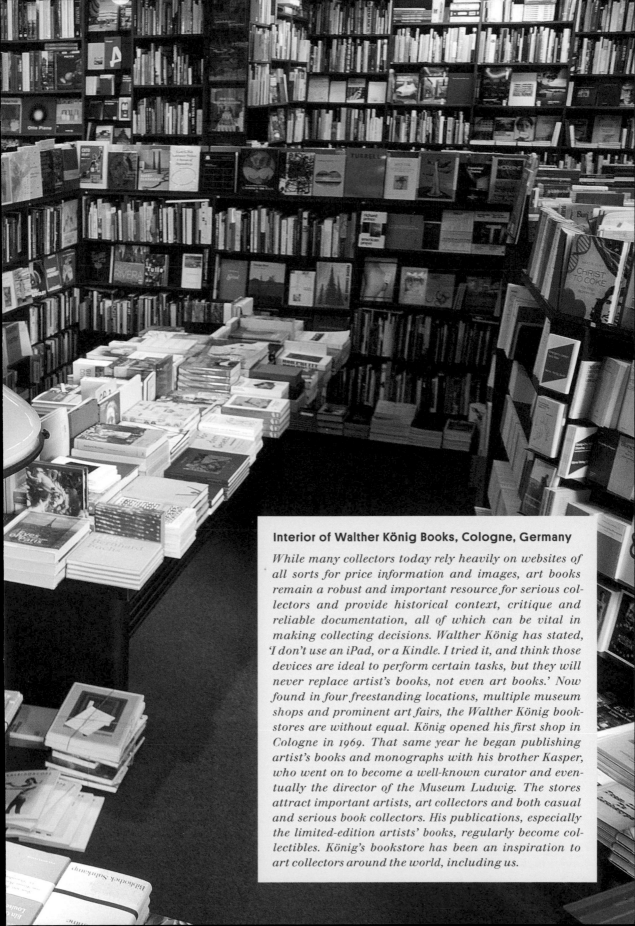

Interior of Walther König Books, Cologne, Germany

While many collectors today rely heavily on websites of all sorts for price information and images, art books remain a robust and important resource for serious collectors and provide historical context, critique and reliable documentation, all of which can be vital in making collecting decisions. Walther König has stated, 'I don't use an iPad, or a Kindle. I tried it, and think those devices are ideal to perform certain tasks, but they will never replace artist's books, not even art books.' Now found in four freestanding locations, multiple museum shops and prominent art fairs, the Walther König bookstores are without equal. König opened his first shop in Cologne in 1969. That same year he began publishing artist's books and monographs with his brother Kasper, who went on to become a well-known curator and eventually the director of the Museum Ludwig. The stores attract important artists, art collectors and both casual and serious book collectors. His publications, especially the limited-edition artists' books, regularly become collectibles. König's bookstore has been an inspiration to art collectors around the world, including us.

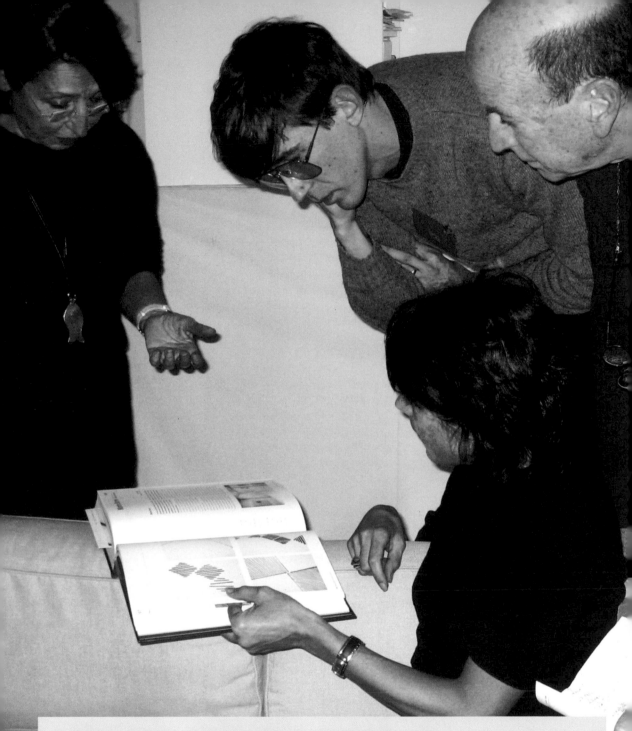

Michele Barré, Cheyney Thompson, Nathalie Obadia and EW, 2007

Developing one's taste and sensibilities requires 'looking, looking and more looking', in the words of New York Times *art critic Roberta Smith. And, when seeking information about a specific artist's practice, the process of looking can be augmented with talking, talking and more talking – with knowledgeable people. When it comes to the work of French artist Martin Barré,* *a painter who in the late 1950s and early 1960s began to explore innovative new approaches to the picture plane, few people – if any – are more expert than Michele Barré, his widow (left); Nathalie Obadia, the Barré estate's dealer (seated, centre); and artist Cheyney Thompson (standing, centre), an American artist who has closely studied Barré's practice.*

Smith mentions. It's often the case that collectors react to or like an artist's work for the very reason that Smith tries to distil or identify through her process: essentially, the work exhibits familiarity – that which has already been expressed by other artists. Knowledgeable art world players refer contemptuously to this sort of art as 'derivative' or 'art that looks like art'. Weaning oneself away from an attraction to what is already known and not particularly original isn't easy, and not every collector can do it. But with 'looking, looking and more looking', it can be achieved – for the most part at least.

There is no definitive list of 'to dos' for tracking art of interest, but online searches, visiting dealers, reading books and art magazine reviews, visiting exhibitions and keeping notes are all important. These activities serve all collectors, and are essential to staying abreast of new ideas and evolving art-making practices.

Developing a relationship with art

Some people in the art world believe that novice collectors shouldn't buy until they've developed an educated eye and investigated the full range of possibilities that fill the art landscape. Such an approach may help prevent mistakes, but learning about and refining one's taste is not a one-time achievement; it's an ongoing process. In practice, becoming a collector requires buying – developing that 'intimate relationship' with art that Walter Benjamin wrote about, discussed in the first chapter. Missteps can occur at any time along the way, and when they do, changes can be made; many collectors plausibly call this process 'upgrading' a collection.

The renowned founder of the Phillips Collection in Washington, DC, Duncan Phillips (1886–1966), was of this mind. He set off as a collector, he said, 'learning from the mistakes I made – eliminating the dross – enshrining the pure gold'.[10] We submit that it's okay to buy what you like when the urge strikes, even though some choices may later be found to be uninteresting or misguided. Buying provokes a more profound and considered engagement with art and provides a deeper understanding of one's taste and proclivities.

In his foreword to *Global Collectors* (2008) by Judith Benhamou-Huet, Sam Keller, director of the Foundation Beyeler and former director of Art Basel, asserts:

> Whatever the case, it is rare for people to become collectors overnight. Ordinarily it is a process that requires having good and bad experiences, seeing, hearing and reading a lot. [...] Some are now ashamed of their first acquisitions; others keep them to bear witness to their evolution.[11]

'Refining one's taste is not a one-time achievement: it's an ongoing process.'

'Exercising one's personal
taste – buying what you like
– is its own reward.'

As the prominent British collector Frank Cohen plainly put it when asked about past errors, 'Everybody makes some. It allowed me to learn.'[12]

Another important point, one that is central to this book, is that exercising one's personal taste – buying what you like – is its own reward; it is an exhilarating and self-defining activity. Indeed, passionate collectors are provoked by what's in their minds and hearts. Much of the personal excitement they derive from collecting comes from the process of searching for objects that reify those personal sentiments – from sifting through the endless possibilities and then, in what for many are magical moments, 'seeing' an object that strikes a response deep inside them. In a flash, desire takes hold and the object must be theirs.

Patricia Marshall, an art advisor and collector who resides in Paris, explains that when she sees a particular piece that compels her, 'It is like being a drug addict…I need to own it.'[13] Marshall is personally compelled by the work of Mike Kelley, Paul McCarthy and Richard Hawkins, among other artists.

Given that many contemporary art collectors draw from a widely shared information pool – monographic exhibitions, large international surveys, cutting-edge shows at exhibition spaces, critical writing in newspapers, art magazines and catalogues, and the interests and choices of leading collectors – they are bound to have overlapping interests.

In the early 2000s we worked with a couple from Connecticut who were intent on building a respectable collection. In certain instances they responded to artists we brought to their attention; in others they found artists on their own. But at all times they were mindful of what a very well-known collector in their social circle was buying, which often prompted them to tell us something akin to 'we want one of those.' Undoubtedly that well-known collector has influenced other collectors, many of whom most certainly have works by the same artists in their collections.

All this considered, there is always ample room for collectors to set themselves apart – to create unique and estimable collections. The individuality that characterizes one's choices, and the conceptual thinking that coheres them, are among the qualities that can make collections especially admirable. If there are unexpected objects in a collection, or perhaps a few lesser-known artists, or a unique collecting perspective, so much the better.

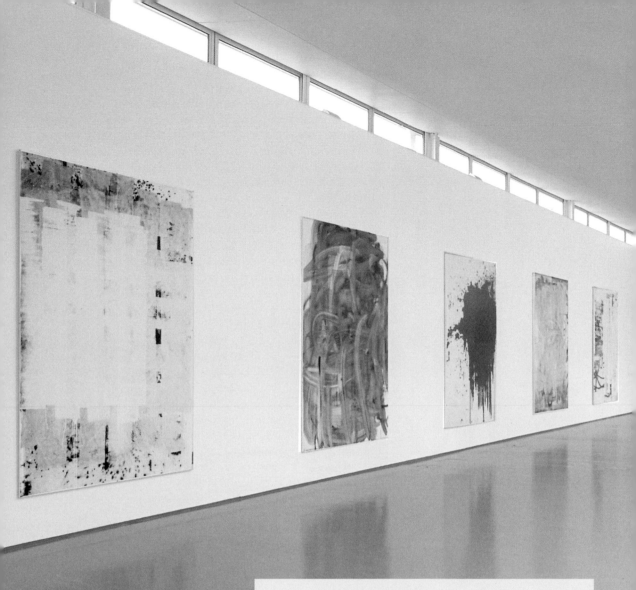

Christopher Wool exhibition at Dundee Contemporary Arts, Scotland, 2003

When it comes to an artist of interest to a collector, whether well known or new, monographic shows at museums and exhibition spaces can enhance understanding. They allow for a comparison of works made over some period of time, and for contemplation of the artist's intentionality and approach. With an artist of deep interest to a collector, an artist that quickens the heart rate, monographic exhibitions can also lead to acquisitions. In 2003 we travelled to Dundee in Scotland to see an exhibition of paintings and photographic works by Christopher Wool. As a direct result of the visit, and with the able assistance of Wool's long-time dealers, Max Hetzler and Samia Saouma, we were able to acquire one of our favourite paintings by Wool, Untitled 2002 (second from left in this image), which hung in our dining room for close to a decade.

The craze for collecting contemporary art

Over recent decades the world of contemporary art has changed dramatically in several ways. Foremost, its cultural station has grown exponentially. The art of the late twentieth century and early twenty-first century is now on view in far more museums, public and private exhibitions, biennials and triennials than ever in history – in the West, in the East and seemingly everywhere else. And to an unprecedented degree, contemporary art is being utilized to add cultural cachet to corporate offices, retail establishments and sports stadiums; to enliven other kinds of public spaces, attract tourists and brand cities.

For centuries the art of the time was widely perceived as the exclusive territory of the very wealthy – of popes, kings and robber barons most famously – or as a remote precinct for the intellectually minded. Today it's a vast playing field open to virtually anyone who wants to assert his or her individuality, taste, hipness, cultural awareness, social connections, fame, daring, wealth, smarts or desire for a richer life experience.

Further, until the second half of the twentieth century, writing about contemporary art was found almost exclusively in art periodicals and books as well as other serious publications, mostly published in Europe, and later in the United States. While contemporary art still receives this kind of serious treatment, now it's also the core subject of a once-unimaginable number of art magazines and journals emanating from Europe, North America, the Middle East, Latin America and Asia. Perhaps most significant, with the advent of the Internet astounding numbers of artworks, artists and viewpoints are appearing via blogs and social media.

Since the turn of the twenty-first century, collectors, museums and exhibition spaces have increasingly 'gone online' to show what they own or have on display. As an example, two French collectors of Chinese art, Sylvain and Dominique Levy, have turned to the Internet to promote their DSL Collection. Sylvain Levy says, 'In the beginning (the mid-2000s) I just wanted to make a website for myself. Then my wife Dominique said "You should make it accessible to everyone." After having become aware that there was a real lack of information [about their collection], we launched the project of the website and the virtual museum.' Most pertinently, he adds, 'The virtual "dematerialization" of art here is conceived as being complementary to a more physical, tactile experience of the artworks.'[1]

Reliance on the Internet to reach a wider audience – an audience comfortable with and desirous of receiving information through this medium – has raised concerns that viewing images and exhibited works in this way will inevitably compromise, perhaps marginalize, the

After-party for artist Ryan Trecartin at the LA home of Jeffrey Deitch, director of LA's Museum of Contemporary Art (MOCA), 2010

In 2004, Artforum magazine, arguably the most influential monthly contemporary art publication in print, initiated 'Scene & Herd', an online report covering the latest art world soirées and events, with photos of art world players featured prominently. In an art world that seems increasingly infatuated with itself, the subjects pictured in 'Scene & Herd' at times receive as much attention as the latest gallery exhibitions. This site and like-kind attention in lifestyle and art publications has helped bring about more of a celebrity culture in today's art world, albeit modest in comparison to the film and music industries. Some are attracted to this social scene, even allowing their art collecting to be guided by it; others couldn't care less.

first-hand contact so essential to the art experience. Keying off painter Charline von Heyl's introspective comments concerning the viewer's need to 'give a work of art time to unfold on its own terms', and look again and again 'until one sees', *Frieze* magazine contributing editor Kirsty Bell touched upon this matter of viewing works of art over the Internet. She said:

> *A large exhibition of von Heyl's paintings is currently on view at Tate Liverpool. I haven't been there, but I've seen it, in a short film on the* Guardian *website. I have a sense of the bold abstract paintings holding their own in the airy, light-filled space. But what kind of seeing is this? The visual material the Internet makes available through museum websites, media platforms, YouTube clips of artists' own web pages allows instant access to practically any number of exhibitions. But does this screen-bound experience, with its dissolution of place and encounter, allow for paying attention?*[2]

We've also heard it conjectured that artists themselves, aware of how the appearance of works of art can be affected when presented in Internet formats, may eventually feel it's necessary to adapt their work so as to benefit commercially from these effects. These and other changes – brought about by electronic communications – in the ways art is presented and seen are yet to play out, but that they will inevitably have enormous consequences is hard to deny.

Art and luxury

'The widespread coverage of contemporary art by the popular media reflects its allure and further propels its makers and adherents to newfound levels of cultural fascination.'

In recent decades, as a cultural topic and as a social activity contemporary art is regularly featured in popular print publications and other media the world over; in fashion, travel and lifestyle magazines, daily newspapers, financial publications, television programmes and, most recently, blogs of all sorts. The widespread coverage of contemporary art by the popular media, though frequently trite and superficial, reflects its allure and further propels its makers and adherents to newfound levels of cultural fascination. Today, artists, collectors and dealers, along with museum luminaries, are treated as celebrities. The ways they live, work and dress have become everyday media fodder. Extravagant art world bashes, gallery openings and auction house functions have become major events where the famous and not-so-famous, the great artists and the not-so-great artists, the true art enthusiasts and the not so dedicated are counted, courted and reported on.

Works of art are increasingly seen as luxury goods, and in certain circles this adds to their appeal. As critic–publisher Isabelle Graw says in her book *High Price: Art*

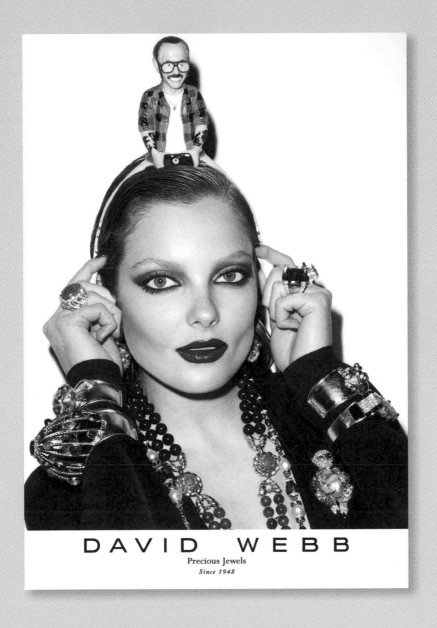

DAVID WEBB

Precious Jewels
Since 1948

Advert for jewellery in *Artforum*, February 2012

In a series of lavish full-page advertisements placed in Artforum magazine during 2012 by New York jeweller David Webb, a female model is pictured bedecked with jewels, wearing a tiara with a miniature likeness of the familiar art world figure, one-time underground photographer Terry Richardson. Artists lending their cultural and intellectual capital to a brand identity is not a new trend. Earlier instances of such collaborations include one between Surrealist artist Salvador Dalí and fashion designer Elsa Schiaparelli, dating from the 1930s. What is certain though is that such collaborations have escalated in recent years, with everything from luxury cars to skateboards bearing artists' imprints. More and more, makers of classic luxury goods have attempted to capitalize on the mutability of art's value to increase the appeal of their own products. In turn, the art world has also been affected by these developments. Some collectors buy art in much the same way they would fashion or jewellery, seeing it as a way to set them apart and exclaim their social position and financial wherewithal.

'ARTWORKS AND LUXURY
GOODS ARE GROWING
MORE SIMILAR, MAKING IT
DIFFICULT TO DISTINGUISH
BETWEEN THEM.'

Isabelle Graw

Between the Market and Celebrity Culture (2010), citing the Hermès Kelly bag, 'Artworks and luxury goods are growing more similar, making it difficult to distinguish between them. Like art-as-commodity, luxury products seek to demonstrate uniqueness by means of limited editions.'[3] In the late 1990s fashion designer Marc Jacobs, himself an art collector, no doubt had this art–fashion connection in mind when he called on artist–fashion photographer Juergen Teller to style an ad campaign that was to feature several celebrities, including actress Winona Ryder, artist Roni Horn and artist–filmmaker Harmony Korine. The same can be said when Jacobs collaborated with artists Takashi Murakami, Richard Prince and Yayoi Kusama on designs for his line of women's handbags; and when he had sculptor Rachel Feinstein design the stage set for his Autumn/Winter 2012 NY catwalk show.

The online contemporary art market

The market for contemporary art today is also vastly different from that of years past. Since the late 1990s it's become a truly global enterprise, with commercially viable artists, successful galleries and auction houses, and enthusiastic collectors no longer located mainly in the United States and Western Europe but in all corners of the world. Far more people now make art, sell art and buy art than ever before. As the art market grows infinitely larger, however, it is also growing more accessible, as gallery and artist websites allow any collector to click on images of available works no matter where the maker, seller or buyer is located.

As Noah Horowitz, managing director of The Armory Show in New York, observed, 'As these tech-fluent buyers enter the market seeking works by living artists, the vision of the Internet as a dynamic art sales engine no longer seems so far-fetched.'[4] Indeed, in addition to Artnet, a long-time player on the Internet, a number of entrepreneurial companies, each with its own slant, are developing ways to hook up the tech-savvy generation with art buying. One such enterprise, Art.sy, plans to use genome technology to match the buyer with artworks based on his/her individual preferences across a wide variety of artwork characteristics. When interest strikes, the buyer is put in touch with the gallery selling the work, which in turn pays Art.sy a commission on any sales that result.

Among other e-commerce ventures, VIP Art Fair places art online for a limited time in virtual viewing rooms, or booths, set up by participating galleries around the globe; Exhibit E is focused on marketing contemporary prints; and Artspace, which is working

with museums and commercial galleries, plans to sell works priced from $100 to $20,000.

The e-commerce sites we've mentioned – and surely there are more to come – essentially provide images of artworks for sale online. How well this business approach translates into significant art sales, and at what price and quality levels, remains to be seen. But the playing field certainly seems to be changing. In reviewing the second edition of the online VIP Art Fair, held in February 2012, *New York Times* writer Martha Schwendener said:

> *In the course of a century we've gone from Dr Albert C. Barnes, the cranky millionaire who would allow paintings from his exceptional collection to be reproduced only in black and white – he wanted viewers to understand that they weren't looking at the real thing – to Charles Saatchi, the British mega-collector who, by his own account, spends several hours a day looking at art online.*

She continued:

> *Our brains have adjusted far beyond Dr Barnes's expectations. Trained by Internet dating and online shopping, we're not under the impression that images offer a flawless reproduction of the real.*[5]

The transformation to buying art online, without seeing it first-hand, is not as great a leap as some might think, at least conceptually. It wasn't long ago that some collectors, mostly those who were keen on chasing the works of popular artists in the heated markets of the 1980s and 1990s, were making acquisitions by thumbing through transparencies. Just a few years later, collectors were scrolling through JPEGs, which had replaced transparencies. By most measures, such images were and are poor excuses for the real thing; nevertheless, they seem to be adequate for some collectors. Still, plenty of people doubt the likelihood that high-quality art will be bought online on a regular basis. The prominent London art dealer Jay Jopling is among them. He said, 'The art market is assisted by technology, free information, but it won't move online in any substantial way except to sell multiples. People still need to stand in front of a work, physically engage with it.'[6]

We, too, believe in the need to encounter art in person, to engage with it upfront and in person, allowing its aura to work its wonders – 'to unfold on its own terms', as Charline von Heyl said. We can't imagine going about collecting any other way. But that is not to say there aren't circumstances that allow for efficacious acquisitions over the Internet. For instance, if a collector is very familiar with a particular artist and body of work, perhaps having seen one of an edition (multiples of the same image) in person, an online purchase may be

'The transformation to buying art online, without seeing it first-hand, is not as great a leap as some might think, at least conceptually.'

ARTWORKS | PROJECTS | FOR GOOD | ART FAIRS | COMMUNITY

FIND ARTWORK **FIND GALLERIES**

Search for a Gallery:

Filter by Gallery Name:

ALL A B C D E F G H I J K L M N O P Q R S T U V W X Y Z

1301PE
Los Angeles, US

47 CANAL
New York, US

713 ARTE CONTEMPORANEO
Buenos Aires, AR

ACME

ALEXANDER AND BONIN
New York, US

ALTMAN SIEGEL
San Francisco, US

AMBACH & RICE
Los Angeles, US

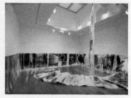

AMERICAN CONTEMPORARY
New York, US

ANDREAS MELAS & HELENA PAPADOPOULOS
Athens, GR

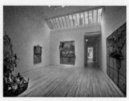

ANDREW EDLIN GALLERY
New York, US

ANDREW KREPS GALLERY
New York, US

ANGLES GALLERY
Los Angeles, US

Galleries listed on Paddle8, a website that facilitates sales of contemporary art

One of the e-commerce sites that may change the way in which art is purveyed in years to come is Paddle8. Online since mid-2011, the website has attracted an impressive roster of participating galleries by promising to vet its users, allowing only bona fide collectors to initiate purchases. Works of art are offered from galleries around the globe, often in online shows put together each month by a guest curator. The website has also partnered with art fairs to provide online sales for 'real world' events. This follows a trend for the Internet to be used in conjunction with 'bricks and mortar' art world businesses. The effects of the Internet on the art market are a hotly contested topic and everybody is eagerly watching these changes, keen to see who is making and funding them. The Internet's role in the art market is fast-changing, and many entrenpreneurs are trying to exploit the opportunities it presents.

appropriate. However, even then the collector must also have absolute confidence in the selling agent to be sure that the work has no condition problems.

For several other reasons it would not at all surprise us if increasing numbers of collectors find online purchasing an expedient approach to their collecting activity. First, going online is a way to keep up in an art world that has grown so large that it is now impossible to negotiate for all but the most dedicated, or for those who utilize art advisors to travel widely on their behalf. It may also be a useful approach for collectors who buy based on art market popularity, those who have no need or desire for (or perhaps even awareness of) the personal aesthetic response elicited by directly engaging with a work of art. If a collector's mantra is 'get me one of those', then going online may be the way he or she increasingly prefers to purchase art. Many busy collectors find shopping online not only convenient but also entertaining; it's a fun way to look at images and to contemplate acquisition possibilities. Finally, at least in our accounting, some collectors, particularly those new to the game, may prefer to go online as a way to avoid the 'pecking order' they regularly experience when in the real space of a gallery.

Until about the late 1990s, accessing historical sales and price information required an extensive library of auction catalogues diligently amended with prices for each lot sold. Today, for a fee paid to any one of several online sites, any buyer can access up-to-the-minute market trends and specific auction sales data on literally thousands of artists going back decades. While these sites provide easy access to valuable price information, the fact is that every bit of it pertains to auction sales; sales data from commercial galleries is not included and cannot be, since that data is not generally divulged. As we discuss in greater detail in the next chapter, this and various other limitations make relying solely on online art data sites a highly problematic way to evaluate art and build a collection.

Supporting artists' work

Notwithstanding these very significant recent changes in the world of contemporary art in general and in its market specifically, several of the most important attractions and rewards of collecting contemporary art have remained constant. With good reason, many collectors place a high value on their position as collector–patrons. They know that their purchases supply the lifeblood of contemporary art production – the financial support that keeps artists going. Although this fact is more or less taken for granted and rarely

commented on in the art press or the general media, it is the most important consequence of the enormous sums of money spent on contemporary art each year. Collectors do not dismiss this vital role in making possible something no less consequential than an unfolding of art history. Indeed, cultural enablement is a crucial and distinguishing attraction of contemporary art collecting, and many of its adherents are dedicated to this aim.

Support provided by collectors through purchases is certainly not lost on the artists whose works they buy, particularly those who are not yet heavily collected. We recall being introduced to Henrik Olesen, an artist whose work we knew well but whom we had never met, at the 2009 Frieze art fair. In the course of the ensuing conversation, we mentioned to Olesen that, although he may not be aware of it, a few years earlier we had purchased several of his works from an exhibition in Zürich. He said something like, 'Know it – are you kidding? For a while I virtually lived on that money.'

Contemporary art also opens up to collectors the prospect of developing personal relationships with artists. In the final chapter we discuss this subject from the standpoint of building an outstanding collection; here we need to mention its various personal rewards. For the collector, cultivating such relationships can provide unique intellectual engagement, expanded insights into contemporary culture and otherwise an enriched social life.

On a trip to Belgium several years ago we visited collectors Annick and Anton Herbert at their residence and exhibition space in Ghent. After touring their extraordinary collection, the four of us, along with our mutual friend the artist Jan De Cock, gathered in the Herberts' sitting room for coffee and conversation. The Herberts are known to have close personal relationships with most of the artists they've collected. Well aware of this, we asked them hypothetically what they would give up first, the art objects they owned or their experiences with the artists. Without hesitation, both of the Herberts offered that the artworks would be sacrificed first. The Herberts' sentiment, though absolutely genuine, may seem a bit extreme to many. However, their response certainly hints at the life-enhancing experiences afforded by knowing artists personally and coming to understand and experience first hand the often-remarkable ways in which they see the world around them.

Intellectual engagement

Because visual artists are invariably engaged with other art forms in addition to their own, and usually have interesting perspectives on the events and circumstances of

their time, contemporary art provides a lens through which the cultural milieu can be better understood and appreciated. It's very common to hear collectors and other art lovers say, after viewing an art exhibition, that they never again will look at architecture, or film, or design, or the 'street' scene, or politics, or cultural mores in the same way. Furthermore, as the extraordinary sculpture collector Raymond Nasher once said, 'If you're interested in art, you look at the world around you and see things differently, with clearer eyes and greater sensitivity.'[7]

In major art cities around the world compelling events are held virtually every week of the year – performances, talks, exhibitions and discussion panels among them. Many of these are publicized on the websites of major museums and exhibiting institutions. Becoming a member of a museum, or even of several, is a useful way to receive information on a regular basis. It's also helpful for newer collectors to speak regularly to their preferred gallerists to hear about less publicized events or those that take place at short notice. Permanent institutions undertake most of these events, but some seem to just appear in the moment, organized by artists or loose collectives as a response to the circumstances of the time.

As an example, in 2005 we received a call from the artist Cheyney Thompson asking if we would be available to discuss and help support a project he and two other artist friends of his, Sam Lewitt and Gareth James, had in mind. They proposed a yearlong programme of talks and a monthly publication intended, as James put it, as a 'political defence of drawing against its instrumentalization by the market'.[8] The three artists secured a small space on New York's Lower East Side, and Scorched Earth, as the stimulating programme came to be called, unfolded with each event packed to overflowing, even on cold winter Sundays. It included presentations by, among others, art historian David Joselit, artists Dan Graham, John Miller and Scott Lyall, and composer–musician Alex Waterman.

At approximately the same time, Orchard, another Lower East Side programme, began; it, too, received an enthusiastic response from a particular segment of the art-going public. Over a period of three years, Orchard put on a number of thematically, conceptually and politically driven exhibitions and other projects organized by a team of twelve founders that included among them artists Moyra Davey, Andrea Fraser, Nicolás Guagnini and R. H. Quaytman. These two innovative programmes, both of which eschewed art market values, offered provocative and expansive ways to look at art and understand contemporary culture.

'IF YOU'RE INTERESTED IN ART, YOU LOOK AT THE WORLD AROUND YOU AND SEE THINGS DIFFERENTLY, WITH CLEARER EYES AND GREATER SENSITIVITY.'

Raymond Nasher

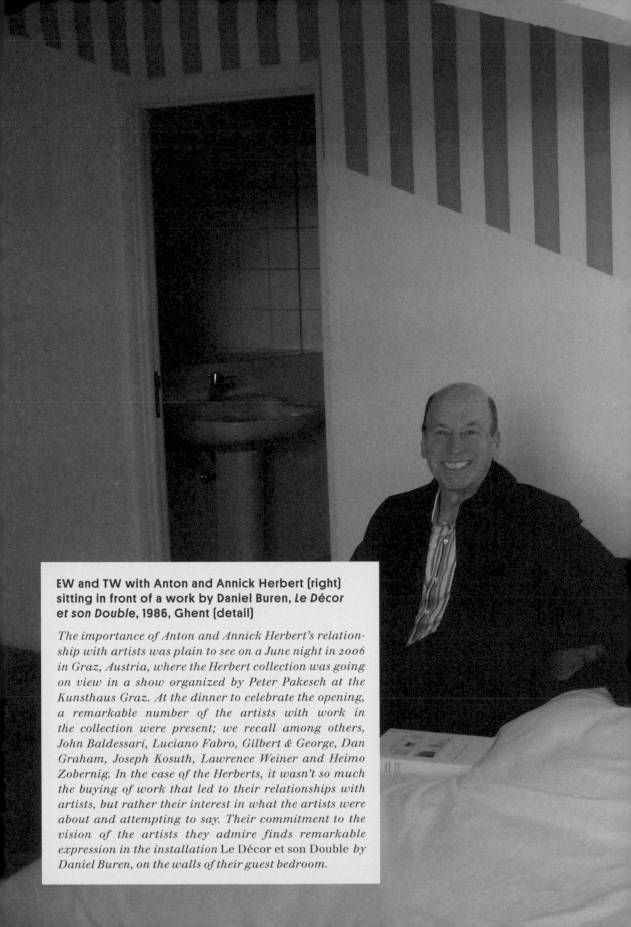

EW and TW with Anton and Annick Herbert (right) sitting in front of a work by Daniel Buren, *Le Décor et son Double*, 1986, Ghent (detail)

The importance of Anton and Annick Herbert's relationship with artists was plain to see on a June night in 2006 in Graz, Austria, where the Herbert collection was going on view in a show organized by Peter Pakesch at the Kunsthaus Graz. At the dinner to celebrate the opening, a remarkable number of the artists with work in the collection were present; we recall among others, John Baldessari, Luciano Fabro, Gilbert & George, Dan Graham, Joseph Kosuth, Lawrence Weiner and Heimo Zobernig. In the case of the Herberts, it wasn't so much the buying of work that led to their relationships with artists, but rather their interest in what the artists were about and attempting to say. Their commitment to the vision of the artists they admire finds remarkable expression in the installation Le Décor et son Double *by Daniel Buren, on the walls of their guest bedroom.*

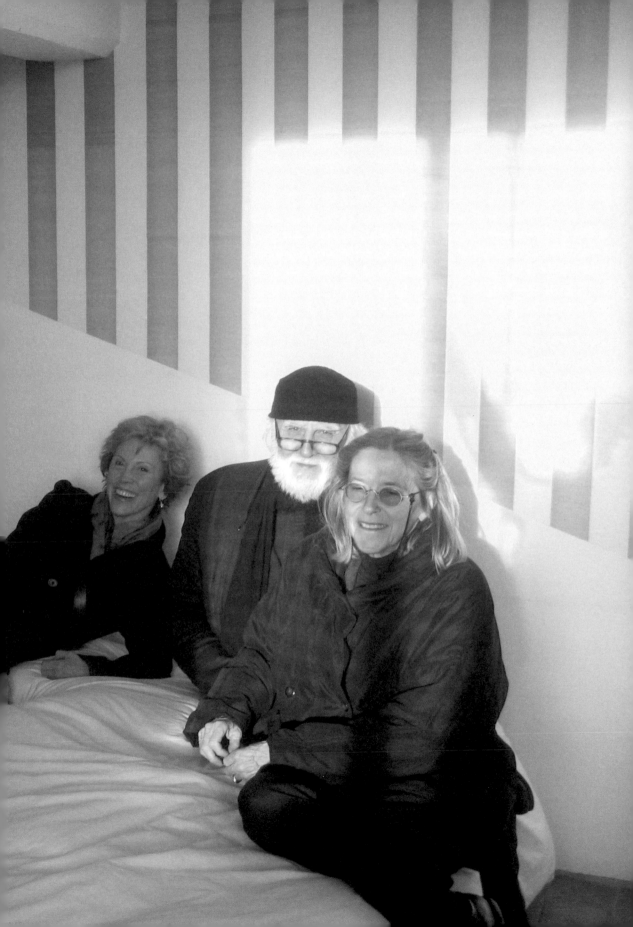

Identifying significant work

Yet another long-standing aspect of contemporary art collecting sets it apart from collecting historically established movements such as Old Master Drawings, French Impressionism, American Abstract Expressionism and Minimalism. With the latter periods, the critical importance of artists is, for the most part, well established: the best artists are already in the canon, their canonical works are known, and much of what they have made can be seen in public museums. However, in the field of contemporary art, most particularly as it pertains to art of recent vintage, there is a lack of certainty about which artists will be historically significant, which of their works will be emblematic, and whose work will be included in museums. Thus collectors who buy the work of young and emerging artists have, at least for a while, considerable autonomy to assert the erudition of their choices – to declare importance as they see it, without much curatorial or critical contradiction. Some believe not only that their selections are perceptive and merited but also that these choices will factor in determining the future market value of the artists, and thus the value of their own holdings.

While prominent collectors can set value in the field of contemporary art, it bears repeating that since the 1990s the market itself has become an even more pervasive gauge of what is deemed important in the art world. This is due largely to the widely accepted correlation between market price and aesthetic value, which helps turn widespread collector support into a measure of art world significance. This may turn out to be fools' gold over the long term, as we discuss more fully later, but in the short term it creates an enormous demand for those artists. But even collectors who are more or less inner-directed and aware of what they personally like and feel to be important can succumb to the market's siren call.

Adam Lindemann, a well-known collector and columnist for the weekly *New York Observer*, is remarkably candid when he writes about what he buys (or, as he has said, 'invests in') and why. In an article on Maurizio Cattelan's November 2011 retrospective at the Solomon R. Guggenheim Museum in New York, he recounted the tale of his long-standing reticence about the artist, but noted that he finally relented – 'broke down', as he put it – in 2008 and purchased Cattelan's sculpture, *Daddy Daddy*. Lindemann said, 'I wondered if it was possible that after ten years of collecting I could miss out on the best art of my time. Was this a risk I could afford to take?'[9] Lindemann was not necessarily saying that Cattelan is the best artist of his time; nor are we. But his

'Prominent collectors can set value in the field of contemporary art.'

comment reflects the possibility that an active contemporary art collector may overlook or reject an artist who goes on to be critically admired or whose prices increase, or both. This notion of missing out plagues collectors of all motivations, and adds even more excitement to the choices one makes.

Buying with conviction

Most passionate and dedicated art collectors, as we've observed, believe the works they buy are special, perhaps even great. But while this conviction underlies and energizes collecting, it is more than a bit unrealistic. Even Alfred H. Barr, Jr (1902–81), the legendary first director of New York's MOMA, understood that some if not many of his choices would one day not be considered so interesting or important, in spite of the fact that they were heralded when he was making them. Working with his trusted collaborator, the museum's curator, Dorothy Miller, Barr made acquisitions for the museum (and for its benefactors, many of whom later donated works) that established the canon of modern art history. Yet Barr notably came late to the Abstract Expressionists and Pop Art. In fact, in 1963 Barr passed on the opportunity to acquire what would have been the museum's initial work by Robert Rauschenberg, the 2.44 × 3.35 metre (8 × 11 foot) seminal painting *Rebus* (1955). Forty years later, after the work had passed from collectors Victor (1913–87) and Sally Ganz (1912–87) to Hans Thulin to Charles Saatchi to François Pinault, the museum purchased *Rebus* for what is thought to be around $30 million.[10]

In the certitude of our choices we are no different from many other private art collectors. From time to time, when we look at the art we've installed at home or peruse the list of artists in our collection, we come away convinced that many of them will carve a place in the history books (and after sharing a bottle of wine over dinner, we are convinced that all of them will). But at other times we cannot help but think about important artists we admire but 'missed', artists whose work we can no longer collect in depth because their prices are now out of our reach. If we could put our collecting on rewind – in effect go back ten to twenty years in time – Sigmar Polke would certainly be at the top of our 'do over' list. Many other artists would be on the list as well, but it's personally too dispiriting to think about.

The reality is that no matter how sedulous and purposeful a collector may be, or how much knowledge is invested in the collecting process, pursuing the best art of one's time always involves hits and misses, thrills and disappointments and plenty of 'what ifs'.

Collecting on a budget

'Outstanding art made by
young and emerging artists
of great promise is available
today for prices in the
low thousands of dollars.'

Collecting art is not exclusively a game for the very rich, although the incessant media coverage of multi-million-dollar auction prices, billionaires flying to art fairs on private jets and glamorous art world parties might lead one to that conclusion. Works of art by important artists who have ardent support from deep-pocket collectors can, indeed, fetch the tens of millions of dollars that generate headlines. But plenty of outstanding art made by young and emerging artists of great promise is available today for prices in the low thousands of dollars in galleries around the world – and that has more or less been the case going back at least 100 years.

Even though the market for contemporary art at the beginning of the twentieth century – particularly for art of very recent vintage – was not large, one would assume that extraordinary financial wealth would have been necessary to assemble a collection like that belonging to New York lawyer John Quinn (1870–1924), which included more than fifty works by Pablo Picasso, nearly as many by André Derain and Henri Matisse, and almost every important sculpture made by Constantin Brancusi and Raymond Duchamp-Villon.

Yet Quinn did not build his spectacular, museum-quality collection with inherited money or the wealth of an early 1900s American industrialist or financier. He managed instead with the income from his law practice as he competed for the best works of his time with a handful of other discerning and knowledgeable collectors, most of whom possessed greater financial means than he.

Always mindful of his financial limitations, Quinn regularly bought works in carefully selected groups in order to secure advantageous pricing; he made special deals with galleries; and he pressed sellers, including artists, for prices he could manage. He sometimes acquired more expensive works of art made a decade or two earlier, as he did with Georges Seurat's *The Circus* (1890–91). But even though he coveted the Seurat masterpiece, he hesitated for a while because of its price. He eventually agreed to pay 150,000 francs for the painting, which had been owned by the artist Paul Signac.[1]

Quinn mostly bought the contemporary, cutting-edge work of his day, which, due to the typically low prices of such works, enabled him to amass an incredibly impressive collection; upon his death from cancer at the age of fifty-four, it numbered some 2,000 works. In one of the unfortunate turns of collecting history, and surely one that restricted his renown, Quinn's collection was never publicly exhibited, with the exception of a small commercial gallery show (the catalogue of his collection published in 1926 lists some 1,300 paintings and drawings and 75 sculptures, which his biographer estimated

Collector John Quinn (second from left) on the golf course at Fontainebleau, France, with (left to right) Erik Satie, Constantin Brancusi and Quinn's buying agent, Henri-Pierre Roché, c.1923.

Few early twentieth-century American collectors assembled art collections equal in quality to that of John Quinn, and several of those collectors who did, such as Walter Arensberg, Albert C. Barnes and Katherine S. Dreier, had the advantage of great personal wealth. In fact, Quinn envied Barnes's fortune and, like the Steins in Paris and many other collectors throughout history, had to sell works occasionally to finance new acquisitions. Financial wherewithal aside, Quinn regularly sought to enhance his knowledge through his various art world relationships, including those with artists. His appetite for looking and learning was never quenched. While in Paris in 1923, John Quinn wrote to his friend, the artist Arthur B. Davies: 'I have seen Braque since I have been here, at his studio, and Picasso … also Brancusi, and I have been to the studio of Signac … This afternoon I have an appointment to see Doucet's collection and probably the Pellerin collection … we played golf at Fontainebleau and on Friday we played at St. Cloud. Brancusi played with us …. You would like Braque very much.'

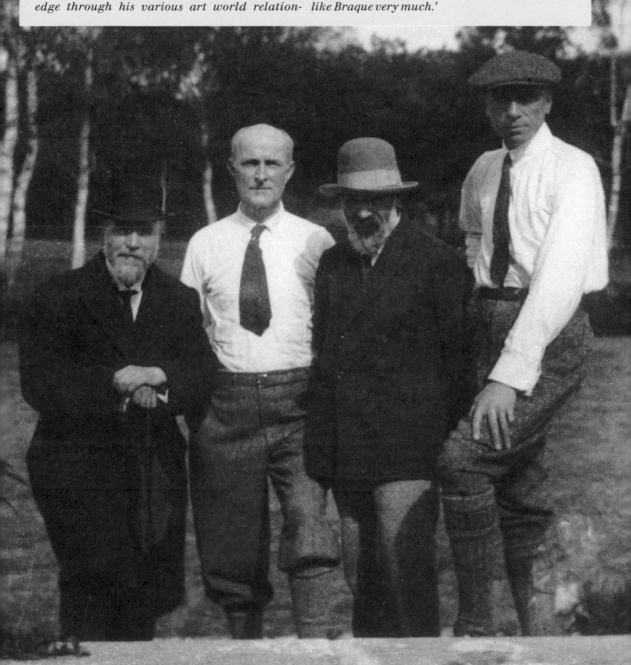

as half the full collection).[2] Many of the works from his collection can today be seen in public museums. Any truncated list of art he owned would include Constantin Brancusi's sculpture *The Kiss* (c.1912) in the collection of the Philadelphia Art Museum, Odilon Redon's *Apollo* (c. 1905–10) in the Yale University Art Gallery, the beautiful late Cezanne landscape *Montagne Sainte-Victoire* (c. 1904–06) in the collection of the Kunsthaus, Zürich, and Pablo Picasso's proto-Cubist canvas *Two Nudes*, (1906) in the collection of the Museum of Modern Art, New York.

Buying early in an artist's career

Works by many of the great artists of the latter half of the twentieth century, such as Jasper Johns, Roy Lichtenstein, Sigmar Polke, Robert Rauschenberg, Gerhard Richter and Andy Warhol, could also be purchased early in their careers at prices in the low four figures or less. For instance, Jasper Johns' iconic *Three Flags* (1958), now owned by the Whitney Museum of American Art, was purchased the year it was made for $900 by collectors Emily and Burton Tremaine.[3] When one of Roy Lichtenstein's paintings was purchased in 1962 for $325 the price was considered good enough that its seller, New York dealer Ivan Karp, and the artist celebrated the sale that night at dinner.[4]

The same kind of early career pricing has applied to more recent generations of artists. In the 1980s, for example, we closely followed and avidly directed our clients' attention to artists such as Robert Gober, Jeff Koons, Cady Noland, Richard Prince, Cindy Sherman and Christopher Wool. Works by these artists now sell regularly for millions of dollars, but when these artists were new to the scene their works could be had for well under $10,000. Sherman, for example, sold her groundbreaking 20.3 × 25.4 cm (8 × 10 inch) black-and-white *Film Stills* from her studio for $50 each when they were first printed. Soon thereafter, when she began to be represented by Helene Winer and Janelle Reiring's Metro Pictures gallery, the photographs were priced at $200. 'We really jacked up her prices,' Reiring facetiously said to us about that moment. By the early 2000s these same works, issued in editions of ten, were regularly fetching hundreds of thousands of dollars – and the prices are still rising as we write.

Collecting with limited means

There is no better-known example of collecting with limited financial means than that of the husband-and-wife couple Herbert (Herb) (1922–2012) and Dorothy

Vogel, who began participating in the New York art world in the late 1950s. Dorothy was a librarian, and her salary covered the couple's living expenses; Herb was a postal clerk, and his salary was allocated to art. The Vogels eventually amassed a collection numbering some 4,500 works, mainly works on paper of modest scale.[5] Their taste favoured Minimal and Conceptual expressions, which could be acquired for very little money throughout their first few decades as collectors. In 1992 the Vogels donated a large portion of their collection, well over 800 works, to the National Gallery of Art in Washington, DC, and additional works to other institutions around the United States.

The Vogels' example has been an inspiration to many other collectors of relatively modest means, among them the widely known contemporary art enthusiast Joel Wachs. Over the last several decades Wachs has acquired more than 700 artworks simply by setting aside a portion of his annual salary for these purchases – a reasonable way to structure spending. When Wachs first started collecting in the early 1980s he earned an annual salary of about $40,000 as a city councilman in Los Angeles, with $5,000 or slightly more of his take-home pay each year going to art. More recently, as president of the Andy Warhol Foundation for the Visual Arts, he's been able to devote about half of his annual salary to art acquisitions. The pieces in Wachs' collection are smaller in scale than those typically acquired by wealthier collectors with grander living spaces, but there are gems throughout.[6] Wachs looks at art wherever he travels, stays abreast of written discourse and is always up for a conversation about what interests him. As with other knowledgeable collectors, he mostly buys early in artists' careers, before prices outstrip his financial capability. Over the years Wachs has donated a large percentage of his works, about 100 as of 2012, to the Los Angeles Museum of Contemporary Art.

From time to time, in order to fund new purchases, he sells a work that has appreciated significantly in financial value. Like Wachs, many collectors sell works to raise cash for the purposes of upgrading a collection and editing out pieces that no longer seem pertinent; in addition, life changes can occasion financial need. It must be noted, however, that when selling the work of living artists, the collector is advised to begin the process with the gallery from which he or she acquired the work. This protects important relationships with the gallery and the artist; it also respects the sensitive financial and personal consequences at stake in divesting oneself of an interest in the work of a living artist.

Despite the highly publicized attention directed towards contemporary art today, and the vibrant market

'Many collectors sell works to raise cash for the purposes of upgrading a collection.'

that underwrites it, the work of outstanding young and emerging artists can still be acquired at reasonable prices. A collector can realistically set out to build a distinguished and enviable collection, buying as many as a dozen or so works a year in this segment of the market, on an annual acquisition budget of tens of thousands of dollars. At the lower end of such a budget, the number of acquisitions may be constrained, but a distinguished collection is not necessarily measured by the quantity of works owned – or, for that matter, by the scale of the works or by the popularity of the artists at the time the works are first purchased. In the words of John Quinn:

> *As I say to my friends, in buying art one does not go merely for numbers any more than in fishing one goes just for fish generally but one should look out for kingfish or brook trout or other game fish. Buying art indiscriminately or the work of an artist indiscriminately is very much like catching fish in a net, only it is more expensive.*[7]

Whether operating on a yearly budget of tens of thousands, hundreds of thousands, or even millions of dollars, virtually every art collector confronts choices dictated by money. There are always desired objects just out of financial reach. It's the bane of all but a very few collectors, not just those with smaller budgets.

We're personally familiar with a wealthy collector who, in the early 1990s, was determined to acquire a seminal painting by Willem de Kooning at a Christie's auction sale. He negotiated unusually favourable payout terms with the auction house, but may not have been aware that the auction house was willing to extend those terms because they wanted to encourage him to compete against another bidder (whom we shall call Bidder Two), who is known to stop at almost nothing to get what he wants.

When the painting went on the block the collector we know bid it higher and higher, duelling with Bidder Two, back and forth, until he was not willing to go further. As the auction house had anticipated, Bidder Two ultimately prevailed. For one collector the price reached a point higher than he was willing to pay, and when the hammer came down he left the salesroom bitterly disappointed. A lesson here is that auction house dealings can be complicated, and it's advantageous to have an experienced professional to assist in these transactions.

Making informed choices

In addition to how much money he or she is willing to spend, a collector's choices are affected by the various conditions discussed earlier, foremost knowledge. By knowledge we mean everything from information

Interior of a Manhattan apartment with works by Ryan Gander, Alex Olson and Claire Fontaine

Two New Yorkers, John Auerbach and Andrew Black, came to our art advisory service in 2011 with enthusiasm and a desire to learn, but spending limits. For the first year they stayed within the $50,000 they had allocated for acquisitions, but as their passion and knowledge grew so did their budget. By focusing on emerging artists, they're assembling a noteworthy collection. Included is Claire Fontaine's Foreigners Everywhere, *2008, a neon wall-mounted sculpture that states in Hebrew the provocative phrase 'foreigners everywhere'. On the floor is a work by Ryan Gander called* What you don't know can't inform you – (Alchemy Box #18), *2008. The artwork consists of the artist's version of a pouffe and, nearby, a sheet of paper attached to the wall that lists the objects the artist claims to have hidden inside the pouffe. With no means of verification, the collector is forced into a position of trust, an apt metaphor for the trust invoked when a collector purchases an artwork.*

'It's incumbent on collectors, whatever their budget may be, to look, read, discuss impressions and look some more.'

about artists' practices, to understanding the art market and gallery scene, to developing a trained eye. While knowledge may seem to be a relative term, a paucity of knowledge is most assuredly a prescription for building a mediocre collection and the eventual depreciation of assets. It's incumbent on collectors, whatever their budget may be, to look, read, discuss impressions and look some more.

Looking at art requires more than registering what is on the surface and readily apparent; it's essential – at the very least advantageous – to also understand an artist's intention and the meaning of her or his work. Discussing collector Victor Ganz, who with his wife Sally in the mid-1900s began assembling one of the most storied collections in American history, the legendary gallerist Leo Castelli said, 'Most people don't look, or they look sort of superficially. They get an impression but they don't know why. Victor would get that first impression that we all get when we see something new, but then he would analyse why it was so.'[8]

It may be argued that the need to understand the 'why' of certain works of art is even more pertinent today, in the second decade of the twenty-first century, when so much outstanding art is conceptually based and thus largely dependent on such understanding for the beauty 'within' to be apprehended.

Gallery owner Tim Neuger (right) with artist Simon Starling and TW in Starling's Berlin studio, 2006

Collectors seeking the best works by young and emerging artists must develop a network of dependable relationships with primary-market galleries, especially if they want to acquire works early, before the market prices them out of reach. Gallerists and dealers hold the keys to access. The best of them are deeply involved with their artists' practices, knowledgeable about their work, and also capable of communicating this in ways that enhance understanding and stimulate interest. Collectors benefit greatly from those rare situations in which several gallerists with this skill set represent an artist they're interested in. This has been the case for us since the early 2000s with galleries that represent the British artist Simon Starling. Starling's research-based conceptual practice addresses technology, ecology, economics and Modernism. His works are realized through 'the physical manifestation of the thought process', as he puts it. Exploring Starling's work with any of his galleries – the Modern Institute in Glasgow, Franco Noero in Turin, Casey Kaplan in New York and Neugerriemschneider in Berlin – is invariably captivating and informative. ↦

Soup Painting #2: Primordial Soup with Homeopathic Dilutions by Keith Tyson (2003–04)

Investigating the meaning of a work of art and the intention of its maker is an essential aspect of informed collecting. Keith Tyson's oeuvre illustrates the point. Tyson's Soup Painting #2 offers a visually rich agglomeration of information. Its central panel contains images, words, symbols, numbers, colours, shapes and lines. With a closer look, the viewer grasps the mechanism by which the side panels, or 'dilutions', are generated. Reference grids are woven deep within the painting's field of imagery.

These selected areas are then repainted and reinterpreted by the artist at smaller and deeper scales on the outer panels. Through this rendering, we are put in touch with the inseparability of structure and form, of the observer and the observed, and of artist and the world he inhabits. More abstractly, through these 'dilutions' (of life) the viewer encounters central themes in Tyson's practice: infinite possibilities, unpredictability and the interdependent nature of the universe.

To acquire the kind of knowledge we are speaking of requires curiosity and dedicated enquiry on the part of the collector, especially those collectors with smaller budgets who by necessity are following and buying the work of less established, younger artists. The reality is that it's easier to identify the more important artists – and their more significant and emblematic works – once their careers have evolved. These artists have longer exhibition histories, and over the years their work is likely to have been rendered more understandable by the attention accorded it by academicians, critics and museum curators.

The art of outstanding established artists (and for that matter, some not so outstanding artists) is regularly priced in the hundreds of thousands and sometimes millions of dollars, which obviously not every collector can afford. Those who can pay these prices usually don't buy until an artist has developed a name and following and a strong track record of sales. They don't often trifle with artists who are early in their careers, before there's a selling history. At these price levels it's financial wherewithal that gains art dealers' attention and regularly assures well-heeled collectors access to the choicest material.

Financial resources, however, are far less relevant at the lower end of the art market – and by 'lower end' we are referring to prices in the thousands of dollars and certainly not to the quality of the work. In this area of the market financial means take a back seat to the collector's enthusiasm, desire to learn and willingness to buy the work of artists who don't yet or may never have popular support. It's where young, promising artists are discovered and where works of art can be acquired at prices that allow collectors with modest budgets to compete.

To come upon the work of an unknown or lesser-known artist, to declare belief by purchasing work, and then to observe that artist develop and manifest his or her potential is one of the most exciting and fulfilling aspects of collecting. The satisfaction we speak of is not primarily connected to other collectors recognizing an artist's contribution and thus raising the financial value of that work. Rather, it derives from experiencing an artist's intellectual, art-making journey up close, seeing how their ideas are expressed, and going along for what may turn out to be an exhilarating ride.

Market speculation

Collectors with an eye on investment often trawl these same waters of young and emerging art, mindful that even if a small percentage of the works they speculate on go up in market value it can be enough to make their

endeavours highly profitable. And though collectors of all financial means play at this game, a collector doesn't have to be really rich to compete. Naturally, collectors who are primarily investors measure their success by how well artists they've bought perform in the market. But it's disconcerting that so many other collectors today – those who may indeed disavow financial gain as their interest in art – still seem inclined to follow the same criterion: price increases = collecting success. In other words, rising prices seem to provide confirmation or vindication, resulting in a conclusion such as the following: 'I guess I was right about that artist, because look at how his/her prices have risen.'

It seems to us that this disposition is largely misplaced, or at least off target. First, truly great, innovative art doesn't always receive immediate market approbation. It can take years, sometimes decades, before great art is understood, let alone supported widely enough that its prices shoot up. Even if it does, for a time, earn widespread market support, this doesn't necessarily mean that the art is truly important and historic. In fact, quickly won popular support is often a signal that the work appeals on a superficial level.

Further to our point, why should an artist's market success or failure trump the emotional and intellectual rewards a buyer derives from a work of art that has already stirred his or her mind and heart? After all, are these rewards not plentiful enough? Certainly it can be personally gratifying when others agree with your point of view. But on its own it's hardly a complete or adequate way to evaluate art acquisitions.

All things considered, at least from our perspective, gradual price increases are infinitely preferable; this allows us as collectors time, measured in years, to acquire the very best works at financially manageable price levels. When these prices reach a point that is beyond our financial means, when we can no longer afford to buy the work of an artist we believe in, it's much more distressing and frustrating than comforting and rewarding.

The issue of money is discussed further in the next chapter. Suffice it to say here that the multi-millions regularly spent for art in today's art world should not daunt collectors of more limited financial means. Any collector who is seriously willing to engage with and understand the art that interests him or her will ultimately be able to assemble a collection of distinction. Budget limitations can have the advantage of focusing collectors and compelling them to find innovative ways to satisfy their objectives. A desire to learn is not expensive, and the collector who has this disposition will always be rewarded.

'Truly great, innovative art doesn't always receive immediate market approbation.'

Art and money/
Money and art

In an HBO documentary film on author Fran Lebowitz, the droll and acerbic writer tells the story of a painting by Pablo Picasso that was accidentally torn in 2006 by the errant elbow of its owner, Las Vegas hotel mogul Steve Wynn, just a day or so before Wynn was set to sell the work to American hedge fund magnate Steven A. Cohen for $139 million. Lebowitz's dialogue goes something like this:

> FIRST WOMAN: *Did you hear about the $100 million Picasso canvas that was ripped while its owner was showing it to some friends?*
> SECOND WOMAN: *No, which Picasso?*
> FIRST WOMAN (with exasperation): *The $100 million Picasso!*

In her sardonic account Lebowitz pokes fun at the way price, or monetary value, elbows aside other ways of describing art in today's culture. Her inference would seem to be that 'which Picasso?' could be answered more evocatively, by saying 'the 1932 portrait of his mistress, Marie-Thérèse Walter', for example; or 'his warmly toned, inventively erotic masterpiece'; or even, simply, '*Le Rêve*' (The Dream).

Price as an indicator of artistic value

Lebowitz's take on the story of this ill-fated painting reflects on price as an indicator of artistic value and as value unto itself. Indeed, in today's art world a work of art's monetary value is an über-signifier. Prices, profits and market goings-on are regularly bandied about in the back rooms of galleries, in the aisles of art fairs, in auction house salesrooms and at art world parties and dinners the world over. Even for those who are merely casual observers of the art world, it's hard not to notice the reports on record auction prices and art market booms and market busts that appear with regularity in the media.

It's not surprising that the media seems to be infatuated with money and prices in the art world. Prices are a handy way to keep score: which auction seasons are up and which are down; which artists are in favour and which are out; which collectors are buying certain artists and for how much. Then, too, the staggering amounts of money spent on all kinds of art, especially contemporary art in recent decades, is endlessly fascinating, perhaps bemusing, even to art world players. After all, art is detached from any function (as the word is typically understood) and yet billions of dollars are spent every year chasing after it.

As for those outside of the art world, many probably find contemporary art-making expressions and the prices paid for them anywhere from unfathomable to

ridiculous. Morley Safer of CBS's *60 Minutes* gave voice to the public's scepticism in an April 2012 piece (as he did about twenty years earlier on the same show) titled 'Yes…But is it Art?'. It's pointless to rail against Safer's smug presentation, but it's fair to assume that CBS must have thought his art world send-up would be entertaining, even considering that it was aimed at one of the more informed television audiences. It's also worth mentioning that Safer's scorn was largely directed at the prices collectors pay for contemporary art.

Art as commodity

A fundamental reason for the link between art and money is the immutable fact that art is a commodity, though owing to its myriad non-economic values, a commodity like no other. Still, like other commodities it is assigned a price; it is subject to the vagaries of supply and demand; it is purveyed through a complex retail network; and *it provides the potential for financial gain* (our emphasis).

For at least several hundred years, art and investing have been coupled. In the early 1600s, when painting had secured its place as one of the major arts alongside literature, music, sculpture and architecture, its value became detached from the worth of its materials and labour, or its cost of production. And with that change art soon began to be treated as a commodity by a rapidly expanding community of merchants and collectors, most prominently in Northern Europe.

In the book *Kings & Connoisseurs* (1995) art historian Jonathan Brown sums up this point in history: 'At the moment when painting was becoming recognized as a superior human activity, it became a vehicle for investment and speculation.'[1] At that time, the first quarter of the seventeenth century, one of England's (and the world's) major collectors was the flamboyant George Villiers, first Duke of Buckingham (1592–1628). Villiers amassed his large and notable collection with the help of a sharp-eyed advisor, Balthasar Gerbier, who travelled widely to acquire works at Buckingham's behest. In a letter to his patron written in 1625, the proud Gerbier wrote, 'Our pictures, if they were sold a century after our death, would sell for good cash, and for three times more than they cost.' It was a modest prediction. Buckingham's collection included paintings by Titian, Tintoretto, Peter Paul Rubens, Guido Reni, Andrea del Sarto and Paolo Veronese, to name a few.

D.H.Kahnweiler, the eminent early twentieth-century art dealer who represented Picasso, Braque and Léger, had his own perspective on the history of collecting and investing. His biographer, Pierre Assouline, wrote:

'AT THE MOMENT WHEN PAINTING WAS BECOMING RECOGNIZED AS A SUPERIOR HUMAN ACTIVITY, IT BECAME A VEHICLE FOR INVESTMENT AND SPECULATION.'
Jonathan Brown

'Art is a commodity, though owing to its myriad non-economic values, a commodity like no other.'

'WHEN YOU PAY HIGH PRICES
FOR THE PRICELESS, YOU'RE
GETTING IT CHEAP.'

Joseph Duveen

When people insisted that speculation was a phenomenon of modern art, he [Kahnweiler] reminded them that the idea of investing in the art market had first occurred in the seventeenth century, when the Marquis de Coulanges stated that paintings were as valuable as gold bars. In 1772 Baron Friedrich Grimm, the shrewd observer of Parisian intellectual and artistic life, noted in a letter his amazement that 'purchasing paintings for resale was an excellent way to invest one's money'.[2]

The developing art market

In the United States, the major collectors of the late 1800s and early 1900s, titans of industry and finance, may have bought art for prestige more than for profit, but the value of art in terms of money was still central to their collecting. Many of them, including Henry Clay Frick, Samuel H. Kress, Andrew Mellon, J. P. Morgan, John D. Rockefeller and P. A. B. Widener, were clients of the inimitable dealer Joseph Duveen. Duveen, who was active in the first half of the twentieth century, was pivotal in developing American taste at that time for Old Master paintings. A shrewd businessman with a reputation for paying and charging high prices, Duveen's core dictum was 'When you pay high prices for the priceless, you're getting it cheap.'[3]

The American robber barons and their contemporaries, who mostly sought the art of earlier centuries, in fact had little need to profit financially from their acquisitions. But plenty of collectors of their time – and others in later decades – must have been so inclined: in 1928 the artist (and sometime dealer) Marcel Duchamp said, 'The feeling of the market here [New York City] is so disgusting. Paintings and painters go up and down like Wall Street stocks.'[4] In 1958 the financier, collector and museum benefactor Roy Neuberger said, 'Contemporary American art had become the subject to excessive speculation and market manipulation.'[5] In 1968 the art historian and critic Leo Steinberg said, 'Art is not, after all, what we thought it was; in the broadest sense it is hard cash.'[6] And in 1978 the art dealer Eugene V. Thaw said, 'I blame the current philistine approach to art collecting as investment which has taken away our society's ability to look at art without dollar signs in their eyes.'[7]

Even this cursory historical synopsis suggests that conflating art and money, and collecting and investing, is clearly not unique to present-day society. But the past we've touched on here is merely a prelude to money's ascending prominence in today's art world. In fact, present art market circumstances make much of what transpired years ago seem quaint.

Marcel Duchamp, *Monte Carlo Bond*, 1924; ink, gelatin silver print and printed paper with tax stamp

Monte Carlo Bond is a work that puts art's speculative value in sharp focus. It reflects on 'chance and strategy, on the notion of art-as-stock/stock-as-art', in the words of one-time MOMA *curator Kynaston McShine. It is composed of a Man Ray photograph of Duchamp's foam-covered head imposed on a roulette table, and parodies an official financial document, with the buyer promised a dividend of twenty per cent on the purchase price. As with all of Duchamp's works, much has been written on its meaning. It has been suggested, for instance, that Duchamp's foam-covered head is a signal that someone, the artist or the buyer, was going to be given a 'shave', or a financial fleecing. Duchamp's intent in creating and selling the work was perfectly clear: he wanted to raise money to try out a mathematical formula he had developed to play the roulette tables in Monte Carlo. As it turned out, his gambling approach wasn't successful; but as a speculative investment his work was. In 2010 the first numbered copy of the original edition of thirty sold at a Christie's New York auction for $1,082,500.*

Art market trends

In the decades since the 1970s the perception of art as a moneymaker or speculative investment alternative has become more common as a result of multiple conditions: several boom periods, an increasing number of collectors, and the expanding globalization of the market, with each of these feeding the others. This trend more or less got underway on the evening of 18 October 1973, when fifty works from the collection of Manhattan taxi tycoon Robert Scull (1916–86) and his wife Ethel (1921–2001) went on the auction block at Sotheby's in New York City.

On that night, one of their Jasper Johns works, *Double White Map* (1965), sold for $240,000 – they bought it for $10,500; their Cy Twombly, *A*, sold for $40,000 – they paid $750 for the canvas; their Andy Warhol painting from the *Flowers* series sold for $135,000 – they paid $3,500; and Robert Rauschenberg's *Thaw* (1958) sold for $85,000 – they bought the painting for $900. The sale totalled $2,242,900. The late dealer André Emmerich called the sale a 'watershed moment'. He said, 'I felt awe and shock – that pictures could be worth that much money.'[8]

While much that was said about the Sculls was snide and derisive ('banal', 'nouveau riche' and 'greedy' were among the epithets tossed in their direction), there is no denying their understanding of the art of their time or their prescience as collectors. The Scull sale made it abundantly clear that high-quality art of recent vintage (more than three-fifths of the works sold had been completed not more than a dozen years before) could fetch very high prices. It also added impetus to a burgeoning art market in Europe as well as in America; and it prompted new and experienced collectors alike to get into the game of collecting contemporary art – many with at least some thought to its profit potential.

Another watershed moment occurred in 1997 when the heirs of New York collectors Victor and Sally Ganz put fifty-eight of the couple's works up for auction at Christie's in Manhattan. Due to the extraordinary quality of the collection and the high regard for the Ganzes as collectors, the sale drew widespread art world attention. When the hammer came down on the last lot the sale had earned $206.5 million – all the more amazing considering that, as was widely reported in the press, the works had originally cost the couple less than $2 million. Of the $206.5 million, a record for a single-owner sale (as the Scull sale had been before it), $164.6 million came from the sale of several works by Pablo Picasso, the Ganzes' first love. One of the Picassos (*Le Rêve*, 1932) fetched $48.4 million. It was the Ganzes' initial art acquisition, made in 1941 for $7,000. (Just

nine years later, but for the errant elbow of the painting's owner at the time, Steve Wynn, the painting would have sold on the private market for $139 million.) Jasper Johns, Robert Rauschenberg and Frank Stella were also favourites of the Ganzes, and each achieved record prices at that 1997 Christie's auction. Also noteworthy in the Ganz sale were the record-high prices achieved by Conceptual and Minimalist artists such as Eva Hesse, Mel Bochner, Robert Smithson and Dorothea Rockburne, none of whose works had previously had an auction history or notable market interest.

Similarly, in 2004 prices for contemporary photographs, mostly from the 1980s, soared to new heights when a collection of some 300 works assembled by Baroness Marion Lambert was auctioned at Phillips de Pury & Company in New York. The Lambert collection sale realized a total of $9.2 million, about a third above its high estimate. Individual records were set for a number of artists, including Peter Fischli and David Weiss, Nan Goldin, Roni Horn, Mike Kelley, Louise Lawler and Cindy Sherman. After the last sale lot, Barbara Kruger's *I shop therefore I am* (1983), was hammered down for $601,600, the crowded auction room burst into applause in appreciation of the record prices achieved that evening.

Where respected collectors lead, others follow, and on one notable occasion the names of important collectors were made plain for all to see. In 1982, having pre-sold many of the works in a show of Julian Schnabel's paintings, the redoubtable New York dealer Mary Boone placed the names of big-time collectors, such as Peter Ludwig, Philip Niarchos and Fredrik Roos on wall labels next to the pictures they had bought. As the intrepid art world writer, Anthony Haden-Guest said in his book True Colors, '…the tactic made the few works still up for grabs twinkle with desirability'.

Belief in market authority

While it's long been the case that prominent collectors can influence what other collectors buy and can ultimately boost an individual artist's market, in recent years the market itself, writ broadly, has emerged as a far more pervasive determinant of value among a significant portion of the collecting community.

If there is one defining difference between collecting in the past – as recent as twenty years ago – and collecting in the second decade of the twenty-first century, to us it is this: in the past collectors largely bought art in the belief (perhaps just the hope) that their acquisitions would, at some point in the future, become important to art history, and that with such recognition the works

'Prominent collectors can influence what other collectors buy and can ultimately boost an individual artist's market.'

Ganz apartment, with Frank Stella's *Turkish Mambo* (1959–60, centre), Eva Hesse's *Unfinished, Untitled, or Not Yet* (1966, left) and *Vinculum I* (1969, right)

Widespread media reports about a group of fifty-eight artworks purchased for less than $2 million and sold years later at auction for over $200 million may have added to the popular notion that art collecting is really about speculating for financial gain. Nevertheless, the couple that acquired these works, Victor and Sally Ganz, were about as far from being art speculators or investors as any collectors could be. They began their collecting in the early 1940s with Picasso and only years later turned to more contemporary artists. The Ganz collection wound up being worth a fortune, but these collectors were first and foremost art lovers.

La Photographie. Collection
Marie-Thérèse et André Jammes

19th and 20th Century Photographs

SOTHEBY'S

London Wednesday 27 October 1999

**Sotheby's catalogue for the record-setting vintage photography sale of the
Marie-Thérèse and André Jammes Collection in London in 1999**

*A single-owner sale that significantly affected
the art market, specifically the vintage photog-
raphy market, took place on the evening of 27
October 1999 at Sotheby's in London, where the
initial tranche of the historically important col-
lection of Marie-Thérèse and André Jammes
went on the block. That sale and two additional
Jammes sales at Sotheby's, in 2002 and 2008,
pushed up the prices of works by any number of
early French photographers; together these sales
also had the effect of increasing collector interest
in early vintage photography. The results of
the Ganz and Jammes auction sales assert an
age-old art world truism: the imprimatur of
knowledgeable, respected collectors can boost
prices and impart appeal; where they lead other
collectors follow. It's no wonder that gallerists
are forever trying to attract such influential col-
lectors to their artists, and why the art gallery
refrain 'A very important collector just bought
[name of artist in their programme]' is so com-
monly heard.*

might also increase in financial value. Today, however, there is a prevalent belief among many art collectors that when an artist's prices increase substantially that development alone – ipso facto – indicates the artist's historical importance. Essentially, the value markers have been reversed.

We'd like to point out another slant on the same crucial matter; that in the past there was an emphasis on art knowledge and connoisseurship – a collector's ability to discern future value in aesthetic terms. Presently there is greater emphasis on amassing empirical price information and being able to gauge the market – a collector's ability to locate future value in monetary terms. This circumstance is partially responsible for the fractious relationship in certain art circles between those who espouse art for art's sake and those who are inclined to buy according to the dictates of the market.

This widely accepted notion of market authority was expressed in bold terms by Sotheby's Worldwide Head of Contemporary Art, Tobias Meyer, when he said in 2006, 'The best art is the most expensive because the market is so smart.'[9] As previously mentioned, for many collectors who subscribe to this view, price has taken hold as a divining rod for artistic importance, though for some it's simply a way to identify what's currently popular and therefore desirable.

The glaring fact is that over the decades that we've been involved in the art world, and undoubtedly for years before that, the art market has been rife with unimportant artists who are overpriced and important artists who are underpriced. '[M]arket value alone is no guarantee for long-term symbolic importance,'[10] asserts Isabelle Graw. And, as we discuss in a later chapter, we wholeheartedly agree.

Tobias Meyer is a widely acknowledged expert on the modern and contemporary art markets; yet, interestingly enough, Meyer and his partner, art advisor Mark Fletcher, themselves have an art collection that is not entirely calibrated to market trends. When we spoke with these two adventurous collectors in their apartment on Manhattan's Upper West Side in 2011, it was clear that they find the works they own compelling and a joy to live with; they attach personal symbolic importance to them, whether they've been endorsed by the market or not.

The reality is that almost no matter what motivates collectors, and whether or not they use the market to dictate some or all of their purchases, as a species they don't ordinarily see (or choose to see) their collecting purely in economic or monetary terms. In fact, almost all collectors speak of their love for the art they own and the objects they desire.

Ensuring access to the best

In a very subtle way, part of this circumstance, or posturing by some, has to do with making sure one has access to the best works of art by the pre-eminent or most promising artists. Neither great art collections nor collections that will be financially remunerative are comprised of mediocre works, even if such works are by outstanding artists. Access to the best is a key aspect of collecting. The surest way to be denied this hard-to-achieve position, or to lose it once earned, is to be perceived as an art investor or, worse yet, as someone who sells soon after they buy – a 'flipper', as such a person is derisively called in art world parlance. The most important primary market galleries, those that offer work directly from an artist's studio, are invested in the careers of their artists and are eager to have their work acquired by museums, if possible, and serious collectors known to hold on to and treasure their acquisitions for a long time.

Further to this point, many artists beseech their dealers not to sell to investors who will soon turn over the works for profit. One such artist is Marlene Dumas who, according to court documents filed in a legal proceeding in 2010, insisted that her dealers keep a 'blacklist' of collectors to whom her work should not be sold.[11]

We recall a wealthy would-be collector from the West Coast who came to us in 2004, expressing a desire to build an 'important' collection. Only a year or so after making a number of opportune purchases, all the while utilizing our firm's access to choice material, he began to sell certain acquisitions, flipping the works sometimes within months of purchase. In one instance, albeit a secondary market transaction, we helped him acquire an important sculpture by Donald Judd on very favourable terms from the long-respected Los Angeles dealer Margo Leavin. We later found out that shortly after the purchase he sold the piece for a considerable profit. Aware that occurrences such as this would surely compromise our long-standing relationships with dealers and gallerists, along with our ability to access desirable, hard-to-get works of art, we had no other choice than to terminate our relationship with the client.

The important thing to bear in mind as a collector aiming to access the best is that galleries, especially those that represent living artists, don't want to see artworks they've sold in the hands of investors. This often pertains to the secondary market too, which means to works that are being resold. Dealers prefer to have works returned to them for resale rather than having them appear in unpredictable auction salesrooms. When the work of a young or emerging artist, or even a

'Galleries, especially those that represent living artists, don't want to see artworks they've sold in the hands of investors.'

more established artist, is bought from a gallery and soon thereafter sold at auction for prices that are dramatically discordant with the artist's normal pricing history, it can change the art world's focus from the merit of the work to the price of the work. Admittedly we're just looking at the negative consequences, but when auction prices are much higher than the norm they can make the artist's market difficult to sustain; when they are much lower they can make any of the artist's work difficult to sell.

Collectors who care mostly about making money from art regularly play down this motivation in their gallery dealings. At the same time that they disavow the profit motive, a posture that the French sociologist Pierre Bourdieu referred to as 'denegation', they pronounce their conviction in art's higher values. This pretence is necessary in order for them to ultimately gain that which they deny. In other words, art investors may adopt the patois of the passionate collector in order to gain access to and profit financially from highly sought-after works of art.

Investor or collector?

Our story of the West Coast collector illustrates another important aspect to all of this. Though his measure of success was, at least when we worked together, largely predicated on how much the art he bought went up in financial value and the efficacy of his selling activities, he also possessed a real fondness for art, as we observed on several occasions. This openness to art's aesthetic values, or willingness to suppress purely financial interests (at least for a moment), is inherent in virtually all collectors to some degree, except those for whom art's 'aesthetic yield is zero', to borrow economics professor William D. Grampp's penetrating phrase.[12] Without a doubt, those art buyers at Grampp's 'zero' can be called 'art investors'.

At the other end of the collecting continuum are very dedicated collectors who go about their art world pursuits with little or no interest in profit. Nevertheless, these collectors too stay abreast of the market, are aware of pricing, and from time to time sell works for any of a number of reasons, pure financial gain among them – as did the Steins of Paris in the early twentieth century. To quote Graw, 'Today, it would be pure illusion to characterize the modern collector as free from speculative interest. And why shouldn't he be interested in converting part of his collection back into money?'[13]

Quite a few well-known art collectors, among them the American publisher and newsprint magnate Peter Brant and the German former art dealer Thomas

'TODAY, IT WOULD BE PURE ILLUSION TO CHARACTERIZE THE MODERN COLLECTOR AS FREE FROM SPECULATIVE INTEREST. AND WHY SHOULDN'T HE BE INTERESTED IN CONVERTING PART OF HIS COLLECTION BACK INTO MONEY?'

Isabelle Graw

'FOR THE JOY AND REWARD,
THE DOMINANT MOTIVATION
MUST BE A LOVE OF ART; BUT
I WOULD QUESTION THE
INTEGRITY OF ANY COLLECTOR
WHO DENIED AN INTEREST IN
THE VALUATION THE MARKET
PLACE PUTS ON HIS PICTURES.'

Emily Tremaine

Borgmann, are active on the selling side of the art market time and again. But being an active seller doesn't necessarily diminish one's seriousness or passion as a collector and art lover. In 2008 the Texas collector Howard Rachofsky sold Jeff Koons's *Balloon flower (Magenta)* (1995–2000) at Christie's in New York in order to raise funds to buy other works of art. As was widely reported in the media, the piece sold for about $25 million. About seven years earlier Rachofsky had sold another work by Koons, *Woman in Tub* (1988), for $2.8 million, in this instance to fund his acquisition of *Balloon flower*, and additional works by other artists. In all likelihood, in these dealings Rachofsky turned something less than $1 million into $25 million; or, as he likely saw it, one work of art in his collection into many.[14]

Buying with acumen

Many collectors today speculate not just for financial gain but for bragging rights too. But here again, financial values are integral. Many such collectors seek to acquire works that will someday take their place in the history books; and if the works also increase in monetary value, so much the better. Emily Tremaine, who with her husband Burton assembled an enviable collection of outstanding works, mostly from the latter half of the twentieth century, put the sentiment this way:

For the joy and reward, the dominant motivation must be a love of art; but I would question the integrity of any collector who denied an interest in the valuation the market place puts on his pictures and he cannot help but feel a satisfaction with his own acumen and with the approbation of his peers when he was perspicacious enough to buy, say a Jackson Pollock in 1948, or a Jasper Johns in 1958.[15]

Perspicacity was no vague, abstract notion to Tremaine: she may well have been referring to her own 1958 Jasper Johns, titled *Three Flags*. The Tremaines bought this work of art from dealer Leo Castelli the year it was made for $900 and sold it through dealer Arne Glimcher to the Whitney Museum of American Art in 1980 for $1 million.[16]

Some collectors – very wealthy collectors indeed – would just as soon not wait for the art they buy to gain critical approbation someday; they're intent on assembling exemplary works by historically important artists here and now. In his book *Art & Money: An Irreverent History* (1980), Aubrey Menen touched on this attitude: 'From Cicero onward (and no doubt before him) the joy in ownership in a work of art lay in being able to say "*That* is a Praxiteles" or "*That* is a Rubens", particularly if it is known that the price of such objects is high.'[17]

As a case in point, the hedge-fund manager Steven Cohen and his wife, Alexandra, collect works of art that are already in the history books. Given the cost of these artworks, it's not surprising that much art world and news media attention focuses on the multi-million-dollar price tags Cohen has paid: $52 million for a Pollock drip painting; $25 million for a Warhol *Superman* (1960) painting; $25 million for a 1938 Picasso; $137 million for de Kooning's *Woman III* (1953); $23.6 million for Koons's *Hanging Heart (Violet/Gold)* (2006); and $8 million for Damien Hirst's shark sculpture, to name a few. These purchases were reportedly made over a five-year period, 2006–11.

Spending by financially well-endowed collectors will likely always draw attention, but in many instances there's much more to the stories of these collectors than money alone. The same Steve Cohen who pays multi-million-dollar prices, for example, regularly explores museums and galleries, maintains a large art reference library and is known to be knowledgeable and precise about the works he buys. Fellow collector Donald B. Marron, a MOMA trustee, said of Cohen, 'He is emotionally involved, has a good eye and knows the works in their context. Those are the ingredients that make a good collector.'[18]

Approaches to investing in art

Turning to the subject of collectors who explicitly invest or speculate in art for financial gain, most such arrangements are carried out privately and discreetly, and therefore rarely come to the attention of the general art public. One such approach to art investing, especially popular since the 1990s, is to partner with auction houses on specific objects. In such deals the private collector–investor agrees to pay the reserve price if no other bidder is willing to go higher. In this way the consignor and the auction house are assured of a sale, and the investor knows he or she will get the work at a price they think appropriate, assuming no one is willing to go above that number. Such third-party arrangements are noted in auction catalogues, but the 'third party' is never publicly revealed.

Another investing approach is to provide capital to galleries in order to gain priority access to the work of gallery artists or inventory in high demand. In 2004, one such deal spilled into the news when a prominent collector, Jean-Pierre Lehmann, sued a gallery called the Project for not fulfilling its promise to offer him first choice in return for his loan to the gallery of $75,000. The suit, which Lehmann won, brought to light similar arrangements that the Project entered into with Miami

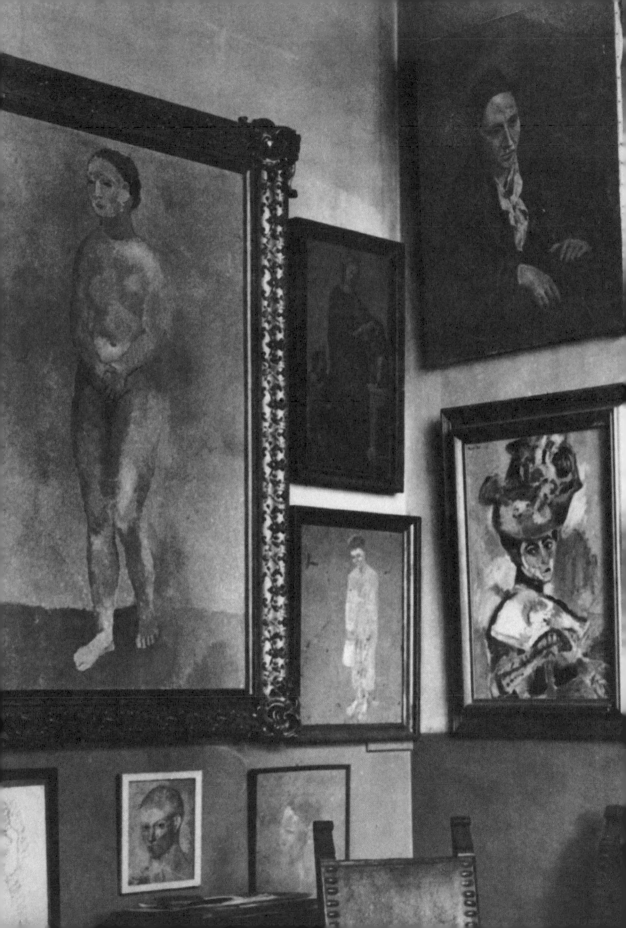

A corner of Gertrude and Leo Stein's apartment in Paris, c.1908–09, with works by Paul Cézanne, Henri Matisse, Pablo Picasso and Auguste Renoir on the walls

Few collectors of the twentieth century are held in higher esteem than the Steins of Paris. Yet, like many collectors, Leo and Gertrude Stein 'considered their paintings to be investments', and regularly sold in order to buy. On one occasion, the Steins traded their Paul Gauguin painting Three Tahitian Women Against a Yellow Background *(1899), along with a Pierre Bonnard, for an Auguste Renoir painting (Leo admired Renoir, while Picasso was more Gertrude's favourite). In a similar instance, Michael Stein and his wife Sarah exchanged three paintings to acquire six works by Henri Matisse. Collectors who don't possess unlimited funds for art, as was the case with the Steins, normally sell works now and then to fund further acquisitions.*

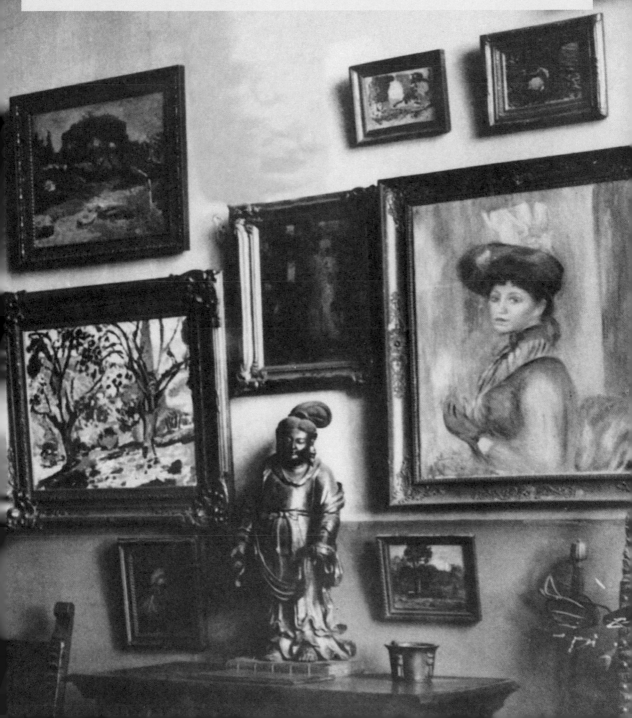

collector Dennis Scholl and Manhattan art dealer–gallerist Jeanne Greenberg Rohatyn. The legal proceedings made clear that what the two collectors and one dealer sought was priority access, most particularly to the work of Julie Mehretu, a widely admired artist with a long waiting list for her time-consuming, labour-intensive work.

Both Lehmann (husband of respected New York gallerist Rachel Lehmann) and Scholl are long-time collectors, and it's not at all likely they were seeking to gain financially from the arrangement, certainly not in the short term, by quickly selling their acquisitions. While some of these deals may indeed be purely aimed at financial profit, in fact many of them are about building collections of hard-to-get work, works coveted by dedicated collectors.

Another modus operandi pursued by art investors is pooling financial resources in order to speculate on a range of promising artists; this type of investment is now commonly known as an art investment fund. Historically, the most famous of these kinds of syndicates, La Peau de l'Ours, could perhaps be said to be the forerunner of today's investment funds, and it's a great story unto itself.

La Peau de l'Ours was begun in 1904 by André Level (1863–1946), a Paris art collector and financier, and twelve other collectors, each of whom he persuaded to contribute 250 francs annually (the equivalent of about $1,200 in 2012) for ten years to buy art he believed would increase in financial value. The investors were allowed to hang these works in their homes, but the overarching strategy was to sell off the 'collection' for profit ten years after its inception. Level and his art syndicate bought presciently: Matisse, Braque, Van Gogh and Picasso were among the artists whose work they acquired. One purchase in particular, Picasso's *Family of Saltimbanques* (1905), today hangs in the National Gallery of Art in Washington, DC, as part of the fabulous Chester Dale Collection. The syndicate's entire trove of just over 100 paintings and drawings was sold in 1914 at the Hôtel Drouot Paris auction for four times what the investors paid. So successful was the enterprise that the participants elected to turn over a fifth of the take to the artists, to be shared among them.

If there are lessons to be learned from Level's art investing strategies (including, perhaps, the advisability of buying a Picasso masterpiece directly from the artist for 1,000 francs) there may be one, as well, in the syndicate's name, which translates as The Skin of the Bear. It comes from the Jean de La Fontaine fable 'The Bear and the Two Companions' ('L'Ours et les deux compagnons') whose message is 'Never sell the bear's

skin before one has killed the beast.' Level's intention in choosing the syndicate's name is open to interpretation, but we take it to be: don't get involved in buying and selling art unless you're reasonably sure of the outcome; it's safer that way.[19]

While Level's 'Bearskin' syndicate served to popularize the idea of art investment funds, it was the British Rail Pension Fund that served to legitimize it. When, in 1974, British Rail decided to invest in collectibles, mostly fine art, it was the first and thought to be the only time a large British pension fund had entered this market. Over a period of seven years British Rail invested about $70 million, or 2.9 per cent of its assets, in fine art, mostly in Impressionist and Old Master paintings and Old Master drawings. Beginning in 1987 and continuing through 1999 British Rail sold off its art and collectibles portfolio, achieving an annual compound return of 11.3 per cent. The art world took note, and the idea of forming art investment funds gained traction, though not, as it turned out, overwhelming success.[20]

Taking their cue from British Rail's venture, many entrepreneurs have attempted to establish private art investment funds, with the goal of maximizing returns for the investors and making money for the funds' founders and managers. Between 2000 and 2011, perhaps fifty or more art investment funds were announced or actually begun, invariably with optimism and some 'unique' investing strategy put forth by the organizers. Many of these attempts dissolved into thin air because the founders were not able to raise the necessary investment capital, while others tanked because the art market declined in the latter part of that decade.

Pros and cons of art as investment

The number of people with a stake in art investment funds is and likely always will be miniscule compared to the number of people who buy art as collectors. But anybody who buys art thinking 'investment' is well advised to accord some consideration to its pros and cons, whether as an expenditure of disposable income, a store of value (something tradable) or a speculative transaction.

Among its many attractions, art offers diversification, as it doesn't always correlate to other asset classes such as stocks and bonds (though we've never seen an auction house salesperson who wasn't jittery before a sale taking place in the midst of a serious equity market decline). Art also provides a range of sub-markets oriented around particular eras, such as Old Masters, modern art and contemporary art, and around geography, including North America, Latin America, China,

'Anybody who buys art thinking "investment" is well advised to accord some consideration to its pros and cons.'

91

India and Europe. And, as the news media regularly reports, the prices of individual works can increase spectacularly. Finally, art's non-economic rewards can be enjoyed even while works increase (or decrease) in monetary value.

On the other side of the ledger, art's disadvantages are numerous and daunting. Its transaction costs are high; it is illiquid compared to other assets like equities; it is expensive to crate, ship, install, store, and insure; it doesn't produce a revenue stream as do bonds, certain classes of stocks and real estate; it is purveyed in an unregulated market; it is subject to damage, and thus to loss of value; and it is subject to fraud, as in fake copies. Condition is also of considerable significance: fading, previous attempts at conservation, surface cracking and the like can vastly affect resale value. In addition its future financial value is always affected by a multitude of variables, not least its critical/aesthetic reception.

The art world, at least the art market, has long demonstrated the capacity to accommodate collectors with varying motives, from very passionate art lovers to mercenary art investors and everyone in between. And, as we discuss in the next chapter, since the mid-1990s the market itself has become a pre-eminent valuing authority, and therefore collectors – especially those newer to the pursuit – are now more inclined to follow market dictates than to make independent choices predicated on aesthetic values.

The vicissitudes
of the
art market

By the latter half of the twentieth century, New York City had eclipsed Paris as the centre of the art world and was firmly established as the largest, most vibrant marketplace for art. Yet, in describing the New York art scene in the mid-1960s, the noted former curator of the Jewish Museum, Alan Solomon, said that in addition to a community of artists it consisted of 'three or four dealers, four or five critics, five or six museum people, maybe ten collectors. And no more.'[1]

Solomon's description is hard to imagine today, in the second decade of the twenty-first century. There are presently at least a half-dozen top galleries on each of several one-block streets in the Chelsea art district alone, and in New York City and its environs there are hundreds of knowledgeable collectors. Art buying in New York in the 1960s was measured in the millions of dollars and, indeed, that volume was marvelled at then. Today, it's measured in the billions of dollars. Worldwide, in 2011 Christie's and Sotheby's achieved total sales of $11.5 billion, and that's only about one fifth of the entire global market for art.[2]

The international art market

By any measure the international art market is now staggering in size. Its influence on the buying decisions of collectors is also staggering. In effect, the art market as a sphere of influence in the art world exerts a gravitational pull on collectors much as physical bodies in space attract with a force proportional to their mass. This could also be described perhaps as 'market empiricism', where the market is defined by observations of itself – with market price as the ultimate indicator of artistic value.

As mentioned previously, art collectors' reliance on the market has been supported by click-of-the-mouse access to price information on virtually any artist who has been sold at auction (secondary market sales) and by a handful of reports that track art's performance as an investment alternative or store of value. In this chapter we take a closer look at how these kinds of reports can be misleading, at several additional factors that can have a major bearing on how artists perform in the art market, and at the collecting risks involved.

According to *Money Week*, the 'most credible'[3] of the art market reports is the Mei Moses Fine Art Index, which provides information on repeat sales of the same works of art on the auction market. The Mei Moses Art Index, conceived and developed by two one-time New York University professors, Jianping Mei and Michael Moses, charts the resale of some 400 artists whose works have come up at auction at least twice. The data

set, which the authors see as comparable to the Standard & Poor's stock market index, goes back to 1925.

More broadly used to source price information and market trends in the art world is the Fine Art and Design Price Database published by Artnet, which was founded in 1985 and moved online in 1996. This database of auction results provides sale prices and basic auction catalogue information and accompanying photos, and indicates whether or not objects sold when they hit the auction block.

As widely used as these and other similar reports are, for numerous reasons they can be misleading when employed as a stand-alone source of information for divining the monetary value of a work of art – let alone when they are relied on to determine the aesthetic importance of an artist's oeuvre. Among the inherent shortcomings of these reports is that they fail to account for the fact that no two objects of art are the same, even if they come from the same body of an artist's work or have identical subject matter. No amount of sales data on like-kind material will negate this truth. Collectors who overlook the uniqueness of each work of art, its one-of-a-kind nature, as they review the auction sales recorded in these reports, do so at their own peril. As Amy Cappellazzo, Christie's reputable chairman of Post-War and Contemporary Development said, 'The problem with ranking artists purely by numbers is that you might only be talking about one or two works that could sell for that price.'[4]

Furthermore, the Mei Moses Art Index and the Fine Art and Design Price Database provide an incomplete picture of the market, as they don't include private gallery sales, which constitute about one half of the overall worldwide sale of art. In fact, private gallery transactions often vary significantly from auction sales results: they are sometimes much higher, and sometimes much lower. Then, too, as Mei Moses makes clear, its index does not incorporate works that go unsold even though these incidences can be as telling about an artist's market support as prices fetched for the work that is sold. Artnet does indicate unsold items, but does not indicate the price reached if the work does not hit the price at which it can be sold – the 'reserve' price.

These factors alone should give pause to collectors who rely entirely on such reports to guide who they buy and for how much. But there are also several other factors that can significantly affect prices realized at auction. For instance, prices fetched do not necessarily indicate the inside knowledge that certain collectors may have about the condition of a work of art, nor do they indicate whether the reserve price – the lowest price at which a work can be sold – was set so high that it

'THE PROBLEM WITH RANKING ARTISTS PURELY BY NUMBERS IS THAT YOU MIGHT ONLY BE TALKING ABOUT ONE OR TWO WORKS THAT COULD SELL FOR THAT PRICE.'

Amy Cappellazzo

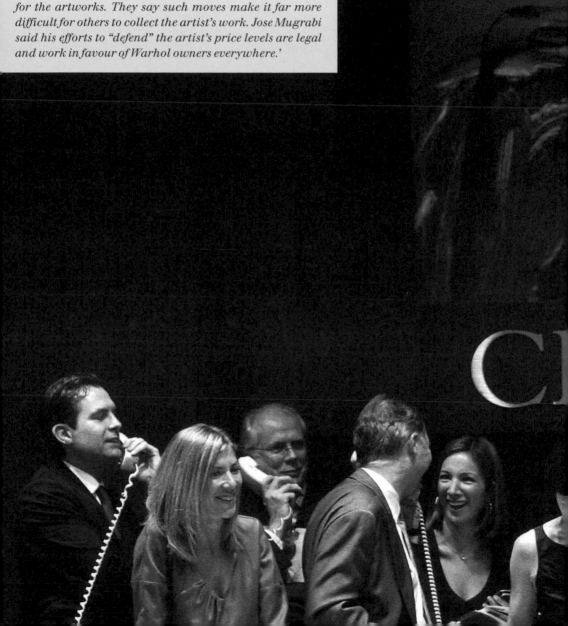

Andy Warhol, *Muhammad Ali*, 1978, synthetic polymer and silkscreen inks on canvas; sold at Christie's on 13 November 2009

When works by Andy Warhol come up at auction – as many as 200 works in some years – the eyes of auction house personnel and scores of others in the salesroom turn to where collector Jose Mugrabi is seated. It is believed that Mugrabi, working with his sons David and Alberto, owns about 800 of the Pop master's works, almost as many as in the collection of the Andy Warhol Museum in Pittsburgh, Pennsylvania. Writing in the Wall Street Journal, *Kelly Crow described one effect of the Mugrabis' collecting: 'Rival dealers say the Mugrabis are doing whatever they can to keep Warhol prices high, including occasionally overpaying – or overcharging – for the artworks. They say such moves make it far more difficult for others to collect the artist's work. Jose Mugrabi said his efforts to "defend" the artist's price levels are legal and work in favour of Warhol owners everywhere.'*

scared off potential buyers; whether the work was 'burned' by having been recently or repeatedly offered on the private market; whether the market had been flooded with too many works by the same artist; whether a particular work may have been bid up in a contrived effort to increase the financial value of a dealer or a collector–investor's holdings of that artist's work; whether the price paid was aberrantly high owing to the charged, competitive atmosphere of an auction salesroom or the capriciousness of as few as two bidders; or whether the object was bought mistakenly, which is rare but, strangely enough, does happen.

We recall one such instance when a very prominent dealer, seated near us at an evening auction in New York City in the mid-2000s, bought a work for several million dollars and a moment later mumbled, 'Oh shit, I bought the wrong picture.' Fractions of a second later he began to discuss, with the associate seated beside him, whom the painting could be sold to. In an auction room mistakes happen, but there's no notation in any of the reports we've been discussing to indicate this.

Price distortion

One of the factors we've noted, that of bidding up prices at auction to boost an artist's market, is fairly common but not especially unique to today's art world. In his book *Art & Money: An Irreverent History* (1980), author and satirist Aubrey Menen tells of coming across a pamphlet, published by Pablo Picasso, that he found in the library of the Victoria and Albert Museum in London. In it Picasso takes note of a collector who paid about £100,000 (then about $200,000) for a Gauguin in a Paris auction. Picasso wrote:

> *That man has other Gauguins in his collection – because he paid over £100,000 for a new one, all his other Gauguins are worth more. The man he beat in the bidding called him on the telephone to thank him. The other man had five Gauguins, and thanks to that record price, he had become richer in five minutes than most people become in five years.*[5]

Whether or not collectors understand the various factors that can distort the meaning of auction sales results and any acquisition decisions derived from them, there is an undeniable allure to quantitative information, to numbers, that draws their attention and faith. This applies to auction results and run-ups in prices on the primary and secondary markets.

One reason for the influence of market numbers is that some of today's collectors find objective price data easier to process and comprehend than subjective notions about symbolic importance and extant critical

discourse on the artist's oeuvre – especially when their art knowledge or 'eye' is limited. For these collectors and perhaps even some that are more experienced and knowledgeable, price becomes a proxy for a deeper, historically rooted, discursive investigation. But then, we do live in a culture that is infatuated with numbers, with their seeming ability to simplify, and impart meaning. Consider society's esteem for IQ scores, the reading public's attraction to bestseller lists, the effect that college rankings have on admission applications, consumer interest in lists of 'best cars', or the way in which numerical ratings impact the sale of fine wines.

This last example is illustrative particularly because fine wine is treated as a commodity and luxury good, as is fine art. The world's most influential wine writer, Robert Parker, uses a hundred-point scale to rate wines in his bi-monthly report, and his scores alone can dramatically affect market price and consumption. The fact that Parker makes clear that his numerical scores are not as important as his written commentary about 'the wine's style and personality, its relative quality vis-à-vis its peers, and its value and aging potential'[6] (each of which parallels art world notions of aesthetic importance) seems not to matter to many wine aficionados. They buy based on Parker's numbers, just as many art collectors buy based on the art market's numbers.

Of course, Parker's ratings are the opinions of Parker (and a few associates), while pricing in the art market is, at least partially and at times almost completely, a reflection of widespread collector support. This notwithstanding, our point is that over the last few decades, quantified art market data – price – has become a determining factor in evaluating acquisition opportunities.

This confidence in the market is compounded by the fact that rising prices tend to be self-affirming; as prices for an artist's work increase, collectors follow along, thus creating greater demand and yet higher prices. Art critic Jerry Saltz put it this way in a *Village Voice* piece: 'Essentially, the art market is a self-replicating organism that, when it tracks one artist's work selling well, craves more work by the same artist. Although everyone says the market is "about quality", the market merely assigns values, fetishizes desire, charts hits and creates ambience.'[7]

Though Saltz's description is valid, when allowed sufficient time the art market generally aligns to artistic importance and to the consensus of informed, critical opinion – though every art world player can point out exceptions. But in the short term, which can mean decades, certain factors extrinsic to the merit of an artist's work can make a correlation between market price and artistic quality exceedingly unreliable.

'ESSENTIALLY, THE ART MARKET IS A SELF-REPLICATING ORGANISM THAT, WHEN IT TRACKS ONE ARTIST'S WORK SELLING WELL, CRAVES MORE WORK BY THE SAME ARTIST. ALTHOUGH EVERYONE SAYS THE MARKET IS "ABOUT QUALITY", THE MARKET MERELY ASSIGNS VALUES, FETISHIZES DESIRE, CHARTS HITS AND CREATES AMBIENCE.'

Jerry Saltz

Geography's influence on market value

One such factor is geography – where an artist lives and works – which has a history of affecting market valuation, though less so in recent years as the market has become more global in outlook. For example, in the 1980s a number of LA-based artists, including John Baldessari, Mike Kelley, Ed Ruscha and Christopher Williams, were grossly undervalued by New York collectors who thought at that time that if artists from different parts of the United States didn't move to New York, they couldn't really be that important. Added to this, many LA collectors were seemingly reluctant to buy homegrown talent, preferring blue-chip New York market stars instead.

Similarly, the market prices of historically significant artists working in Brazil in the 1950s and 1960s, among them Lygia Clark, Hélio Oiticica and Lygia Pape, were drastically held down by the fickle fate of geographic divide – their work was hardly ever seen then in the United States, and the collecting community in their home country was small.

The same can be said of artists who worked in Paris around the second half of the twentieth century, such as Martin Barré, Simon Hantaï and Yves Klein. When these artists began to make their mark, Klein in the 1950s and the other two from then onwards, continuing to at least the 1980s, the New York art world and its price-defining

Atsuko Tanaka, *Electric Dress*, 1956 (reconstructed 1986), enamel paint on light bulbs, electric cords and control console

Geography has a history of delimiting collector support and holding down prices, even when artistic practices merit greater market approbation. An example of this is the art of postwar Japan, particularly as it applies to artists associated with three avant-garde Japanese collectives: the Gutai Art Association (1954–72); Hi-Red Center (1963–64); and Mono-ha (1968–73). Though artists in these groups, and others who worked at that time and later, made original and influential work, they had scant collector support in the West. That's changed since the late 1990s, as knowledgeable American galleries have spurred greater interest – and much higher prices. If history is prelude, there likely are forces at work today that, as with geography in the not-so-distant past, are distorting specific artists' markets. Perhaps this can be said about the effects of Internet art sales, the demand for large-scale work by collectors who need to fill grand exhibition spaces, the type of work being made for art fairs and the globalization of the art market. ↦

market, consumed as it was during those years with Abstract Expressionism, Pop Art and Minimalism, took scant note of what was happening in France. It's only since the turn of the millennium that the markets for these three artists has begun to reflect their considerable artistic achievements – and their influence on many of today's younger artists.

Gallery representation

Another factor that can affect an artist's market price, and sometimes even spur greater curatorial interest, is gallery representation. A prestigious gallery, one that has an outstanding programme and influence in the art world, can dramatically increase demand among collectors. That occurred, for example, when the conceptual photographer Christopher Williams left the Luhring Augustine gallery in New York in the late 1990s and soon thereafter joined the David Zwirner gallery, also located in New York. Since Williams made this move there has been no change in the quality of his work (it remains consistently high), but there has been an increase in the American market's appreciation of it.

Another such instance is reflected in the market trajectory of the American painter Lee Lozano, who died in 1999. As Dorothy Spears wrote in a 2011 *New York Times* article, some say that it was the mystique of Lozano's rejection of the art world in the early 1970s that spurred an inevitable interest in her work. It may also be claimed that the Lozano exhibition at P.S.1 Contemporary Art Center in New York in 2004 provided a boost, at least among a few keen-eyed buyers. But when word spread in 2006 that the high-powered international gallery Hauser & Wirth was going to represent the Lozano estate, her market really took off. Hauser & Wirth has since put on one-person gallery shows of Lozano's paintings and drawings in London, Zürich and New York and, deservedly, prices for her work continue to rise.

With an almost insatiable need to provide product for its twelve exhibition spaces around the world (and counting), the Gagosian Gallery has added quite a few young and emerging artists to its stable since the turn of the twenty-first century. No gallery in the world is the equal of the Gagosian Gallery. Among its various credits, it has staged historically important, museum-quality shows of Arshile Gorky, Kazimir Malevich, Piero Manzoni, Claude Monet, Pablo Picasso and Andy Warhol, among others. And it represents several of the most important artists of recent decades, including Mike Kelley, Jeff Koons, Richard Prince, Ed Ruscha and Richard Serra. But a hard look at other artists in their programme, and surely certain artists at other

mega-galleries, begs the question: can high prices be sustained over time when artists fail to engender any serious critical and curatorial interest?

Supply and demand

Yet another circumstance that can produce anomalous prices in an artist's market occurs when that artist's work goes on the auction block for the first time, especially when bidding reflects pent-up demand. When Julian Schnabel's initial painting fetched $93,500 at auction in 1983 it shocked the art world, especially as prices for his work on the primary market were then in the $5,000 range. The Washington, DC art consultant Anita Reiner, who reportedly paid the five-figure price, told people she did so because she wasn't able to access a Schnabel from the Mary Boone Gallery, the artist's primary dealer at that time.

In February 2009, a young artist named Jacob Kassay had his initial solo show, at Eleven Rivington, a small gallery on Manhattan's Lower East Side. His silvery surfaced, mirror-like paintings were then priced at about $6,000 to $8,000. They caused quite a stir among a number of collectors searching for the 'next big thing', and almost immediately the gallery had a waiting list for Kassay's work. Then, in November 2010, one of his paintings popped up at a Phillips de Pury & Company auction in New York and fetched a surprising $86,500. Weeks later, at a benefit auction for The Kitchen, a well-known not-for-profit art and performance space in Manhattan, another one sold for $94,000. And about six months later, in May 2011, again at Phillips, one of his 117×91 cm (46×36 in) paintings fetched the startling price of $290,500.

During this period and the year after Kassay was included in a few group shows, had commercial gallery exhibitions in Paris (Art Concept gallery) and Los Angeles (L&M Arts gallery), and was given a one-person exhibition at the Institute of Contemporary Arts (ICA) in London. Anytime an artist's prices and exposure increase precipitously – especially those of a young artist – it ordinarily takes some doing by the artist and his or her dealers to keep the market up in ensuing years. In May 2012, Phillips sold another of Kassay's paintings, this time for $98,500, not at all a bad price for a young artist but nevertheless about one-third of the price paid a year earlier for a canvas of the exact same size. Art advisor Lisa Schiff, a self-described fan of Kassay's work, once said about Kassay's auction results, 'There is a fine balance with success in the art world. A little too much can turn things the wrong way.'[8] As for Kassay, the story has only just begun.

The influence of star collectors

The sanction of major collectors, particularly those who conspicuously display their collections to a wide audience of collectors, is another in the list of factors that can significantly affect an artist's prices. These so-called 'star' collectors can, on occasion, lead other collectors to great art and to art that will appreciate in the market. And sometimes they can lead them right over the cliff.

The British former advertising mogul Charles Saatchi is a paradigmatic example of collector influence, and of influence gone astray. Saatchi deservedly emerged as an influential collector in the mid-to-late 1980s, when he curated works from his collection in a 2,787 square metre (30,000 square foot) converted paint factory in North London. The first of his extraordinary shows included Donald Judd, Brice Marden, Cy Twombly and Andy Warhol. He followed this with a show of the great American Minimalists, and then an exhibition of emerging artists from New York, including Jeff Koons and Robert Gober. From 1986 through 1991 he continued to mount outstanding exhibitions. During those years there was constant art world buzz about which artists he was buying, how many works, and his aggressive demands for large discounts.

In 1992, Saatchi famously put on a show of the Young British Artists, the YBAs, which included Damien Hirst's vitrine containing a 5.2 metre (17 foot) dead tiger shark, titled *The Physical Impossibility of Death in the Mind of Someone Living* (1991).[9] (Saatchi bought the work the year it was made for £50,000 and sold it in 2004 to the aforementioned collector Steven Cohen for a reported $8 million.) Saatchi's 1992 show led to the highly controversial exhibition of his YBA collection, titled 'Sensation'.

Since those days Saatchi has twice moved his Saatchi Gallery, increasing its area each time. He buys and sells with the regularity of a dealer, but not one that seems concerned about artists' careers. As he once said, 'I don't buy to ingratiate myself with artists.'[10] In 2004, Damien Hirst said about Saatchi, 'He only recognizes art with his wallet... he believes he can affect art values with buying power, and he still believes he can do it.'[11]

Another locus of 'star' collector influence, at least every December, is Miami, Florida, where the Art Basel Miami Beach art fair has been held since 2002. Thousands of collectors from around the globe flock to the fair and, not incidentally, to visit several prominent, trendsetting private collections that are open to the public or invited guests. Miami art collector and design maven Craig Robins told us:

When Art Basel was coming to Miami, a group of us got together and immediately began to stage

exhibits that were not about selling art, and diff-
erent kinds of parties and events. A lot of collectors
agreed to open up their homes and collections in
different ways, and that just spiralled into some-
thing that changed the art world.[12]

Most collectors who travel the world looking at and
buying art are curious about the vision and choices
of well-known collectors, and this inquisitiveness is
certainly accommodated with open arms in Miami.
A few of the Miami collections are housed in enormous
warehouse-like spaces (the Rubell Family Collection,
the Margulies Collection at the Warehouse, the Cisneros
Fontanals Art Foundation and the De la Cruz Col-
lection). Others can be seen in collectors' homes or
offices (Debra and Dennis Scholl, Irma and Norman
Braman, Rosa de la Cruz and Craig Robins).

Each year most of the prominent Miami collectors
re-install or curate anew for the annual hegira, and all
together they put on quite a show. Scores of visiting col-
lectors leave Miami impressed and with the names of
newfound artists on their 'must-buy' lists. In fact, in
some instances increased market support for certain
artists can be traced to these very Miami collectors.
However, it's also the case that visiting collectors, our-
selves included, have departed the scene dismayed by
certain collections that seem to be focused largely on
what's hot or will make a splash.

With two expansive exhibition spaces in Venice, the
Palazzo Grassi and the Punta della Dogana, and a col-
lection thirty years in the making and numbering some

**'To the Moon via the Beach' conceived by Philippe
Parreno and Liam Gillick, 2012. Commissioned and
produced by the LUMA Foundation for the Parc des
Ateliers in Arles, France**

*Maja Hoffmann founded the LUMA Foundation to support
cultural projects worldwide. In July 2012, it sponsored a
three-day event in a Roman amphitheatre in Arles,
curated by Tom Eccles, Liam Gillick, Hans Ulrich Obrist,
Philippe Parreno and Beatrix Ruf, presenting work by
more than twenty artists. Hoffmann comes from a family
for whom collecting is just one part of the altruistic ethic
that shines through their involvement with art. The
Emmanuel Hoffmann Foundation, begun by Hoffman's
grandmother Maja Hoffmann-Stehlin in 1933, supports the
activities of the Kunstmuseum Basel, the Museum für
Gegenwartskunst Basel (the world's first museum exclu-
sively dedicated to contemporary art, founded in 1980),
and the Schaulager, a state-of-the-art storage facility,
research institute and exhibition space, also in Basel.* ↦

3,000 objects, François Pinault is one of the world's most influential collectors. His exhibitions staged to coincide with the Venice Biennale are a 'must-see' for the thousands of collectors, critics, curators, dealers and artists who congregate in Venice every odd-numbered year. Though a retinue of advisors assists him, Pinault knows what he likes, collects in depth, has access to the very best and, we've been told, regularly spends time with artists in their studios.

Undoubtedly, Pinault's collection is world-class, and yet somehow his three Venice exhibitions as of 2011 have been uneven and somewhat disappointing. There are those, too, who feel that the way in which some works have been installed has disadvantaged the art. But, then, perhaps a collection of the tremendous scope and scale of Pinault's is beyond conventional appraisal.

There is no questioning Pinault's dedication to collecting and his passion for art. In a conversation with Jackie Wullschläger of the *Financial Times*, Pinault said about his coming to contemporary art, 'Two things mattered: the first, to do with my character, my curiosity for knowledge; the second, to be able to buy artists who count.' In that same conversation, Wullschläger quoted Russian collector Sergei Shchukin as saying, 'If you feel a psychological shock before a work, buy it without further ado.' Pinault is reported to have replied, 'It's the same with me.' And, referring to a visit with artist David Hammons, he exclaimed that he had been so shocked by the work that he left, but then returned to purchase two of Hammons' works.

While beginning and even seasoned collectors might learn of new artists, see interesting groupings and installations or be inspired by visiting the collections of others, it's never advisable to copy someone else's collection. Looking to mega-collectors is indeed one way to broaden one's vision, but in the end collectors are best advised to assert their own thinking on the acquisitions process. The greatest reward of building a personal collection is finding one's own voice.

The impact of personality

Among the factors that can influence market support for certain artists is personality, a dicey subject to be sure, but one that does play a part in or is integral to the course of some careers. No artist can charm her or his way into the historical canon, but by dint of personality, using the term broadly, and the social connections derived from it, they can attract interest to their practice and support for their work.

For instance, virtually everyone we know who has spent time with Jeff Koons in his New York studio, going

back to the mid-1980s, has come away won over by his intensity, conviction and disarming attentiveness to visiting collectors, all of which has probably helped some in engendering support for his career, at least early on. Simply put, his is a unique and compelling personality. By no means does this diminish his extraordinary accomplishments, or the widespread belief that he is one of the most important artists of his time. But it's not to be completely dismissed in contemplating his success, either.

In an essay about artists of the 1990s, New York-based art advisor Allan Schwartzman said of Matthew Barney, 'Equally important to Barney's work is Barney himself, his appearance and his reticent personal sense of style, of public persona.' Schwartzman continued, '... Barney and Gladstone [Barney's long-time dealer, Barbara Gladstone] carefully regulate how he is portrayed and how often, making him unavailable for interviews and thus, deliberately removing him from the cult of personality in a way that is destined to create one.'

Then, too, there is Damien Hirst, an artist with a singularly audacious nature. Beginning in the late 1980s, displaying a surfeit of vitality and nerve, he (along with Charles Saatchi) brought widespread media attention and collector support to a generation of young British artists – and to his own considerable practice. There's little doubt that Hirst's brash personality has had a positive effect on the market for his work – in fact, some would say it's the quintessence of his practice.

Notwithstanding these examples and others we could mention, in our experience it's not that often that an artist's personality has a direct, unequivocal bearing on collector support and the sale of their work. But an artist's personality can impact the market in indirect or convoluted ways as well. We know of some artists whose personal nature is such that it makes it difficult for commercial galleries to work with them; artists who are painfully shy and avoid art world events where they would ordinarily meet buyers for their work; and artists who go to extremes not to be complicit in the commoditization of their work.

Admittedly, in assessing an artist's place in the art market or their standing among collectors at any moment in time, it's simplistic to separate or untangle their personality from their creative/artistic talent. Nevertheless, the personalities of individual artists may at times – for better or worse – influence the course of their careers.

Considering the many thousands of professionally capable artists making art today, and the many hundreds of adept and committed galleries around the world that represent them, it's incumbent on collectors

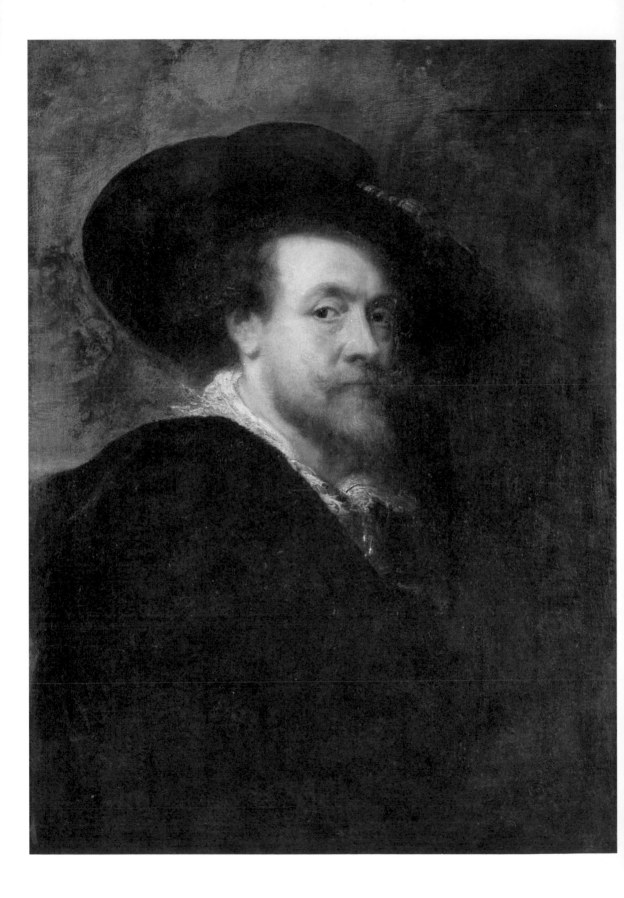

to find ways to narrow their choices – to determine which artists to follow and which works to buy. In this milieu, made ever more baffling by the exorbitant attention paid by the media to artists of all talent levels and all ages, it's no wonder that many collectors have turned to the art market as their guide: they view the market as an easy-to-compute indicator of artistic significance or, at the very least, as a way to acquire works that are comforting because they have broad support in the collecting community.

However, as we've discussed in this chapter, various factors can significantly effect, at least in the short term, artists' market position and any assessment of artistic merit derived from it. Among these factors are where artists live and work, which galleries represent them, how they fare when they hit the auction block, the sanction of prominent collectors, and even an artist's personality.

Collectors oriented to making acquisition decisions based solely or even primarily on market support would be wise to take this into consideration. And they will benefit further by incorporating into their decision-making process several other ways of evaluating artists and understanding art that are discussed in the chapters that follow.

The relevance of critical writing

The nature and merit of any art collection are determined by several circumstances or factors, not least a collector's depth of knowledge as he or she goes about the process of making choices and acquisitions. As we discussed in the previous chapter, art market support – as measured by prices – provides collectors with one kind of perspective or base of knowledge. Published critical writing provides another, and it can have a significant effect not only on collecting acumen but also, at times, on what art the collector responds to.

'Art collectors today are inundated with data, images and published discourse available in print and online.'

Art collectors today are inundated with data, images and published discourse available in print and online. There's plenty of conversation and free advice to be had too, as few art world players are shy about sharing their views. In this environment of information overload the challenge for collectors is not so much to uncover material on the art and artists they're interested in but rather to home in on that which can expand their vision and inform their understanding and choices.

The purpose of criticism

On a regular basis collectors hear about shows, individual works of art and the predicted flight paths of artists' careers from galleries, other collectors, auction house experts, advisors, artists and curators. But much of this information or opinion is offered up with narrow, self-serving motives. This doesn't necessarily make it inconsequential, but it does after all come from people

Arthur Dove, *The Critic*, 1925, collaged paper, fabric, newspaper, cord, glass, pencil and watercolour

Arthur Dove's collage 'hilariously satirizes Royal Cortissoz, the famously reactionary critic of the old New York Herald-Tribune', *said fellow critic Hilton Kramer. Cortissoz's reputation as a reactionary may have been sealed when he deemed the art in the history-changing 1913 Armory Show '...a gospel of stupid license and self-assertion which would have been swept into the rubbish-heap were it not for the timidity of our mental habit'. As for Kramer, who died in March 2012, his reputation may have suffered some when he called Pop Art 'a very great disaster', and Conceptual art 'scrapbook art'. Every critic gets it wrong now and again, which becomes clear when certain of their more outspoken evaluations are examined with the advantage of hindsight. Of course, the same can be said about choices made by the best curators, the best dealers, the best advisors and the best collectors. Consistently making spot-on judgements about the art of one's time is no easy task.* ↦

'I DON'T KNOW ANYBODY
WHO NEEDS A CRITIC
TO FIND OUT WHAT ART IS.'

Jean-Michel Basquiat

with natural biases – from those with skin in the game, so to speak. In this regard it would be fair to say that dealers seek to advance their artists' careers; collectors typically want to see an increase in the critical acclaim accorded to the artists they collect, or an increase in their market value, or both; auction house personnel have 'lots' to sell; advisors hope that artists they recommend do well; artists often talk up friends and acolytes; and museum curators who privately advise trustees and donors (as distinct from curate exhibitions) ordinarily have their institution's collecting interests at heart. Most art world players are advocates with specific agendas.

Some may attribute to critics biases that are similar to those held by dealers, collectors, advisors and other art world insiders, especially when critics are paid by galleries to write essays for monographic catalogues; but the reality is that most published critical discourse provides perspectives that are free of economic or commercial prejudice. In fact, even when they are writing at the behest of galleries, good critics usually have something valuable to add about how the work of an artist can be seen and understood. As a general rule, critics and art writers are evaluated on the basis of whom they choose to write about, their objectivity and how well they rationalize and explicate their thoughts and perceptions.

Of course, there always have been and likely always will be art world players – prominent artists among them – who hold a disdainful view of art criticism. Jean-Michel Basquiat once said, 'I don't know anybody who needs a critic to find out what art is.'[1] Earlier in history, Marcel Duchamp called on his audience in America to think for themselves and not to mind what critics have to say. Duchamp's friend Man Ray had a more drastic proposal: 'All critics should be assassinated,' he declared.[2]

The nature of critical discourse

We wish to stress that by critical writing we mean thoughtful assessment, not necessarily negatively slanted judgement, which some among the general public mistakenly equate with the idea of 'criticism'. In fact, today's critical discourse contains very little qualitative evaluation or conclusive judgement, negative or positive – the implications of which we'll discuss shortly.

It may be said that there are two primary categories of contemporary writing on visual art, though at times the lines between them can be blurry. One is academic writing produced by historians and scholars for university presses and art-historical journals. The other is journalistic writing and criticism, mostly reviews produced for newspapers, weekly publications, art magazines, blogs and catalogues. Included in this

Cover images of volumes I and II of Hans Ulrich Obrist's *Interviews*, published by Charta in 2003 and 2010, edited by Charles Arsène-Henry, Shumon Basar and Karen Marta, with cover photos by Hans-Peter Feldmann;[3] microphones turned 'ON' in an homage to artist On Kawara, who never gives interviews

The artist's interview is a form of published writing that is gaining in popularity among collectors, in large part because the spoken word is less encumbered by art-speak than in typical critical writing, and in no small part because of the masterful use of the form by Hans Ulrich Obrist. The peripatetic Obrist is Director of International Projects at the Serpentine Gallery, London. He comes at each of his countless interviews with well-informed and incisive questions. No single question and answer plucked from one interview can do justice to all of them, but the following excerpt from Obrist's interview with the artist Thomas Schütte in Mousse magazine

(no. 28, April 2011) hints at the candid, often unique insights that interviews can expose.

HUO: Another part of your oeuvre that touches on the field of architecture are the large sculptures. Die Groben Geister *were the beginning. Is this a direction you are continuing with your work at the moment, the large, almost monumental sculptures?*

TS [referring to his Kleine Geister (Small Ghosts/Spirits)]: I decided after this astounding success – which I can't believe in really, because it destroys you if you do believe in it, that I no longer wanted any more commodity trading, products and trophies. It doesn't interest me.

'THROUGH MY WRITING
I CAN ELUCIDATE ITS FORM,
UNCOVER ITS STRUCTURE AND
UNDERSTAND ITS MEANING
AS FILTERED THROUGH
MY FACULTIES, AND MAKE IT
SHAREABLE. STILL, ALL
MY EFFORTS CAN NEVER HOPE
TO SEIZE ITS ESSENCE, AND
STEAL ITS SECRETS.'

Christian Schaernack

second category is poetic, belletrist writing, a form that serves as its own aesthetic experience contingent not so much on the subject – the artist – as on the beauty of the language itself and the author's subjective impressions. Other kinds of journalistic writing are cultural criticism, which aims to juxtapose fine art with the cultural surround; blogs, a more informal mode of writing that has emerged in our networked media age; and artist interviews (including recorded conversations).

For our purposes here we are taking the liberty of lumping together all written critical discourse in one pot – a big stew of analysis, perspective, opinion and interviews with artists – with a dash more emphasis on reviews and articles available in great quantity in daily, weekly and monthly publications. As rich as this stew is, it's difficult to be certain how much of it is sampled. In fact, there's a widespread belief that many collectors barely peruse even the better of the widely distributed monthly art magazines; it is thought that they glance at the ads and images and perhaps take note of the artists reviewed but don't really delve into the writing per se.

Indeed, in developing opinions about a particular artist or work of art many dedicated collectors say they would rather just look and not get too caught up in critical rhetoric. Speaking of this kind of disposition, the poet Rainer Maria Rilke said, 'Works of art are of infinite solitariness, and nothing is less likely to bring us near to them than criticism. Only love can comprehend and hold them, and can be just towards them.'[4] But, even if one accepts that Rilke was commenting on criticism of a negative or unfavourable bent, loving an object and being informed about it are not mutually exclusive. In fact, they often go hand in hand.

The reality is that virtually all art world players, including us, subscribe to the view that words can never express or do full justice to that which is conveyed by a work of art; but that is not criticism's claim. Rather, as art historian, critic and curator Johanna Burton says, 'Criticism, at its best, speculates on ways of seeing rather than reiterating them...'[5] The polymath art writer for *Neue Zürcher Zeitung*, Christian Schaernack, said it this way: 'Through my writing I can elucidate its form, uncover its structure and understand its meaning as filtered through my faculties, and make it shareable. Still, all my efforts can never hope to seize its essence, and steal its secrets.'[6]

Informing and elucidating

'And yet words can be illuminating,' said the great collector, Dominique de Menil. 'They put you in a frame of mind that the invisible becomes visible.' She felt, for

example, that Roland Barthes helped her to love Cy Twombly's work and that Leo Steinberg led her to see Jasper Johns's 'more fully'. She added, 'Poets as well as scholars must participate in the permanent celebration that should surround art. Books, catalogues, lectures, informal talks, panel discussions, all have their privileged and welcome place. But discourse must not take the place of art itself.'[7]

For anyone interested in art, being informed can make the difference between 'getting it' and being left unaffected, particularly when it comes to art that is unfamiliar or breaks new ground, or perhaps conceptually based art that may be difficult to comprehend at first glance. In dealing with the new or the strange, and even with art that's familiar, collectors can turn to critical discourse to help them comprehend an artist's meaning, intentions and process, place the work in a historical context, connect precedents and influences, and lift the lid on the abstruse and hermetic. All things considered, criticism has the capacity to help a collector grasp what may have gone undetected, and it may even prompt different evaluations and feelings about an artist's work. In our view the proper role of art criticism in the collecting process is not necessarily to engender agreement or disagreement with what is written, though on occasion that can make for heated and entertaining conversation, but rather to inform and elucidate.

In June 2010, as we wove our way through the crowded hallways and awkward spaces at Liste, which bills itself as the Young Art Fair and runs concurrently with the annual Basel fair, we came upon the work of James Beckett, an artist unfamiliar to us. The gallerist showing him, Wilfried Lentz, was from Rotterdam and was also unknown to us. We found Beckett's work arresting, intriguing and beautiful, and then and there we spent a considerable amount of time learning more about it from Lentz. As we looked and listened we were increasingly persuaded of the work's merit. But before we decided what to buy we asked for time to read the published material Lentz had available. Late on that first night in Basel and the following morning we read enthusiastically about Beckett's research-based practice; as a result of the investigation we became more knowledgeable about what it was that so intrigued us. No doubt we would have purchased Beckett's work without having read the catalogue essays and looked at images of earlier work, but we certainly would not have done so with the expansiveness or precision that we feel the reading enabled.

Four months later we flew to Rotterdam to spend time with Beckett and Lentz and also to see two exhibitions of Beckett's work in museums around Amsterdam.

'For anyone interested in art, being informed can make the difference between "getting it" and being left unaffected.'

Before our trip, New York gallerist Andrew Kreps suggested that while in Rotterdam we visit an artist named Melvin Moti. Although Moti was not part of his gallery programme, Kreps thought highly of him. We knew very little about Moti, but we respect Kreps's eye for talent and gladly scheduled an appointment. This type of activity can be stimulating and rewarding, but when it comes to an artist whose work we've not seen before, it doesn't always result in deep interest on our part. On this occasion, however, it did.

Moti is essentially a moving image practitioner, film being his primary means of communication. Despite being able to see Moti's films only on his laptop computer – hardly the best way to gain full appreciation of very nuanced work – we found them quite compelling. After several hours together, most of which we spent listening to Moti discuss his way of thinking, we became even more fascinated. Enquiring about buying work in a moment like this didn't seem appropriate, especially as we didn't even know who represented him in the gallery world. We left the meeting by and large persuaded but wanting to know more.

Upon returning to New York with a couple of the extraordinary artists' books that Moti had published and graciously given to us, we went online and found edifying articles on his practice in several major monthly art magazines. The additional understanding we gained from the published critical discourse gave us even more reason to want to travel to see Moti's work in an upcoming two-person show organized by João Ribas at the MIT List Visual Arts Center in Cambridge, Massachusetts. In June 2011, at Art Basel, we acquired our initial work by Moti, purchased from the Meyer Riegger gallery. Although it was nearly a year from the time we first learned of Moti until we made an acquisition, the decision was an easy one, as we felt sufficiently informed as a result of the time we had spent and the knowledge we had gained.

In these two experiences and many others, making use of published writing to gain information, perspective and insight and to propel thinking has been so utterly essential and advantageous to us that we've always assumed other collectors followed a similar approach. Among the collectors who feel similarly about written discourse is Erling Kagge, the very precise art collector (and famous outdoor adventurer) from Oslo. He told us:

There are a few advantages to being an art collector living closer to the North Pole than to Manhattan. To reside beyond the daily 'blah, blah, blah' is a timesaver. Nobody is around to tell me the latest rumours about artists who are just about making it

big. Also, I can collect more with my eyes, than my ears and nose. Viewing art while travelling, discussing art and artists with some close friends and reading magazine articles and criticism while at home is the way I collect.[8]

We're sure that Kagge and many other collectors interested in published critical thought would agree that not every piece of criticism is spot-on or particularly well written, and critics cannot in every instance fathom (much less explain) the intentions of the artist they're writing about. Some critical writing also comes across as glib and tossed off, seemingly produced to satisfy an editor's needs more so than to really dig into the artist's work. Nevertheless, for the most part there is a great deal to be learned from the art writing published in print and online, in newspapers, magazines, journals, books and catalogues.

'There is a great deal to be learned from the art writing published in newspapers, magazines, journals, books and catalogues.'

Criticism disempowered

Thus it was disquieting to find, while researching this book, a widespread belief among critics that what they write has little impact or relevance in art world thinking – in the formulation of shared beliefs about what is symbolically and critically important. In the last decade many conferences, panel discussions and published articles, with critics at the forefront, have addressed

Denis Diderot by Louis-Michel van Loo, 1767, oil on canvas and Charles Baudelaire by Étienne Carjat, c.1863, Woodburytype

France's pantheon of extraordinary writers includes encyclopedist–art critic Denis Diderot (1713–84) and poet–art critic Charles Baudelaire (1821–67). Diderot's entertaining reviews of mid-eighteenth-century French Salons turned attention in Paris and beyond away from accepted academic criteria to matters of individuality, creativity and passion. Charles Baudelaire, though not fully appreciated during his lifetime, is generally considered the father of modern art criticism. He embodied what it meant to be a modern artist: to capture the ephemeral experience and heroism of urban life. It may be premature to equate today's critics to such resplendent voices. But surely there is writing about art-making approaches today that will be seen in such a light. David Joselit's 2009 October magazine essay, 'Painting Beside Itself', seems to fit the bill. In it he discusses 'transitive' painting and the artists engaged with this practice, from Martin Kippenberger and Stephen Prina to, among others, Michael Krebber, Merlin Carpenter, Jutta Koether and Cheyney Thompson.　　　　↦

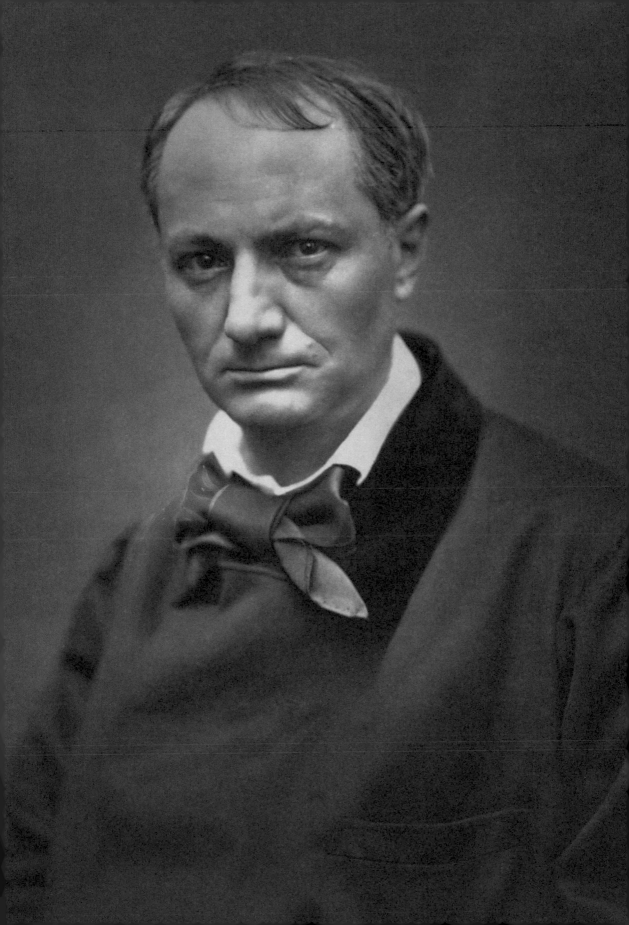

the disempowered state of art criticism. As writer–gallery owner–artist John Kelsey said, 'Most critics today somehow agree that they've been simultaneously retired and co-opted by market forces.'[9]

At the outset of his brief but pertinently titled volume *What Happened to Art Criticism?*, James Elkins, chair of the Department of Art History, Theory and Criticism at the Art Institute of Chicago, summed up the prevailing situation:

> *Art criticism is in worldwide crisis. Its voice has become very weak, and it is dissolving into the background clutter of ephemeral cultural criticism. But its decay is not the ordinary last faint push of a practice that has run its course, because at the very same time, art criticism is also healthier than ever. Its business is booming: it attracts an enormous number of writers, and often benefits from high quality color printing and worldwide distribution. In that sense art criticism is flourishing, but invisibly, out of the site of contemporary intellectual debates. So it's dying, but it's everywhere. It's ignored, and yet it has the market behind it.*[10]

As for Elkins's last point, many feel that published reviews and essays, especially those that are penned for monographic catalogues commissioned by commercial galleries, serve as not much more than a kind of intellectual validation for the market.

However serious critics may feel the situation is today vis-à-vis the voracious, all-consuming market, art writing in the service of the market has been part of art history for some time – well over 100 years in France. There, until the latter part of the nineteenth century, the Royal Academy of Art, which was loosely part of the state bureaucracy, reigned supreme. It recruited and trained artists, staged enormous exhibitions through its Salons, bestowed awards, arranged sales and commissions, established ideology and set standards around its own notions of excellence. But just as the Academy came to replace the guild system, it too was eventually superseded by influential art dealers and reviews published in newspapers, a combination that was labelled the 'dealer-critic system' by the sociologists and art historians Harrison and Cynthia White.

In the Whites' interpretation, as they recount in their fascinating book *Canvases and Careers* (1967), the dealer-critic system came about due to the 'coalescing' of a number of developments. Among these, the Academy couldn't adequately serve the vast increase in the number of artists who looked to painting as a way to earn their livelihood; and an ever-expanding, more speculative art market called for the promotion of

artists' careers over individual works, which increased the need for written, explanatory discourse.

Evaluative criticism

The necessity for a new system was underscored by the emergence of the French Impressionists in the late 1800s. These artists came to be promoted not so much through massive Salon exhibitions but through individual and small group shows put on by commercial galleries, foremost among them Paul Durand-Ruel and Ambroise Vollard. And the Impressionists' considerable artistic achievements, notably what many believe to be nothing less than an ushering in of Modernism, were enthusiastically taken up by an expanding group of critics writing for an emerging number of French publications.

Art criticism in France at the end of the nineteenth and beginning of the twentieth century 'invited the public to understand and admire the technique and theoretical knowledge of the artists and to make its value judgments in these terms. As new directions in art multiplied, this style of criticism became predominant,'[11] wrote the Whites. In other words, they continued, 'The better critic attempted to teach the public how to look at a painting, rather than how to interpret its subject.'[12] Also, it was then common for critics to make conclusive evaluations, whether favourable or unfavourable.

Evaluative criticism reached an apogee of sorts when the avant-garde shifted from Paris to New York, and English became the dominant art world language. From the late 1940s through to at least the late 1950s two New York critics, Clement Greenberg and Harold Rosenberg, held sway. Greenberg favoured the likes of David Smith, Barnett Newman, Mark Rothko, Ad Reinhart, Clyfford Still and Kenneth Noland, but he was most identified with Jackson Pollock. As Tom Wolfe wrote in *The Painted Word* (1975), 'Greenberg hadn't created Pollock's reputation but he was its curator, custodian, brass polisher, and repairman, and he was terrific at it.'[13] Rosenberg, an existentialist and romantic, took up the cause of gestural abstraction, arguing, 'What was to go on the canvas was not a picture but an event.' He wrote favourably about Pollock, Franz Kline, Robert Mothcrwcll and cspecially Willem de Kooning.

As for qualitative evaluation, it's fair to say neither Greenberg nor Rosenberg held back. Late in his career Greenberg said, 'Description, analysis and interpretation, even interpretation, have their place. But without value judgment these can become arid, or rather they stop being criticism.'[14] In a conversation with Jerry Saltz, the art historian Mark Stevens said that Greenberg

'DESCRIPTION, ANALYSIS AND INTERPRETATION, EVEN INTERPRETATION, HAVE THEIR PLACE. BUT WITHOUT VALUE JUDGMENT THESE CAN BECOME ARID, OR RATHER THEY STOP BEING CRITICISM.'

Clement Greenberg

'loved to play the part of the hanging judge, regretfully executing artists who fell afoul of serious taste'.[15]

The two critics and quite a few outstanding writers who followed them in the United States, notably Leo Steinberg, often wrote quite passionately and decisively about the art and artists in whom they were interested. But by the late 1980s to the early 1990s, strongly judgemental, declarative criticism began to wane – description was trumping evaluation.

Even before that time, however, the landscape of American art criticism had begun to change in other ways with the founding of *Artforum* in 1962. The magazine became an important outlet for influential critics, such as Robert Pincus-Witten, but also provided a platform for the writings of artists such as Robert Smithson, Donald Judd and Sol LeWitt. Further, in encouraging historians such as Rosalind Krauss, Robert Rosenblum and Michael Fried to write about contemporary artists, the magazine blurred the lines between art history and art criticism.

As for outright evaluative criticism of art, by the year 2002 'judging' was the least popular goal of critics and 'describing' was the most popular, according to a study carried out at Columbia University of 230 American critics from large-circulation publications.[16] It cannot be unremarked that the decreased use of 'judgemental' writing occurred at the very same time that art critics were perceived to be losing much of their influence in the art world, surely among collectors.

Criticism today

This was not the only change that affected the role or influence of art criticism during the last several decades. As an example, from about the end of the Second World War through to the 1980s or so, collectors depended on critics to inform them about the latest developments on each side of the Atlantic. When long-distance air travel became more commonplace in the 1980s, and American collectors were flying regularly to Cologne and other destinations, while Europeans flew to New York and Los Angeles, there was less need for this kind of information.

There are also those who feel that critical writing on the subject of art has diminished in importance because it has become weighed down with hard-to-comprehend art theory, jargon and esoteric metaphor. An opposing point of view holds that collectors have become just plain lazy, and that in today's fast-paced, market-oriented art world thoughtful criticism is too much trouble or not what collectors are looking for. As the noted art historian Benjamin Buchloh opined, 'You

don't need criticism for an investment structure, you need experts.'[17] No doubt many collectors in times past welcomed the once prevalent thumbs-up or thumbs-down evaluative judgements of critics as a guide to help calibrate acquisition decisions; clearly there is at present not much of that kind of criticism. Furthermore, as we've noted, other developments have served to diminish the importance of critical writing in the collecting world. Sam Keller, the current director of the Fondation Beyeler and the former director of Art Basel and Art Basel Miami Beach art fairs, observed, 'When I entered the art world, famous critics had an aura of power. Now they're more like philosophers – respected but not as powerful as collectors, dealers or curators. Nobody fears critics any more, which is a real danger sign for the profession.'

Indeed, there are those in the art world who now perceive the critic to be outside of the field of influence. What the Whites once called the 'dealer-critic system' has morphed into what is currently referred to as a 'dealer-collector-curator system'. But in our view this label seems too absolute; it's a misnomer. There's simply too much thoughtful, objective, insightful art criticism available today, in more publications than ever, for critical discourse to be entirely removed from the equation.

Widely read and respected critics who write for large daily and weekly publications or their own blogs can affect collector (and public) attendance at an artist's exhibition and get people talking and thinking. For those in doubt, just ask a Manhattan gallerist what happens to crowd size and collector attention following the publication of a review by Roberta Smith in the *New York Times*. There are also vital publications – *Artforum*, *Parkett* and *Texte zur Kunst*, to name but a few – that have avid followings in segments of the collecting community; plenty of collectors care what art critics writing for these and other important monthly publications have to say about artists and issues of interest. Finally, and probably most important, critics and historians, especially those who write longer-form essays, continue to influence the future historical position of artists they write about.

Today's enormous, unrelenting art market trades on much of what is published weekly and monthly. In one way or another, art dealers and gallerists use critical writing as a kind of intellectual confirmation for the art they purvey. But when looked at historically this circumstance is mostly different in degree not in kind. It doesn't make meritorious critical writing any less informative, valuable and provocative to today's dedicated, curious collectors.

'WHEN I ENTERED THE ART WORLD, FAMOUS CRITICS HAD AN AURA OF POWER. NOW THEY'RE MORE LIKE PHILOSOPHERS – RESPECTED BUT NOT AS POWERFUL AS COLLECTORS, DEALERS OR CURATORS. NOBODY FEARS CRITICS ANY MORE, WHICH IS A REAL DANGER SIGN FOR THE PROFESSION.'

Sam Keller

Public exhibitions and curatorial practice

If there is one undeniable and universally accepted given in the activity of collecting, it is the need to look at art – to see as much as one can see. At the forefront of viewing opportunities are professionally curated biennials and triennials, and exhibitions at public exhibition spaces and museums around the world.

Biennials and triennials are mega-exhibitions of contemporary art. 'Biennial' is used here as a convenient catch-all term that also includes triennials and less frequently occurring exhibitions, such as Documenta, Manifesta and Skulptur Projekte Münster. There are noteworthy differences between museum exhibitions and biennials. While biennials are usually large-survey shows comprising many artists, sometimes a hundred or more, museum shows are usually monographic, and when they are thematic they don't often include more than twenty or so artists. *Kunsthallen* (a word used mainly in German-speaking countries) and exhibition spaces (the term commonly used in the United States and other parts of the world) afford their own kind of viewing opportunities. As distinct from museums, these venues have no permanent collections and their mandate is to organize temporary exhibitions of contemporary art.

The rise of biennials

Allowing that biennial curators, who are essentially the authors and impresarios of large-survey exhibitions, are seen by many as today's art world 'rock stars', let's begin with this vital and interestingly mutable topography.

Among the most important changes in the art world in recent decades is the exponential growth in the number of biennials and triennials worldwide. Governments, cultural organizations, museums, tourist boards, business groups and even individual collectors have established such events around the globe, in locations that not long ago would have seemed fanciful.

Beginning with the establishment of the Venice Biennale in 1895 and the Carnegie International (originally annual; it became biennial in 1950 and triennial in 1955) in Pittsburgh the following year, over the course of the subsequent 100 years there were only 17 of these international shows in existence. That roster included the São Paulo Biennial (1951, Brazil), Documenta (1955, held every five years in Kassel, Germany), the Whitney Biennial (1973, New York), Skulptur Projekte Münster (1977, held every ten years in Munich, Germany), the Havana Biennial (1984, Cuba) and the Istanbul Biennial (1987, Turkey). Today more than 100 such exhibitions are held in over 50 countries, including Albania, Angola, Chechnya, Ecuador, Indonesia, Latvia and Morocco.

'Among the most important changes in the art world in recent decades is the exponential growth in the number of biennials worldwide.'

This 'biennialization' of the art world, much of which has taken place since the 1990s, has fittingly chipped away at the hegemony of American and European art-making practices and brought art, almost all of it of recent vintage, to the doorstep of disparate cultures around the globe. Based on attendance figures that regularly climb into the hundreds of thousands – and sometimes to over one million at the more famous exhibitions – it would seem that a broad, interested public has come to appreciate these shows virtually everywhere and anywhere.

Biennials serve the political goals of host countries and the economic and branding needs of host cities. With the Havana Biennial, for example, Cuba aimed to showcase art from less developed countries; with the founding of Documenta, Germany wished to assert a postwar image of reconstruction and democracy; and South Korea was eager to show off its newly won democracy. As critic–curator Michael Brenson has written, 'By becoming a recognized event, covered by newspapers and art magazines and attended by people from the region and perhaps from all over the world, the local is validated in a way in which few local cultures anywhere – not even in urban centers like New York, Los Angeles, Berlin or Tokyo – can now validate themselves.'[1]

Biennial-type exhibitions have also been a boon to art students and artists located in what were once the far reaches of the art world by providing them with opportunities to experience art at first-hand, often made by important practitioners. Until about the 1990s, the closest thing this vitally interested audience could ordinarily get to the art being made in Europe and the United States was what they might see in art magazines. At the same time, their work was hardly even heard of, much less seen by most artists in the West.

Curatorial practice and independent curating

Not incidentally, the burgeoning of large-scale survey exhibitions has also created unprecedented opportunities in the curatorial profession, especially for big-name curators who can attract media attention and large crowds, and who by virtue of their authorship can motivate the art world to attend such shows. Some of these curators are art writers and art historians, others are affiliated with museums, and still others operate on a completely freelance basis.

Common to the practice, biennial curators are generally free to make their own choices and judgements; to conceive an exhibition thematic and then place their imprimatur on scores of artists whom they admire.

133

Harald Szeemann at the Joseph Beuys retrospective he organized at Kunsthaus Zürich, 1993

In an interview in Artforum *in November 1996, Hans Ulrich Obrist posed a question to Harald Szeemann, saying, 'Félix Fénéon described the role of the curator as that of a catalyst, a pedestrian bridge between art and public. Suzanne Pagé, a curator at the Musée d'Art Moderne de la Ville de Paris, with whom I often collaborate, gives an even more humble definition. She defines the curator as* commis de l'artiste *[assistant of the artist]. How would you define it?' Harald Szeeman replied, 'Well, the curator has to be flexible. Sometimes he is the servant, sometimes the assistant, sometimes he gives artists ideas of how to present their work; in group shows, he is the coordinator, in thematic shows, the inventor. But the most important thing about curating is to do it with enthusiasm and love; with a little obsessiveness.'*

Important to all who attend these shows, and certainly to dedicated collectors, curators can provide unequalled opportunities: for viewing the work of large numbers of artists in one general location, discovering new or relatively unknown artists, seeing work being made throughout the world and seeing how more established, well-known artists hold up in the free-for-all of a large-survey exhibition.

The role of independent curator got its start in the late 1960s; oddly enough, it was a large tobacco company and a powerful corporate public relations firm in the company's employ that helped get this underway. Seeking cultural credibility, in 1968 representatives of Philip Morris travelled to Switzerland with members of the public relations firm Ruder Finn to encourage Harald Szeemann (1933–2005), curator of the Kunsthalle Bern, to put on a major independent exhibition with the assurance of total curatorial freedom and plentiful corporate funding. Szeemann agreed, and the future course was set.

Szeemann titled the show 'Live in Your Head: When Attitudes Become Form'. It was, as Daniel Birnbaum wrote in an *Artforum* article following Szeemann's death in 2005, 'the first major survey of Conceptual art to take place in Europe'. Birnbaum, himself a well-known curator, also noted that 'the tumultuous 1969 show, subtitled *Works, concepts, processes, situations*, marked an important methodological shift for exhibition practice in that artists were more or less free to contribute any work that they felt would be relevant.'[2]

Among the seventy artists in 'Live in Your Head...', Mario Merz made one of his igloos; Joseph Beuys made a sculpture out of animal fat; Lawrence Weiner removed three square feet of wall space; Michael Heizer opened up a section of pavement; Robert Barry irradiated the roof; Richard Serra exhibited one of his molten lead *Splash* pieces and Richard Long went on a three-day hike in the Swiss countryside. In his 1996 *Artforum* interview with art writer–curator Hans Ulrich Obrist, Szeemann said, 'The *Kunsthalle* became a real laboratory and a new exhibition style was born – one of structured chaos.'[3]

The show, no matter how legendary it soon became, was at first not well received by the public or by many critics. Added to what was at best a mixed initial reception, incessant carping from the provincially minded Kunsthalle Bern board ultimately drove Szeemann to resign from the institution (the board complained that Szeemann's shows promoted too many 'foreigners' and not enough Swiss artists). However, as Birnbaum noted, Szeemann left the Kunsthalle 'only to become something that had never previously existed, assuming a role

'THE KUNSTHALLE BECAME A REAL LABORATORY AND A NEW EXHIBITION STYLE WAS BORN – ONE OF STRUCTURED CHAOS.'
Harald Szeemann

that would affect the most fundamental operations of the art world community for decades to come: the independent curator'.[4]

Szeemann's prolific, endlessly inventive forty-year career set a worthy example for the curators of his time and those that followed.[5] Many of these curators have conceived and produced historically important shows, and in so doing have not simply followed one common, strict approach, even though almost all of these shows are essentially the same format – a large-scale survey exhibition. Biennial curators regularly bring nuanced innovations and different approaches to curatorial practice, and thus offers novel responses to locale, political circumstances and the specific physical characteristics of exhibition venues.

Showcases of the present

Biennials pay little attention to art of the past; these shows are mostly about today and tomorrow. As the well-known curator–critic Rosa Martínez declared in her statement for the 2005 Venice Biennale:

A biennial ... looks beyond the present and into the future ... Biennials are the most advanced arena for this expanded field precisely because they do not function like museums. Museums are temples for the preservation of memory ... Biennials are a context for the exploration and questioning ... of the present.[6]

It's a bit of hyperbole to relegate museums only to the past, as many of them increasingly feature art of the present in their programmes, as we'll discuss shortly. But Martínez is on target in identifying the biennial's chief characteristic as its focus on the present and future. This orientation has special allure for the many contemporary art collectors for whom collecting the 'new' is highly valued.

These large-survey shows stimulate lively discourse in the contemporary art world and build constituencies for new ways of seeing and thinking about art and curatorial practice. As prominent as they have become, however, these shows naturally draw criticism. Some people, for example, have expressed disapproval over the seemingly ubiquitous presence of so-called biennial artists who are favoured by curators. Sometimes cited in this regard are artists associated with the movement that curator–critic Nicolas Bourriaud dubbed Relational Aesthetics. But at least in our view, Liam Gillick, Dominique Gonzalez-Foerster, Pierre Huyghe, Jorge Pardo, Philippe Parreno, Rirkrit Tiravanija and others identified with this compelling, alive movement are important enough to deserve the repeated exposure they've been accorded.

Installation view of Martin Kippenberger's *METRO-Net Transportable Subway Entrance* at Documenta X, 1997

Among even the most important of the many, many mega–survey shows now staged across the planet, Documenta stands out for the curatorial intelligence that traditionally characterizes the show, for the ample time it allows artists to create work for the exhibition, and for its wide-ranging, egalitarian coverage of contemporary art-making practices. Documenta openings are crowded with art world professionals, museum groups and plenty of serious-minded collectors. Anywhere from 100 to 200 artists are typically presented; in recent years many of them have been from non-Western art centres. It's always a challenge to take it all in, even allowing a few days to do so, but it's impossible not to want to try. Collectors depart from Kassel cogitating the meaning of all that they've seen – many with catalogues in hand but all of them, inevitably, with specific stand-out artworks fresh in their minds. At Documenta X in 1997, one particularly memorable work for us – and no doubt for many other collectors – was Martin Kippenberger's METRO-Net Transportable Subway Entrance. At that point Kippenberger had for some years envisioned a global subway system connecting the peoples of the world, but he had only completed a few of the 'entrances' (one of which is pictured) before he died in March 1997 at just 44. Something about Kippenberger's faux metro entrances (realized in Syros Greece; Münster, Germany; and Dawson City, Canada) captures the viewer's imagination: they are absurdist but moreover, as was typical of Kippenberger's work, provocative and poignant.

'[BIENNIALS] ARE CONSTRUCTED
BY CURATORIAL AUTHORS
AS LABYRINTHINE NARRATIVES
WHOSE PLOT EVADES ANY
ATTEMPT AT BEING FOLLOWED,
NEVER MIND CRITIQUED.'

George Baker

Another criticism is that the often-perplexing titles that curators give these shows are occasionally designed or worded more to accommodate a grab bag of choices than to identify a present or developing cultural zeitgeist. As *Artforum* critic and art historian George Baker has written, '[Biennials] are constructed by curatorial authors as labyrinthine narratives whose plot evades any attempt at being followed, never mind critiqued.'[7]

Some also gripe that an air of 'festivalism', as many call it, regularly pervades these events. But one might ask, What kind of 'air' should one expect when the art crowd gathers for highly anticipated exhibitions, with everybody holding forth on what they like and don't like, often enjoying the repartee at fabulous dinners and parties? After all, if it can feel festive to spend several days in the dreary town of Kassel, Germany, where Documenta is held every five years, it must be the art that stimulates the throng. And what other kind of mood could there be but festive when, along with art, one also experiences the glories of Venice, the excitement of New York City, the spirit of the people of Havana and the architectural wonders being built throughout Asia and in the Middle East?

Even more telling is concern about the aura of familiarity that pervades some of these mega-shows, and the reduction in overall quality when curators attempt to avoid artists who have little or no exhibition history. Therein lies a conundrum. It's difficult, or at least uncommon, for biennial curators to find consummate artists who haven't already been discovered and shown by the vast worldwide network of commercial galleries and by forward-looking, quick-footed public exhibition spaces. While this effort is deserving of respect and praise, the reality is that it doesn't always result in the presentation of groundbreaking, critically important art. But when biennial curators do focus their choices on artists who are considered important, or who are at least widely known and exhibited, it leaves well-travelled collectors with a 'been there, seen that' reaction. In fact, when this impression takes hold biennials can appear not altogether very different from commercial art fairs.

Biennials vs. commercial fairs

In recent years there have been efforts in the commercial sector to break down and to some degree obfuscate the differences between commercial fairs and not-for-profit, not-for-sale survey shows. Established in 2008, abc Art Berlin Contemporary was billed as 'a new independent, hybrid exhibition or art fair format, between curated show and gallery event'.[8] Art Basel, under

the able direction of Annette Schönholzer and Marc Spiegler, has augmented its annual fair with various presentations and programmes that have a less commercial orientation. And Independent, conceived and organized by gallerists Elizabeth Dee and Darren Flook, 'Strives to re-examine traditional art fair models and methods'[9] in a commercial fair produced since 2010 at the former Dia Center for the Arts space in Manhattan. But then, when it comes to this overlap between commercial and non-commercial, it must be recalled that from 1942 until 1968 the Venice Biennale maintained an office for selling works exhibited at that bi-annual event.

The line between biennial-type exhibitions and art fairs is muddled by other circumstances, too. As Whitney Museum of American Art curator Chrissie Iles said in a 2011 interview in *The Art Newspaper*:

> *First of all I'd like to say that we are in a crisis in the art world in that the market is threatening to overwhelm everything and is tearing at the delicate fabric of curating. I find it problematic that every gallery emails all of us professionals saying that they congratulate their artists on being in the [Venice] Biennale: this co-opts the exhibition into being a window display for the galleries and reframes it in terms of the market. It fragments the curator's voice and the curatorial aspects of the exhibition and threatens to turn the whole thing into an art fair.*[10]

An artist's perspective

Artist Daniel Buren launched another complaint concerning biennial-type exhibitions in 1972, at a time when the modern biennial movement was in its incipient stages. Years later, in a 2004 essay published in *The Biennial Reader*, Buren updated his views. Buren expressed concern that artists were being *used* by the 'organizers/manipulators' of these exhibitions – 'the reversal of roles ratifying the organizer as author and the artist as interpreter'. Buren proposed an alternative:

> *If the organizer of the exhibition is a full-time artist, it is worth betting that he or she will take enormous risks and that his or her vision will be more explicit, less neutral, more engaged; in a word, it will make more sense than that of an organizer by profession, whether or not he or she proclaims him- or herself an author.*[11]

The influential LA artist–teacher John Baldessari shares Buren's concern. He said:

> *What disturbs me is a growing tendency for artists to be used as art materials, like paint, canvas, etc. I am uneasy about being used as an ingredient for*

Gilbert & George at the Venice Biennale, 2005

No art world event is anticipated quite like the Venice Biennale. Apart from the wonders and charms of Venice, the Biennale regularly offers up great art for tourists and art lovers from around the world. Always high on the agendas of visiting collectors is the possibility of discovering new artists and of seeing recent work by artists they already admire and collect. Gilbert & George fall into the latter category for us. At the 2005 Biennale their Ginkgo Pictures, twenty-five new works, were presented in the British Pavilion – thus that was our first stop at the Biennale. After walking through their splendid show we were determined to acquire one of the pictures, but several museums and big-name collectors had the same objective in mind. Sales of these works were being handled right there on the Giardini di Castello grounds by Gilbert & George's London gallery, White Cube. As it turned out, we were able to acquire the picture we wanted, perhaps because of our devotion to the artists' work over many years. Still, the process was a bit of an ordeal and required patience and persistence in dealing with the gallery – beneficial qualities for any collector hoping to acquire art works in high demand.

an exhibition recipe, i.e., to illustrate a curator's thesis. A logical extreme of this point of view would be for me to be included in an exhibition entitled 'Artists Over 6 Feet 6 Inches', since I am 6' 7". Does this have anything to do with the work I do? It's sandpapering the edges off of art to make it fit a recipe.[12]

As for the key matter of authorship, an issue that obviously troubles both Buren and Baldessari at least, it's fair to say that from Szeemann's early years through today, curators have indeed been in charge. This 'wandering global nomad',[13] as former, long-time curator of MOCA Paul Schimmel has called them, is the author and producer of the show. It's a powerful position, and one that has greatly affected the field of contemporary art collecting. Biennial curators, in a most unreserved way, make judgements about artists and individual bodies of work. In this regard they, along with the art market, have substantially usurped the critic's role in declaring what should be deemed worthy, important and potentially historic.

Acquisition opportunities

Biennials provide shopping and networking opportunities of extraordinary scope and scale. Collectors are generally avid attendees of these shows: they are interested in the overall quality; in the way works of art relate to each other; in how well, if at all, the show's theme is realized; and in the cultural issues that the show addresses. Many collectors also travel to these mega-exhibitions to see and talk about what looks exceptional, what's new to their eyes, how well artists in their collections hold up, and what they like. As Los Angeles collector Lorrin Wong said to us:

Much as critics will point out shortcomings in these shows, they are highly useful and important to a collector like Deane [Lorrin's wife] and me.

He continued:

A number of years ago we saw Robert Gober's work in a Whitney Biennial for the first time. We had never seen anything like it, but it was riveting. We subsequently discovered that this was a good sign, but at the time Gober had an eerie, creepy feel that was uncomfortable. Are there other artists who would have the same impact as Robert Gober? We visit biennials and survey shows searching for them.

We have attended many biennials not only to learn and hopefully expand our vision but also – like many others – with an eye toward possible acquisition opportunities for clients and for our own collection. At the 2006 Whitney Biennial we came upon Anne Collier's

'Biennials provide shopping and networking opportunities of extraordinary scope and scale.'

photographs for the first time. A day later we were on the phone with her Los Angeles dealers, Marc Foxx and Rodney Hill, and since then we've been acquiring her work for clients and ourselves.

In 2001, at the 49th Venice Biennale, we had the unique opportunity to see not only the exhibition and what might be new to our eyes but also works that we and several of our clients already owned. That year's curator, Harald Szeemann, had given British artist Keith Tyson a large room in what was then called the Italian Pavilion (now the International Pavilion). In the middle of the room Tyson had installed his sculpture *The Thinker (After Rodin)*, which we had acquired about a year earlier, surrounded by sixty-eight of his *Studio Wall Drawings*, several of which were from the collections of our clients. More recently, a number of artists we're deeply interested in were being exhibited at the 54th Venice Biennale, curated by Bice Curiger, in 2011. Certain of the works we saw exhibited there, by Ryan Gander, Annette Kelm, Klara Lidén and Frances Stark, led to acquisitions.

The rise of the new museums

'The last several decades have seen a vast increase in the number of new art museums around the world.'

While biennials have come to serve as important venues for collectors, feeding in one way or another an ever-growing appetite for contemporary art, the museum community has not exactly been sitting on its historical haunches. The last several decades have seen a vast increase in the number of new art museums around the world, and many existing institutions have been substantially enlarged. Much of this new brick and mortar encases spaces devoted to the exhibition of contemporary art, and much of what underlies that construction is the belief that, along with art, attention-getting architecture will attract tourists and spur economic growth.

Just as relevant to this discussion as the number of new museums – or perhaps even more so – is the fact that since the turn of the twenty-first century many of these long-established institutions have invigorated their staff by hiring curators with extraordinary vision and a deep understanding of contemporary practices. For example, at New York's MOMA, associate director Kathy Halbreich has energized the contemporary programme, along with Roxana Marcoci, Klaus Biesenbach, Sabine Breitwieser, Doryun Chong and Christian Rattemeyer, among others. At the Whitney Museum of American Art, former *Artforum* editor Scott Rothkopf came on board in 2009, and former gallerist Jay Sanders was added in 2012. These two supplement the Whitney's already highly regarded and knowledgeable curatorial team that includes Donna De Salvo,

Elisabeth Sussman and Chrissie Iles, along with its director, Adam Weinberg, himself a highly regarded former contemporary art curator.

Even The Metropolitan Museum of Art in New York, not traditionally a venue for the 'new' but a paragon of so much else, has jumped in on the act. In 2009–10, in a show organized by Gary Tinterow, then Chairman of Nineteenth-Century, Modern and Contemporary Art, the Met exhibited an installation of beautifully rendered, fanciful architectural drawings and a suite of etchings by the Argentinean-born, London-based artist Pablo Bronstein. Bronstein, born in 1977, is the youngest living artist ever to have been given a one-person exhibition at this venerable institution. Also, among other contemporary initiatives, in 2007 the Met established its first gallery dedicated exclusively to photography created since 1960 (the Joyce and Robert Menschel Hall for Modern Photography). Under the leadership of Malcolm Daniel and Douglas Eklund, several extraordinary contemporary shows have since been staged in this space.

Museums on the West Coast of the United States have also heeded the burgeoning interest in contemporary art. Since becoming director of the Hammer Museum in Los Angeles in 1998, Ann Philbin has turned the museum into 'a hip institution with an international reputation for supporting emerging artists'.[14] At the Los Angeles County Museum of Art (LACMA), which includes the 6,689 square metre (72,000 square foot) Broad Contemporary Art Museum, Michael Govan has provided spirited contemporary programming since becoming its director in 2006. Gary Garrels, brandishing a distinguished résumé of contemporary exhibitions, was brought back to SFMOMA as its Senior Curator of Painting and Sculpture in 2008. And in 2010, MOCA appointed the long-time, adventuresome New York contemporary art gallerist Jeffrey Deitch as its director.

Similar stories are being written by museums in other parts of the US, Europe, the Middle East and Asia. A prime example is China, which has built several contemporary art museums since 2005 and has many more in the planning stages. Shanghai, home to many of the country's art collectors, now boasts several substantial spaces devoted to contemporary Chinese and international art, as does Beijing, home to many of the country's artists. New museums with similar orientations are already open or are on the way in Hong Kong, Chengdu, Guangdong, Shenzhen and other cities across the country. This explosion in the number of museum spaces, many of which are privately funded, in part reflects China's booming economy; it also perhaps signals a change in the government's attitude towards the

The Guggenheim Museum Bilbao

The robust growth in museums in recent years is partly thanks to the opening in 1997 of the Guggenheim Museum Bilbao, in Spain, designed by Frank Gehry. The kind of economic rejuvenation it brought about is now commonly referred to as the 'Bilbao Effect'. Many consider Gehry's masterpiece on the Nervión River 'the greatest building of our time', as architect Philip Johnson called it. But even though Gehry's spectacular building is deserving of the highest praise, the reality is that more than a few of its interior spaces are too large and quite problematic when it comes to showing art to its best advantage.

There are various other flaws in the design of recently built art museums that have seemingly favoured exterior architectural form over their function as platforms for art. With tongue in cheek, this phenomenon can be called the 'Bilbao Defect'. Among the art museums that have attention-getting exteriors but art-defeating interiors, many would include the Kiasma Museum of Contemporary Art in Helsinki, Finland (1998); the Kunsthaus Graz in Graz, Austria (2003); the Amir Building of the Tel Aviv Museum of Art in Tel Aviv, Israel (2003); the New Museum in New York (2007); and MAXXI in Rome, Italy (2009).

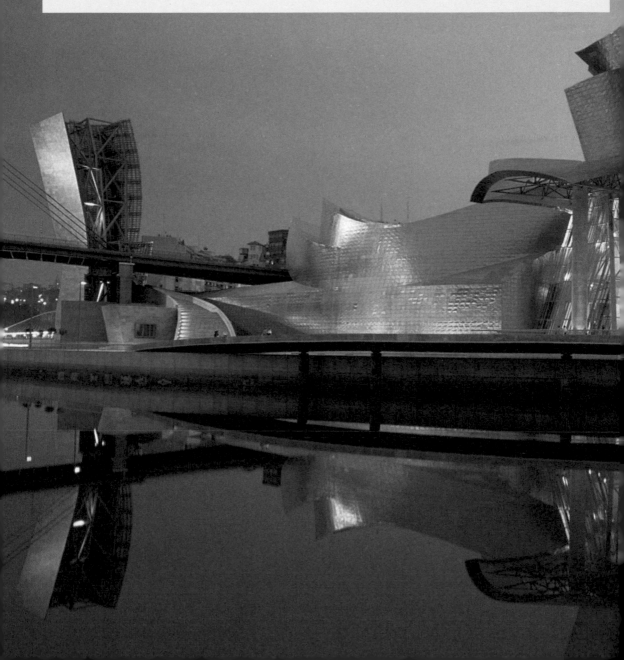

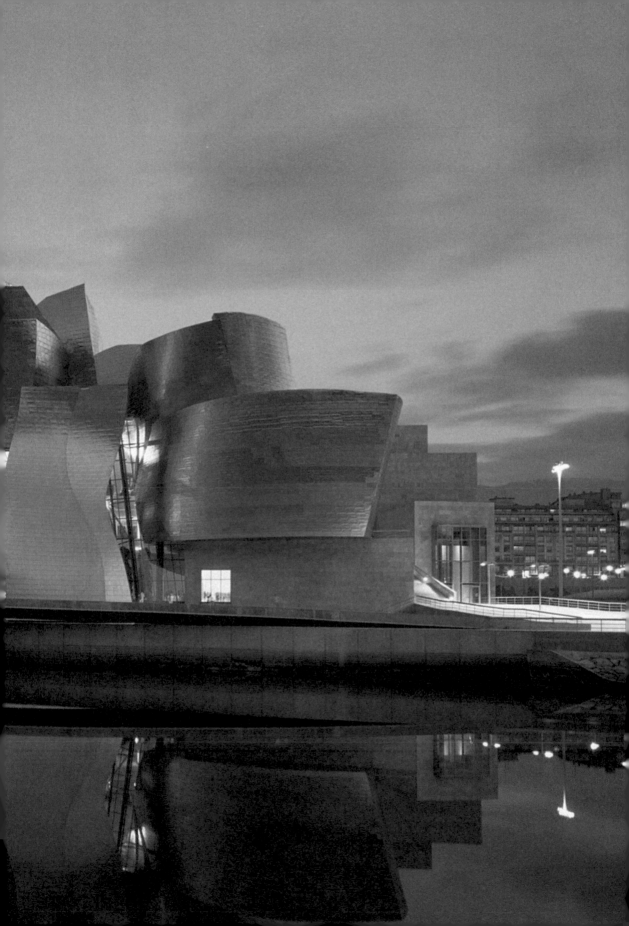

art of today. In the 1990s the dearth of exhibition spaces for contemporary Chinese art resulted in a flourishing culture of unofficial exhibitions in private living spaces.

China has some way to go before it develops the coterie of curatorial talent needed to service the vast number of planned museums and other open-to-the-public exhibition spaces, but that too is moving apace. For the moment talented curators are being imported from the West. One example is Lars Nittve, the highly experienced Swedish museologist and art critic, who was made Executive Director of the West Kowloon Contemporary Art Museum, a major institution slated to open in Hong Kong in 2016. But reliance on Western curatorial talent may soon diminish as more Chinese students become educated in the profession.

Given the government's mostly reluctant stance on freedom of expression, it remains to be seen whether curators and artists will have the freedom to openly express their ideas in China. Certainly the arrest in 2011 of the internationally renowned artist Ai Weiwei, and the suffocating terms of release imposed on this outspoken and internationally respected political critic, does not bode well.

There are differences between museum and biennial exhibitions that are worth noting. While biennials typically show over 100 artists, sometimes considerably more, group exhibitions at museums are usually substantially more limited in number. In this regard, it's often the case that biennials expose the viewer to a wide range of art-making practices, and from parts of the world that are often less familiar. And while museum curators go through a vetting process in which they must persuade chief curators, museum directors and committees of trustees of the merits of a show before it is given the go-ahead, biennial curators have virtual carte blanche as to who and what they exhibit. For this reason the names of biennial curators are sometimes accorded the same prominence as the event itself – or even more. With museum exhibitions, the institution's name ordinarily supersedes that of the curator. These differences are neither good nor bad: each institution offers collectors different experiences, ways of receiving information and collecting perspectives.

Temporary exhibitions and *Kunsthallen*

If we take museum curatorial practice and biennial curatorial practice as two legs supporting the proverbial sitting stool, the essential third leg is the curatorial practice that takes place at *Kunsthallen* and exhibition spaces. A key characteristic of these spaces is curatorial freedom: they don't need to draw enormous crowds to

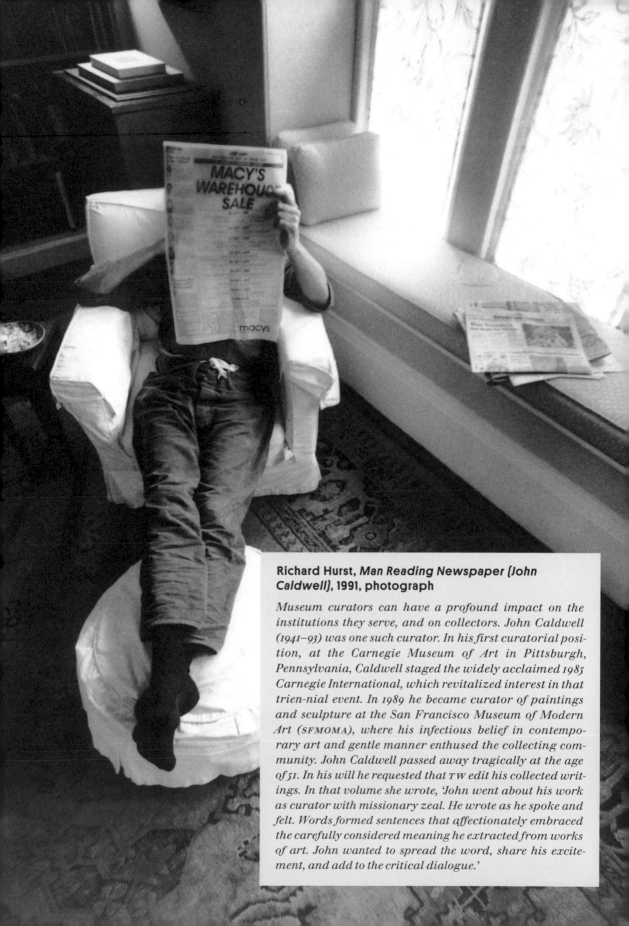

Richard Hurst, *Man Reading Newspaper (John Caldwell)*, 1991, photograph

Museum curators can have a profound impact on the institutions they serve, and on collectors. John Caldwell (1941–93) was one such curator. In his first curatorial position, at the Carnegie Museum of Art in Pittsburgh, Pennsylvania, Caldwell staged the widely acclaimed 1985 Carnegie International, which revitalized interest in that trien-nial event. In 1989 he became curator of paintings and sculpture at the San Francisco Museum of Modern Art (SFMOMA), where his infectious belief in contemporary art and gentle manner enthused the collecting community. John Caldwell passed away tragically at the age of 51. In his will he requested that TW edit his collected writings. In that volume she wrote, 'John went about his work as curator with missionary zeal. He wrote as he spoke and felt. Words formed sentences that affectionately embraced the carefully considered meaning he extracted from works of art. John wanted to spread the word, share his excitement, and add to the critical dialogue.'

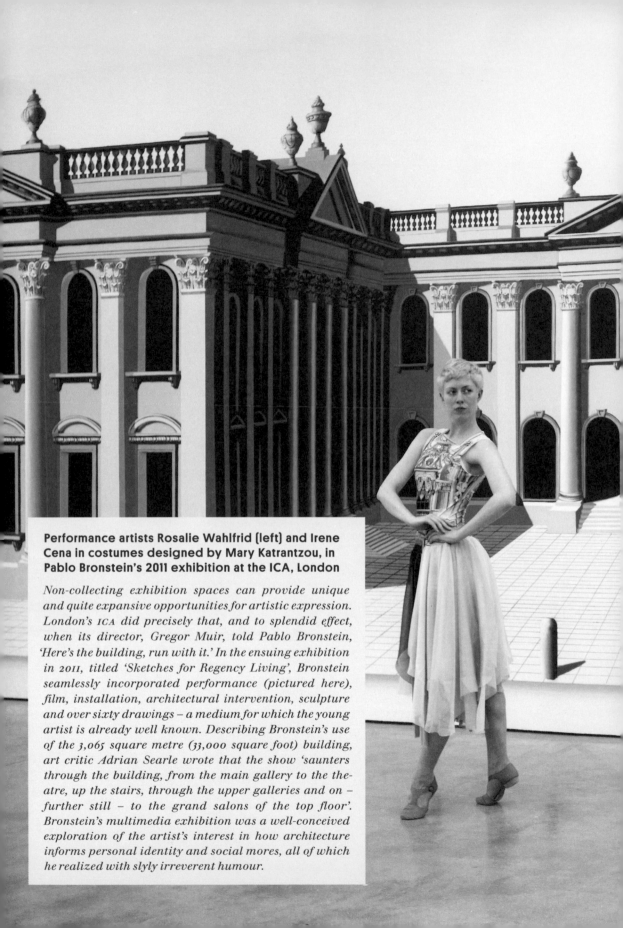

Performance artists Rosalie Wahlfrid (left) and Irene Cena in costumes designed by Mary Katrantzou, in Pablo Bronstein's 2011 exhibition at the ICA, London

Non-collecting exhibition spaces can provide unique and quite expansive opportunities for artistic expression. London's ICA did precisely that, and to splendid effect, when its director, Gregor Muir, told Pablo Bronstein, 'Here's the building, run with it.' In the ensuing exhibition in 2011, titled 'Sketches for Regency Living', Bronstein seamlessly incorporated performance (pictured here), film, installation, architectural intervention, sculpture and over sixty drawings – a medium for which the young artist is already well known. Describing Bronstein's use of the 3,065 square metre (33,000 square foot) building, art critic Adrian Searle wrote that the show 'saunters through the building, from the main gallery to the theatre, up the stairs, through the upper galleries and on – further still – to the grand salons of the top floor'. Bronstein's multimedia exhibition was a well-conceived exploration of the artist's interest in how architecture informs personal identity and social mores, all of which he realized with slyly irreverent humour.

thrive, as do most museums. Their raison d'être, and in fact part of their appeal, is to engage with (and gain financial support from) a segment of the art world that's highly curious and knowledgeable though by definition also limited in number.

As Stefan Kalmár, director of New York's Artists Space, describes it:

> *In some respect one could argue that the* Kunsthalle *is in historical opposition to the Museum, while the Museum conserves the* Kunsthalle *innovates, while the Museum preserves the* Kunsthalle *creates ruptures in what has been preserved – in the presumed. Here not having responsibility to the conserved – is the pre-condition that allows us to continuously rethink the parameters of the contemporary: art, exhibition making as well as the institutional framework itself.*[15]

When compared to museums, *Kunsthallen* mostly have modest gallery spaces and small staffs, the director and chief curator usually being one in the same. They're also far less bureaucratic than large collecting institutions and provide wide-open opportunity and freedom for curators who have something to say. Indeed, *Kunsthallen* curators with a keen understanding of art and a clear, defined vision – those who can identify the most current developments in art-making practices and spot the best young and emerging artistic talents – can, in short order, vitalize a programme and build an enthusiastic constituency.

'Some of the finest and most influential contemporary curators in the world are associated with temporary exhibition spaces.'

It's not surprising that some of the finest and most influential contemporary art curators in the world are associated with temporary exhibition spaces. Among those on the European continent are Beatrix Ruf at the Kunsthalle Zürich, Adam Szymczyk at the Kunsthalle Basel, Peter Pakesch at the Kunsthaus Graz, Rein Wolfs at the Kunsthalle Fridericianum, Dorothea Strauss at Zürich's Haus Konstruktiv, and Dirk Snauwaert and Elena Filipovic at WIELS in Brussels. In London, there are Julia Peyton-Jones and Hans Ulrich Obrist at the Serpentine Gallery, Margot Heller at the South London Gallery and Polly Staple at the Chisenhale Gallery.

Across the Atlantic, in New York standouts include Matthew Higgs at White Columns, Anthony Huberman at The Artist's Institute, Gianni Jetzer from NY's Swiss Institute of Contemporary Art and the previously quoted Stefan Kalmár at Artists Space. Also in the US are several important university curators, among them Sherri Geldin at the Wexner Center for the Arts in Columbus, Ohio, João Ribas at the MIT List Visual Arts Center in Cambridge, Massachussets, Jens Hoffmann at the Wattis Institute of Contemporary Arts in San Francisco, and Mark Murphy and George Lugg at CalArt's REDCAT in

LA. And, though recently retired (in 2012) after almost four decades at the University of Chicago's Renaissance Society, the extraordinary and famously prescient curator Susanne Ghez more than deserves a mention.

The abilities, prestige and art world relationships of well-known curators are held in high regard and at times put to special use by the commercial art world. Prominent, financially able galleries regularly turn to top professional curators to mount major monographic shows in the hope they will draw crowds and make a mark historically. On occasion professional curators are hired as permanent gallery staff, as was John Elderfield, who joined the Gagosian Gallery in 2012 following his retirement as MOMA's chief curator for painting and sculpture. From time to time galleries employ curators and art writers/critics to author catalogue essays and organize summer survey shows, all in an effort to attach intellectual heft to their programmes.

Biennials, museums and *Kunsthallen* between them provide the most prominent and noteworthy public platforms for artists' work in today's art world. Their curators are vital cultural arbiters, having much to say about which artists are ultimately deemed relevant, meaningful and historically important. No less, the exhibitions put on by curators at public venues add indispensible richness to the private collector's experience.

Navigating
the
art market

Long gone are the days when collectors living in important art cities could canvas their local art gallery scene on a single Saturday afternoon, as they could even in New York City until just a few decades ago. There's now so much art on view in any given month in scores of cities around the world that it is beyond what a collector can see, much less digest and fully evaluate.

As we have pointed out in earlier chapters, the commercial art world is no longer local but worldwide. Given the many thousands of artists who produce works of art for exhibition and sale around the globe, the multifarious appeals of hundreds of viable galleries in dozens of countries, and the extraordinary increase in the number of art fairs and auction sales in the West and more recently in the East, the challenges facing art collectors are substantial and daunting. This chapter addresses the nature of the commercial landscape and the challenges that go with it, and proposes certain ways collectors can navigate this vast, complex terrain efficiently and effectively.

The importance of commercial galleries

Commercial galleries, particularly those that sell contemporary art, offer collectors the most important and varied opportunities for buying art. Each gallery's programme – the artists it represents and the shows it puts on – sets it apart and largely establishes its draw. Furthermore, among the thousands of gallery owners around the world can be found a profusion of exceptional, knowledgeable people – a veritable cornucopia of singular and compelling personalities. There's likely never been a classified advertisement for the position of 'primary-market gallery owner', but hypothetically it might read something like this:

> WANTED:
> *Intelligent, highly energetic individual to invest all his or her money and additional capital wrangled from family, friends and maybe a collector or two, to establish art gallery representing young and emerging artists.*
>
> QUALIFICATIONS:
> *In overseeing gallery artists it may be useful to have experience parenting teenage children. 'Thick skin' also an advantage, as collectors may commonly refer to gallery owner as 'just another money-hungry, venal dealer' or worse.*
> *Candidate must be adept at making a 10 per cent discount sound like a really attractive bargain and not well up with tears when an art collector or*

advisor demands a 'courtesy' discount of 25 per cent or more.

The candidate must have the ability to consume copious amounts of liquor (and possibly drugs), party until the wee hours of the morning, and soon thereafter greet gallery or art fair visitors with bonhomie and pithy conversation.

The candidate must also not be disposed to take umbrage at museum curators who never attend their shows, critics who come and go in less than a minute, or collectors who want assurance that any work they buy from gallery owner will immediately increase in financial value.

Finally, all candidates must be able to resist suicidal urges when an artist they've represented for many years, and for whom they've flown around the globe attending various openings and other events, announces by email that she/he has joined another gallery.

We confess to perhaps having embellished a few of these qualifications and job requirements ever so slightly, but improbably enough, they're still more realistic than humorous. Yet even possessing these qualifications and skills won't ordinarily lead to success in the gallery world unless the owner supports and sustains a love of art, delights in exhibiting it and is dedicated to the people who produce it. Gallery owners – especially those who represent living artists – without such attachments to art will have a difficult time meeting the demands of the job and making the sacrifices that go with them. Yes, running a gallery is a business, but for most players in the commercial art world, especially primary-market gallery owners, it's much more than that. Berlin gallerist Johann König told us, 'The reason I opened the gallery was that I wasn't brave enough to become an artist myself, or I simply knew that I wasn't gonna be a good one. I opened a commercial gallery because that's the most direct way to work with artists and support their ideas. I thought, if I can't do it myself I'd help make it happen.'[1]

For the most part art dealers and gallerists (the terms are used interchangeably) recognize a fundamental, historical truth as they go about developing their programmes: the artists make the gallery. The notable, long-time New York dealer Paula Cooper said as much: 'The artists are the gallery; if they are doing well, the gallery does well and we can continue to grow.'[2] Gallery success, both in critical and financial terms, is ultimately determined by the quality of a programme – the initial stable of artists and those added to it as time goes on.

Primary market dealing

Primary market dealing – exhibiting works directly from artists' studios – dates back well over 100 years. Examples of this history abound, but it was the perspicacious art dealer Daniel-Henry (D.H.) Kahnweiler who, more than anyone else, shaped the gallery paradigm of the past century. At just twenty-three years of age Kahnweiler opened his gallery in 1907 on rue Vignon, Paris. He soon became the key dealer for an extraordinary stable of artists, including Georges Braque, Andre Derain, Pablo Picasso and Maurice de Vlaminck, and was on his way to establishing the concept of exclusive or near exclusive primary gallery representation. In the following years he added Juan Gris, Paul Klee, Fernand Léger and André Masson, along with a few others. The legendary dealer told his artists, 'You do your painting, I will look after the rest.'[3] He did just that, taking care of sales, maintaining complete photographic records of his artists' paintings (likely the first dealer to do so), putting on exhibitions, looking after the artists' various problems, financial and otherwise, and promoting their work abroad.

Almost immediately after being founded, the gallery became a meeting place for prominent artists, critics and literary figures, and a pre-eminent buying venue for a passionate, discerning international coterie of collectors. Over a span of just eight years, from 1907 until 1915 (a period of time that Kahnweiler's biographer, Pierre Assouline, called the 'Heroic Years'), Kahnweiler became a cultural entrepreneur, a close friend and travelling companion to the artists in his circle, a literary publisher without peer, and the key spokesperson for the art movement called Cubism.

The twentieth-century gallery scene

By the mid-twentieth century, at which time New York City had surpassed Europe as the world's most important commercial art centre, a number of dealers of distinction had emerged in the 'New World' of art, too. One of the pathfinders was Alfred Stieglitz, who opened his famed Little Galleries of the Photo-Secession, colloquially known as '291', on Fifth Avenue in 1905. As a gallerist, Stieglitz made his mark by championing photography and a handful of outstanding American Modernist painters. In an article for *TIME* magazine, Robert Hughes said about Stieglitz, 'Thus every time he embraced an artist's work and showed it in his miniscule gallery, it was to some extent a missionary act, a declaration of faith, not a mere display of the latest thing in stock.'[4]

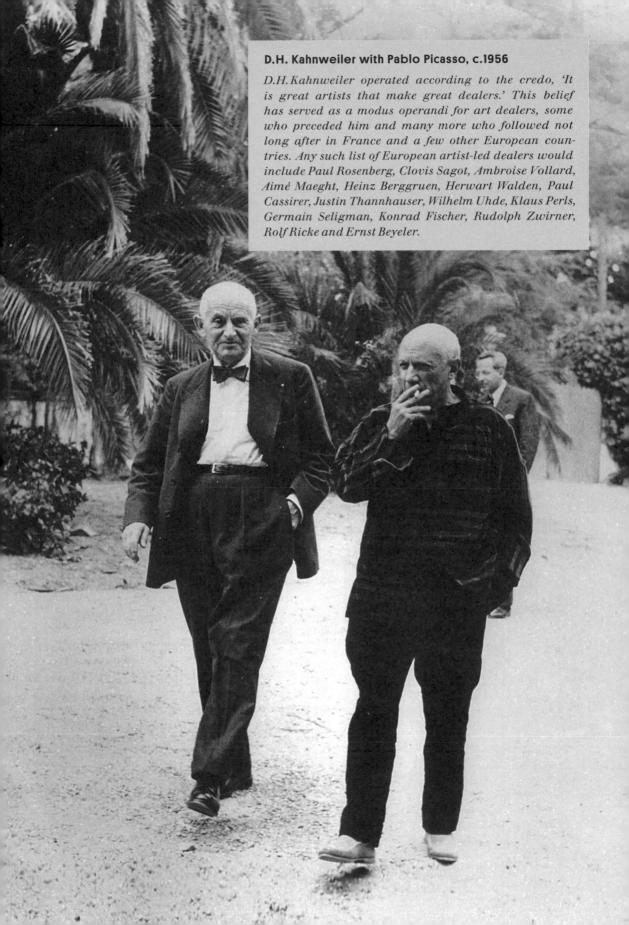

D.H. Kahnweiler with Pablo Picasso, c.1956

D.H. Kahnweiler operated according to the credo, 'It is great artists that make great dealers.' This belief has served as a modus operandi for art dealers, some who preceded him and many more who followed not long after in France and a few other European countries. Any such list of European artist-led dealers would include Paul Rosenberg, Clovis Sagot, Ambroise Vollard, Aimé Maeght, Heinz Berggruen, Herwart Walden, Paul Cassirer, Justin Thannhauser, Wilhelm Uhde, Klaus Perls, Germain Seligman, Konrad Fischer, Rudolph Zwirner, Rolf Ricke and Ernst Beyeler.

By almost all accounts that same 'declaration of faith' was sustained by many other influential twentieth-century dealers in the United States, including Irving Blum, Leo Castelli, Virginia Dwan, Martha Jackson, Sidney Janis, Sam Kootz, Julien Levy, Betty Parsons, Ileana Sonnabend and Curt Valentin.[5] While history tells us that Castelli had the greatest impact of all, Virginia Dwan's support of the Conceptual, Minimalist and Land Art movements that are now identified with the Dia Art Foundation may have been as extraordinary, and perhaps more so because these artists didn't enjoy a ready market for their work. (It can be argued that Dwan's considerable inherited wealth mitigates this assessment, as it enabled her to support these artists absent ordinary financial concerns.)

It is beyond question, however, that Castelli, who opened his first US gallery in 1957 on New York's Upper East Side, assembled a programme that made art history and invigorated collecting in the US and Europe. At his side in those early years were his one-time wife and lifelong collaborator, Ileana Sonnabend, and Ivan Karp, both of whom later opened galleries of their own.

Embracing the new

Ileana Sonnabend thought of herself as an 'amateur', by which she meant a true art lover, and virtually everyone who knew her recognized the devotion and intelligence with which she approached art. One evening in 1998 she was at our home for a small dinner party with her gallery director and adopted son, Antonio Homen, and mutual close friends – Arnold Lehman, the director of the Brooklyn Museum, and his wife, Pamela. At one point the conversation turned to a group of new galleries that had sprung up in Brooklyn, and Arnold urged us to spend an afternoon together checking them out. No one expressed more enthusiasm for the idea than the art-loving dealer Ileana Sonnabend; she was ready to go despite the sad fact that she could barely walk and sometimes needed a wheelchair to get around (not to mention that in those days for a resident of Manhattan to go to Brooklyn was tantamount to visiting the Outer Hebrides).

Describing his, and by inference Sonnabend's formative endeavours, Castelli said:

> *There are certain moments in the evolution of art when it seems that it is not enough to create in the spirit of the previous generation. There is a feeling that new ideas must appear, and perhaps great contradictions. A dealer must be able to pinpoint these moments when they occur, and to identify which artists embody these new ideas. When I opened my gallery I felt I was at one of those*

moments, and when I came upon them, I felt that
Jasper Johns, Bob Rauschenberg, and Cy Twombly,
each in his own way represented the quantum leap
to something new.[6]

Of course, gallerists cannot expect that Castelli's 'something new' will be an actual movement, a historically important development such as Pop Art or Minimalism. Nevertheless they're always searching – if not for something radical, then at least for shades of new, something original, something that nudges art-making practices forward. Noted art dealer Marian Goodman said, 'I am interested in people who move art history along, who make the advances. There is something profoundly moving about man's urge and capacity to create.'[7] Of course, there are also dealers who are mostly attentive to what will sell – those who above all are profit-oriented. But whatever their underlying motives may be, commercial dealers need to assemble a programme they believe in and then go about persuading others of its merits.

Collectors also hunt for artists they respond to and believe in. It may be stating the obvious, but neither dedicated gallerists nor passionate collectors seek out artists whom they think have little or nothing to say, who possess no original creative impulses or who lack the ability to make interesting and/or beautiful and meaningful objects. Collectors may and often do wind up with artists of this ilk, but that's not what they set out to do or, as a rule, believe they've done. The reality is that in any given generation not many artists command critical and curatorial attention over the long term, and/or sustain market support. Fewer still make it into the art history books in any significant way, if at all.

Leo Castelli viewing a multimedia work by the artist Keith Sonnier at the Castelli Gallery, 1969

An impeccable gentleman, gallerist Leo Castelli loved art and warmed to those who shared his passion. In the early 1980s, when the Castelli Gallery was located in New York's SoHo district, TW approached Castelli about purchasing a neon Tatlin *sculpture by Dan Flavin. The problem for TW was not the fairness of the approximately $18,000 price, but finding a way to pay the sum. As he often did when a client coveted an object and needed time to pay, Castelli extended monthly payment terms, and many years later the Flavin was finally hers. As said by art advisor Rob Teeters, 'Trustworthy relationships in the art world are indispensable. When a dealer knows a collector on a personal level and knows there isn't anything in their mind but to own a coveted work, they'll always try to make it available.'* ↦

'The challenge for collectors is to cut through all the hype and hyperbole in order to determine which galleries are worth their effort.'

When it comes to seller–buyer transactions, if the words of gallerists and dealers were taken as gospel, no collector has ever bought a work of art that wasn't 'great' or 'a wonderful example' or 'a good buy' or 'a key piece by a very important artist' or 'an extremely opportune acquisition, because the [insert the name of a museum] is also considering it but, you know, that takes a long time, so if you write a cheque now it's yours'. The challenge for collectors is to cut through all the hype and hyperbole in order to determine which galleries are worth their effort – where best to spend time and money.

Collecting established artists

The art that is exhibited in galleries and held in back-room inventory is affected, over time, by what art critics and historians say and what curators show; professional evaluations inevitably affect what appeals to collectors. Collectors who buy the work of established artists commonly know which artists they're interested in before they head to a particular gallery, perhaps having been persuaded by history books, permanent museum collections and prominent private collections, in combination with their own taste. Thus in buying the work of established artists a collector is tasked with locating the best, most desirable works of art more so than with discovering new artists. Identifying galleries that carry the work of long-famous, historically recognized artists, including those that represent artists' estates, is a straightforward matter of going online to check out gallery websites, perusing art magazine ads and simply asking around the art world.

Similarly, for collectors intent on acquiring art by popular contemporary artists the challenges are somewhat narrowed because the market has more or less already signalled whom these artists are. There's a wealth of information available in print and online to help collectors identify these artists and where their work is sold.

In the chatty art world what's heard on the street can also help fill in the blanks. Most dealers, for example, aren't the least bit shy about telling collectors that an artist they represent has mounting support among other collectors ('big collectors'); being put on a waiting list for that artist's work is usually a reliable sign that the dealer's assertion has some veracity. In a buoyant market, of course, there are an enormous number of artists in high demand, and few collectors can afford or manage to buy all of them. But if a collector's list of desired artists is limited to those who have achieved or are in the throes of achieving market ascendancy then the task of locating relevant galleries is relatively straightforward.

Collecting emerging artists

A far more complicated task for collectors striving to discover young and emerging artists is identifying the most pertinent, vital galleries that represent them. This segment of the art market is enormous. Hundreds upon hundreds of galleries all over the globe purvey the work of young and emerging artists, and almost all of them make comparably enthusiastic claims about those that they represent.

Looking back at the great galleries in Europe and the United States in the first half of the twentieth century, it's easy to forget that at one time collectors approached their programmes tentatively, not sure of the claim these galleries or their artists would make historically. Typically, the more daring, dedicated, curious collectors were the early patrons; then others followed. Castelli once said, 'The dedicated collector supports the gallery and the artists with unparalleled commitment in scale and daring. He makes choices way before any general consensus of approval. In this respect, he is as much a champion of uncharted territory as a dealer. None of us could survive without him.'[8] It's pretty much the same today with galleries of recent vintage. Becoming an early patron of a young gallery has significant rewards, including access to highly desirable work in the short term – especially when it's available at reasonable price points – and to the best material down the road, when there is more competition for the work.

This dynamic raises the broader matter of collector–gallery relationships, the fundamental importance of which we cannot overstate. Galleries want to be sure they are selling work to the best collectors (especially when it's in high demand) – those who love art for art's sake, don't sell soon after they buy, are involved with museums, regularly show their collections to other collectors, and are otherwise prominent in the art world. When a collector finds a gallery with a programme of interest, it's incumbent on the collector to establish his or her collecting bona fides and to develop a good working relationship with the gallery owner. Gallerists, too, are interested in establishing these kinds of relationships and will go to great ends to nurture them and in the process gain the confidence and patronage of the collector.

Identifying key galleries

Fundamental to the search for galleries that may be a fount of interesting emerging art is the recognition that even this sizable part of the commercial gallery world is not a monolith: not all galleries are equal or even vaguely similar in what they offer to any given collector.

Emily Sundblad viewing Josephine Pryde's 2004 exhibition, 'Brute', at her and John Kelsey's Reena Spaulings Fine Art, at the gallery's first location on Grand Street in Lower Manhattan

Since the 2000s certain art galleries have been eschewing a sales-above-all attitude in favour of artist-centric platforms for critical engagement; galleries where people, not money, charge the atmosphere. In the 1980s and 1990s Colin de Land was the gallerist who, perhaps more than anyone else, promulgated this non-commercial approach; his American Fine Arts was more a dynamic social space for conversation and inter-action than a hard-nosed commercial enterprise. Since opening in 2004, Reena Spaulings Fine Art has followed in this spirit. Its first space was an inauspicious storefront on Manhattan's Lower East Side; it currently occupies a larger space in a Chinatown walk-up. It is run by founders Emily Sundblad (when she's not making or per-forming her art) and John Kelsey (when he's not engaged in writing projects or making art) and by gallery director Carissa Rodriguez (when she, too, is not making art). Gallery hours can be erratic, and a blasé atmosphere pervades. Yet Reena's (as many call it) attracts an avid audi-ence, and has one of New York's most innovative, critically important programmes.

Rather, it's a universe that can be reduced to a constellation or cluster of galleries that aligns to each collector's interests and proclivities. Identifying which galleries should be part of that 'go-to' cluster where the collector can spend time most productively requires lots of looking and learning – seeing shows, checking out artists, and sizing up galleries.

Art collector Budi Tek said, 'When I was a newcomer in art collecting, dealers came to offer mediocre works. They made me buy a heap of rubbish. But then I learned, read and made friends with art critics and curators as well as artists. So as to keep from making erroneous buys.'[9] For those just starting out, as Tek did in about 2004, the task is admittedly daunting. One way to tackle it, or at least get a head start on it, is to visit exhibitions that have received a review in a daily newspaper that assiduously covers a city's art scene, and to follow this approach over an extended period of time. Not every city has such dailies, but the *New York Times*, the *Frankfurter Allgemeine Zeitung* (from Frankfurt, Germany), the *Neue Zürcher Zeitung* (from Zürich, Switzerland) and the *Los Angeles Times* are among those worth following. In many large cities there are also weekly publications, such as *Zitty* and *tip* in Berlin and *Time Out* in London and New York, that have a record of identifying important shows and thus galleries worth visiting. Then too, there is the *Contemporary Art Daily*, an online daily journal of international exhibitions that is becoming a reliable source for identifying interesting shows around the world.

Collectors can augment this winnowing process by listening to what artists, curators, advisors and like-minded collectors have to say about individual gallery programmes: the kind of art shown and the reputations of the galleries as well as the people who run them. Though it's true that buying works of art is better done with one's eyes than with one's ears, locating the most appropriate selling venues, at least narrowing the list of possibilities, can be assisted by listening to what others have to say and by staying abreast of developments through art publications. Nobody's advice is foolproof, and galleries are always evolving, with new galleries appearing and some disappearing. But this general approach can help increase the likelihood of coming across galleries with accomplished, compelling artists.

Still other observable indicators can help guide a collector to specific galleries. It's often the case that when an artist that a collector admires is added to the roster of an unfamiliar gallery, the collector is likely to find other artists of interest in that gallery's programme. In our own case, a number of primary-market galleries, including Miguel Abreu, Daniel Buchholz,

Cabinet, Campoli Presti, Gavin Brown, Gisela Capitain, Chantal Crousel, Andrew Kreps, Neu, Reena Spaulings and Simon Lee, each represent a handful or more of young and emerging artists that we actively collect. Because a few of these galleries and another dozen or so of significant interest to us are located in our home city of New York, it's easy for us to attend their shows regularly. As for galleries outside of New York, including a few in Los Angeles and another dozen or so in Europe, we regularly stay in touch, sometimes travel to see their exhibitions, and otherwise make it a point to visit them at art fairs and other art world events.

We are by no means suggesting that when a gallery represents several artists of interest, it's an unerring signal that the entire programme is exemplary, or that the collector will respond to all of the artists in it – that's never the case. Nor are we suggesting that when an artist does not have multiple gallery representation it signals some shortcoming in the artist's work. Many outstanding artists simply do not produce enough work to supply more than one or two galleries; others prefer not to deal with a slew of galleries; and still others need time for their work to be fathomed, even by sharp-eyed gallerists. But as a general rule, artists can lead collectors to galleries that will be of interest just as galleries can lead collectors to artists of interest.

Right show, wrong gallery

This raises the important matter of context, or the credibility and significance that a gallery imparts to an artist by virtue of its overall programme. When a gallery with a stable of historically important artists adds a new artist to its programme the glow from the established, widely respected artists tends to reflect on the new artist. It's the art world's equivalent to the real-estate mantra 'location, location, location'. On the other hand, when a gallery that does not have much respect or critical standing in the art world adds a new artist that artist's career may suffer as a result, whether it's merited or not – an effect summed up by the depreciative phrase, 'Right show, wrong gallery'. This tug towards or away from an artists' work depending on where it is shown can be difficult for a collector to resist, but it's vital to do so, for when collectors become overly dependent on just a few galleries they can get stuck with a range of possibilities that is too limited.

Many years ago, in a 'previous life', as they say, one of us (EW) purchased a house in California that had an aviary in the backyard. With excited kids in tow we went to a livestock show where we were told we could buy exotic birds. However, on the day of our visit there were

The Wrong Gallery, Chelsea, New York; Adam McEwan's _Untitled (Closed)_, 2003

In 2002, Maurizio Cattelan, Ali Subotnick and Massimiliano Gioni – the former an artist of considerable fame and the latter two well-known curators – opened the Wrong Gallery in New York City. The trio staged more than forty shows in an exhibition space on Twentieth Street that was really just a door, a mere 3 metres (10 feet) tall and 30 centimetres (1 foot) deep. They showed mostly established artists, all the while tweaking the very notion that a good show (or artist) can somehow be denigrated by its selling venue. In an essay in the Maurizio Cattelan monograph The Taste of Others (published by Christophe Boutin and Melanie Scarciglia's Three Star Books), Gioni wrote, 'The gallery's name was also an example of appropriation, or creative borrowing: it was gallerist Jeffrey Deitch – now director of MOCA – who told Catellan, Gioni and Subotnick that he'd always been amused by that typical New York expression so often used to dismiss an exhibition: "It's a great show, but it's in the wrong gallery."'

no cockatoos, canaries or even finches to be had – only pigeons. Resigned to putting something with feathers in the aviary, we went ahead and selected four of the most 'beautiful' pigeons available. But alas, in the bright light of the next morning our collection was just a bunch of pigeons, and they didn't look (or sound) particularly special. The moral of the story is: to avoid a collection of pigeons, if you will, in the pursuit of art, it's essential to be expansive in outlook, familiar with the landscape of selling venues, informed about what's available – and patient enough to wait for the best, which isn't always easy for passionate collectors.

The opportunity to see other artists' work

When galleries of interest are located in the city near where an art collector lives, it's easy to get to know their rosters of artists and discover new galleries as a regular part of the collecting activity. One time, after we had viewed a show at the Gagosian Gallery on Twenty-Fourth Street in New York in the early 2000s, an assistant there fortuitously suggested that we spend time with nearby gallerist Andrew Kreps, and specifically that we look into the work of one of his artists, Cheyney Thompson. We did just that and were immediately compelled by Thompson's conceptually rigorous and beautiful work; we've been collecting it and recommending it to our clients ever since. After that first visit to Kreps's gallery we eventually began enthusiastically collecting several other of the artists Kreps represents as well.

When collectors are in cities they rarely or only occasionally visit, it's worth taking time not just to see what's on view at that moment but also to become familiar with complete programmes. As with other collectors, we've had many invaluable experiences and gained considerable knowledge through following this approach. Some years ago, for example, after viewing a compelling show of Gareth James's work at Galerie Christian Nagel in Cologne, we asked if there was any artist in the gallery's programme that we had overlooked in our visits over the years. The estimable Nagel and his partner, Saskia Draxler, promptly put a Heimo Zobernig catalogue in front of us. Though Zobernig has had numerous museum and gallery shows across Europe, he was not then well known in the United States. After looking at images of Zobernig's installations, paintings and sculptures, we were enthralled. Ever since that moment we have been following his shows, collecting his work and enthusiastically recommending it to clients. We also now have about forty of his catalogues and artist's books in our library.

International art fairs

Over the last decade, art fairs have experienced phenom-
enal expansion; there's one taking place somewhere in
the world almost every week of the year. According to
the Saatchi Gallery's website, there were over 300 of
these fairs at the time of writing in 2012, the vast majority
of which show contemporary art. In looking over several
comprehensive lists of art fairs, we came across almost
every conceivable name from A to Z – from 'Affordable'
to 'Zoom' – with major fairs each year in Basel, London,
Maastricht, Miami, New York and Paris. Art fairs attract
large crowds by enabling attendees to see thousands of
works of art under one roof or tent top, with the added
attraction of satellite fairs that further increase viewing
opportunities – art shopping made easy. As the crowds
converge on the opening day of a big fair, every manner
of collector can be seen, from those known for their
seriousness and passion to those who arrive with an
agenda full of A-list parties and a cavalier 'I'll have one
of those' buying mentality.

Common practice in recent years is that prior to
the opening of a fair, most participating galleries send
emails to their clients with images of the works they'll
be showing. A few well-heeled galleries publish elabo-
rate catalogues depicting works that will be on view,
and some create online spaces that allow buyers a vir-
tual tour of their booths. Our practice, and that of other
advisors and collectors, is to proactively seek out as
much information as possible before a fair opens. When
called for we put works on 'reserve' or 'hold', which
means the dealer agrees not to sell the works until our
clients and we can see them first-hand at the fair. When
the market is hot, as it mostly has been over the last few
decades, gallerists don't ordinarily permit reserves to
last very long once the fair opens. When demand is high
they can sell much of what they've put up even before
the second wave of collectors has moved through the
aisles. In fact, it's not atypical for gallery booths to look
very different on the second or third day of the fair,
when sold works have been removed and replaced with
new works that are still available.

Galleries, especially those from out-of-the-way
cities, depend on fairs to meet new clients, so they're
only too happy to encourage visits. As it happens, many
of these galleries have interesting programmes and
bring excellent material to art fairs, and their founders
are a pleasure to talk with and learn from – as is always
the case with Massimo Minini from Brescia, Toby
Webster from Glasgow, Peter Nagy from Delhi,
Micheline Szwajcer from Antwerp, Umberto Raucci and
Carlo Santamaria from Naples, Annet Gelink from

*'Prior to the opening of
a fair, most participating
galleries send emails to their
clients with images of the
works they'll be showing.'*

Top, l to r: Artist Matias Faldbakken, TW and Eivind Furnesvik, Standard of Oslo gallerist;
bottom, l to r: Matias Faldbakken, EW, TW and Eivind Furnesvik, at Art Basel, 2010

Oddly enough, given how tumultuous they are, international art fairs can provide plenty of opportunities for learning. As a fair simmers down over the course of a week and the number of serious buyers diminishes, there's time for collectors to visit with galleries from far and near, to learn about programmes, artists that are new to the galleries, and what's going on with artists already of interest, as well as to build all-impor-tant relationships with gallerists and dealers from cities off a collector's beaten track. For example, at Art Basel in 2010 we got together with Oslo gallerist Eivind Furnesvik and one of his artists, Matias Faldbakken, to discuss final arrangements for a work by Faldbakken to be installed at Norah and Norman Stone's 'art cave' in Napa Valley, California for their 2011 exhibition 'Politics is Personal'.

Amsterdam, and T293's Paola Guadagnino and Marco Altanilla, also from Naples, to name a few. David Maupin, co-founder with Rachel Lehmann of the Lehmann Maupin Gallery, summed it up: 'The fairs give buyers a comfort zone to meet people from the gallery.'[10]

The prevalence of art fairs has, however, resulted in certain problematic outcomes for collectors. First of all, art fairs have become pre-eminent buying venues for scores of collectors such that many attend these events increasingly to the exclusion of visiting monographic gallery exhibitions – which invariably offer better learning and viewing opportunities. Art fairs frequently require hurried acquisition decisions, and they lack the important social and aesthetic context of the gallery space, both of which are circumstances that can lead to mistakes or misreading on the part of collectors unfamiliar with an artist's practice. As well, art fairs mostly call for smaller-scale works that fit exhibition booths and are less expensive to ship, which frequently results in one-off works that look 'turned out', if not completely inconsequential to knowledgeable collectors.

Added to this, artists are now constantly driven by their galleries to make objects specifically for fairs, which puts pressure on them to produce works when they may not be ready. As art consultant Mark Fletcher has said, though speaking of the art market in general, 'I think it would be very difficult for a young artist to say "no" when the market is saying "yes".'[11]

The secondary market

In the art world, as we've said, the words 'gallerist' and 'dealer' are often used interchangeably. In discussing the primary market we've tended towards using the word gallerist, as Leo Castelli did to describe himself, because it connotes collaboration with artists in the development of their careers more so than it does simply selling inventory. But make no mistake, the nomenclature is less important than the knowledge, eye and even the personality of the seller.

In discussing the secondary market – essentially works of art that have been sold before – the word 'dealer' seems more suitable. Yet it's problematic to make absolute distinctions between primary-market gallerists and secondary-market dealers because the former often have secondary-market material for sale while the latter often include young and emerging artists in their programmes in order to stay vital and maintain a constant supply of works to sell. Dealers with established programmes and large inventories of secondary-market material have followed this approach for many decades.

'I THINK IT WOULD BE VERY DIFFICULT FOR A YOUNG ARTIST TO SAY "NO" WHEN THE MARKET IS SAYING "YES".'

Mark Fletcher

The fact is that comparatively few galleries deal exclusively with secondary-market material, but the majority of those that do are long established, many in Europe. One American gallery that follows this paradigm, Skarstedt Gallery in New York, has taken an assured, highly defined position offering the work of mid-career artists (including Richard Prince, Sherrie Levine, Mike Kelley, Thomas Schütte, Cindy Sherman, Rosemarie Trockel and Christopher Wool). The founder, Per Skarstedt, works in concert with the artists' primary-market galleries, and hand in glove with collectors who believe in his eye and market acumen.

The better secondary-market dealers develop special expertise in specific artists, alive or deceased. Arguably, in no field is this more apparent than photography, where dealers such as Stephen Daiter (Chicago), Jeffrey Fraenkel and partner Frish Brandt (San Francisco), Howard Greenberg (New York), Michael Hoppen (London), Edwynn Houk (New York and Zürich), Rudolf and Annette Kicken (Berlin), Hans Kraus (New York), and Peter MacGill (New York) offer up extraordinary knowledge and connoisseurship, along with astonishing inventory and elegant exhibition spaces.

From the collector's standpoint buying on the secondary market, including buying at auction, is mainly focused on specific works of art – purchases that ordinarily come after a collector has developed an interest in a particular artist. Thus it's usually the 'made' rather than the 'maker' that is sought on the secondary market. Works of unique appeal, and works rare and fresh to the market, are regularly seen by collectors in the back rooms of the better secondary-market galleries; examining this kind of material with knowledgeable dealers can be enlightening – and often thrilling.

For some collectors a thrill of a different sort comes from secondary-market purchases made at auction, some of which seem to be more about money and bragging rights than about a work of art's quality or critical importance. That aside, auction sales are an enormous part of the secondary fine art market, with much of the high-end material coming on the block at attention-getting evening sales at Sotheby's and Christie's, the auction world's behemoths.

Since about the mid-1980s each of these auction houses has increasingly turned to art of recent vintage to stock their sales. And another, Phillips de Pury & Company, has virtually made contemporary art the sum and substance of its business. This significant strategic turn reflects the inevitable depletion of available material made by world-famous, high-priced artists of earlier generations, even from as recently as the mid-twentieth century.

In a conversation with Christopher Burge, Christie's top auctioneer until he retired in 2012, Burge likened the situation to oil resources:

We were using it up very fast, because so much began to pour into museums. Every museum had a new wing, every museum wanted to secure that local collection; that promised collection from someone who'd been born in the city, or whatever it was. Which now means there really are virtually no Impressionist collections left in this country with any significance, with a few obvious exceptions in New York. You know, the great accumulators like Paul Mellon and so on, that's all gone, most of it to museums. We had a couple of sales. We were in the heyday when Norton Simon was forming his museum. So, by default, contemporary art became an auction field.[12]

The way in which Burge describes the auction world's waning supply of established, time-tested material calls to mind a work of art, *Autoxylopyrocycloboros* (2006), made by the ecologically minded Conceptual artist Simon Starling. In his seven-minute projection piece a 6.71 metre (22 foot) long steamboat is seen in the middle of a large lake, with Starling and a mate (the boat's 'boiler man') on board. To feed the boat's wood-burning engine the protagonists break apart the boat's hull until there's almost nothing left, and finally – plunk – into the lake they go.

Emerging artists at auction

Over the last decade or so, as Sotheby's, Christie's, Phillips and other auction houses have increasingly exploited younger and younger contemporary artists to fill their sales, they've been roundly criticized for the damaging effects that this approach can have on formative careers. It's a legitimate concern, without question. Dealers and gallerists are among those who bitterly complain about this practice. In fact, several have sought to squelch it by requiring collectors to sign legal agreements promising that if the collector ever resells works of art acquired from them on the primary market he or she will only do so through the gallery. While it appears that such agreements have scant legal standing, galleries arguably do deserve a first crack at secondary-market sales of this sort, as almost all galleries have a far greater interest in their artist's careers than do the auction houses. But this is not to say that dealers don't also have their own financial interests at stake, or that they are entirely realistic about the vicissitudes of an open, unregulated art market.

Roland Augustine, a former president of the Art Dealers Association of America, has been vociferously outspoken about keeping artists away from the auction houses and anonymous buyers that 'flip' works for financial gain. He takes the position that primary-market dealers, such as his gallery, Luhring Augustine, are scrupulous about placing their artists with collectors who aren't prone to resell at auction. Or so the argument goes. Between 1997 and 2004 the Luhring Augustine gallery sold a number of paintings by Christopher Wool, a highly sought-after artist, to one of its carefully chosen collectors, Anthony Pilaro. A few years later Pilaro put four of these works on the auction block at a Christie's London sale. The move netted Pilaro some $4 million and demonstrated once again that the art market is not one that can be easily controlled.

'Auctions appeal to buyers; many favour the democratic nature of an auction saleroom where they don't have to worry about their relationships or art world stature.'

As long as auction houses are around they're likely to continue to attract coveted material – works that will cause the collecting community to practically pant with desire – because many sellers believe they will get their best price by selling at auction. Auctions appeal to buyers, as well; many favour the democratic nature of an auction saleroom where they don't have to worry about their relationships or art world stature, as they do in the gallery world, in order to buy what they like. In auction salerooms money talks, and it's virtually the only language one needs to speak.

All that aside, the sale of young and emerging artists by the auction houses, their implied endorsement and all the build-up that goes with it, should give buyers pause. History makes clear that very few of these artists, no matter how hot they may be when they go on the block, will likely be names on everybody in the art world's tongue in years ahead.

Knowing when to stop

Furthermore, buying at auction can be a dicey practice, if for no other reason than that buyers sometimes lose their self-control when the bidding gets competitive. As the psychoanalyst Werner Muensterberger put it, 'decision-making can become quite independent of a bidder's better judgment'.[15] Auctioneer Christopher Burge also spoke of this problem: 'The auction house is only one of several places, and the main thing is never, never buy in the first sales [by which Burge means the first auctions attended by a collector to actually buy art]. And if you decide you want to buy, leave the bid, do not do the bidding yourself because you always overbid, and then you get discouraged right at the beginning'.[14]

Thus when buying at auction it's wise not to exceed a predetermined top price, which is our practice when

bidding for clients. That being said, there are times when an experienced buyer knows to go that extra tick or two to secure an outstanding work of art. As an example, in May 1992 one of us (TW) was bidding at Sotheby's for a work by Eva Hesse, *An Ear in a Pond* (1965), on behalf of long-time clients, Norah and Norman Stone. The Stones, who were on the phone from San Francisco, loved the work, but when it hit their top price they told TW not to bid any further. Sensing the tempo in the auction room and that one more bid might earn the prize, TW put the phone in her lap and made the next bid – the final one, as it turned out: at a cost of $93,500 the work took its place in the Stones' collection. After the fact, thankfully, there were no regrets. The Stones, who mostly hold on to the work they buy or donate it to museums, eventually sold *An Ear in a Pond* at auction in 2006 to raise funds to buy more recent art. It was hammered down at $2,000,000.

When buying from private dealers in the secondary market, where there tends to be more flexibility in asking prices, we always negotiate aggressively to achieve the best price possible for our client. However, when buying on the primary market, especially when buying the work of emerging artists, it's best not to press for discounts larger than the gallery offers. Prices for works by these artists don't ordinarily have much profit margin to begin with, so pushing gallerists beyond a ten or fifteen per cent discount is most often not appropriate and can jeopardize the collector's position with the gallery and may preclude access to the most desirable works of art. In order to collect effectively, it's vital that collectors know where to spend their time and effort – where to find the very best acquisition opportunities and those selling agents they are confident in and comfortable with. This takes some considerable work, but once accomplished the collector is better prepared to go about building a collection.

Building a
great collection

Many if not most serious collectors, no matter what their instigating desires and ambitions are, eventually seek to assemble a collection that sets them apart. There are a number of approaches or methodologies that can help the collector achieve that goal. We offer these approaches not as how-to absolutes but rather as ways to advance a collection and perhaps even to enthuse new and experienced collectors alike.

Focusing a collection

One such approach to collecting art is to focus on a particular art-making discipline, such as photography, sculpture, film and video, or works on paper. These disciplines can be further delineated or narrowed; for instance, to colour photography, architectural drawings or artists' books. By focusing in this way the best collectors have not only built distinguished collections but have also shed light on their subject of enquiry and even become respected, sought-out experts in their field.

In the expansive area of photography, one such erudite collector is the Amsterdam-based Manfred Heiting, who began building his world-class collection in the mid-1970s. By 1998 Heiting was talking about bringing his photography collecting to a close. He had already amassed most of the approximately 4,000 works that would ultimately comprise the collection, which spans the years 1840 to 2000, and had begun work on his four-book catalogue, intended to chronicle it. In 2002 and 2004 the Manfred Heiting Collection was acquired by the Museum of Fine Arts, Houston, in a gift and purchase arrangement said to be valued at approximately $35 million. Describing Heiting's collecting strategy and accomplishments, photography dealer and gallerist Peter MacGill said:

> *Manfred Heiting is the best kind of collector. He approaches this job with passion and intellectual rigor. As a collector of photographs Manfred was interested in collecting the best examples of the best artists known, and he was also interested in collecting the best examples of the unknown. Combining these two approaches, Manfred simply and quietly created a new history of the medium.*[1]

Another art discipline, sculpture, was the primary collecting focus of Patsy and Raymond Nasher, collectors from Dallas, Texas. By their own account, the seeds of what grew into their world-renowned collection were planted on vacations in the 1950s in Mexico, where the couple would buy pre-Columbian objects for twenty, thirty, and forty dollars, amounts that fit their budget at the time. In 1967 Patsy gave her husband a bronze sculpture by Jean Arp, a gift that turned out to be a milestone

in the couple's collecting history. As Raymond Nasher explained in a television interview: 'It was the beginning of our collecting sculpture and also getting into the next league of sculpture, because Arp was truly one of the fine sculptors of the century.'[2]

'Next league of sculpture' indeed: in the ensuing decades the Nashers went on to assemble about 300 works by many of the twentieth century's most significant modern and contemporary artists; in a reflection of their intense passion, they collected many of those artists in depth, including Henri Matisse, Pablo Picasso and Alberto Giacometti.[3] Since 2003 the collection has been open to the public at the Nasher Sculpture Center, a 5,156 square metre (55,000 square foot) building designed by Renzo Piano in downtown Dallas.

Two San Francisco collectors, Pamela and Richard Kramlich, assembled another notable collection with a specific focus. When they began thinking about building a collection, around 1990, they were intent on a framework that would be different from that of other collectors in the competitive collecting community of the city's exclusive Pacific Heights neighbourhood. As the Kramlichs' advisors, we recommended that they concentrate on film, video and other new media, partly because of Richard's professional career as a new technology venture capitalist but more so because that focus established, at least then, an innovative armature for a contemporary art collection.

The Kramlichs' first major acquisition was Dara Birnbaum's multi-monitor video work *Technology/Transformation: Wonder Woman* (1978–79), which Pamela Kramlich installed to great effect in the circular central staircase of their city residence. The Kramlichs went on to collect key works by essential European and American moving-image artists, including Vito Acconci, Eija-Liisa Ahtila, Matthew Barney, Marcel Broodthaers, James Coleman, Stan Douglas, Gilbert & George, Dan Graham, Gary Hill, Steve McQueen and Bruce Nauman. Working together with the Kramlichs we also developed what are now widely accepted procedures for archiving, conserving and exhibiting this genre of art; and we conceived a not-for-profit entity called the New Art Trust, a then-novel collaborative approach through which such a collection could be shared among a number of exhibiting institutions – in the Kramlichs' case, SFMOMA, MOMA and Tate Modern in London.

Drawing is an art-making practice that has always held special appeal for collectors – certainly since the widespread availability of paper, which more or less dates to the time of Leonardo da Vinci and Michelangelo. Drawing is particularly appreciated for the immediacy

Photograph by Roe Ethridge of collector Agnes Gund's apartment with Roy Lichtenstein's painting *Masterpiece*, 1962

New York collector/philanthropist Agnes Gund's collection includes outstanding examples of the work of Jasper Johns, Roy Lichtenstein, Mark Rothko, Gerhard Richter and Brice Marden among others, many of which she bought early in the artists' careers, as she's now doing with younger artists. Her passion for art is obvious when she speaks about the role of collecting in her life. 'So I think I have to collect and get things because I really do see them as part of nature and the rest of life – they make me feel happy, or tell me something, or give me a feeling or emotion.' Gund's sentiments will strike a chord with collectors the world over – collectors who are enthralled by the profound ways in which art informs and enriches life.

of expression that it often embodies. Many collectors, especially those who collect artists in depth, seek out drawings as a way to delve into the essence of an artist's thinking and creative impulse. One collector who specializes in the genre is New York collector Werner (Wynn) Kramarsky, who began assembling works on paper in the late 1950s.

Kramarsky started collecting drawings because of his self-described interest in process – 'how things are made', as he put it – and to get closer to an artist's expression. 'You can see what's happening in a drawing,' he said to us. He continues to hold fast to his personal notions of 'artisanship, craftsmanship and ideas'.[4] Today Kramarsky owns some 1,800 drawings, many by American progenitors of Conceptual, Minimal and post-Minimal art. For many years Kramarsky maintained an exhibition space on Broadway in Manhattan's SoHo district, and selections from his collection have been widely exhibited in the United States and Europe. Since he began collecting he's given away almost 2,000 works to various public institutions.

Subject matter or conceptual framework

Another approach, one that is favoured by certain collectors to novel and illuminating effect, is to concentrate on a specific subject matter or conceptual framework. As with focusing on a particular medium, this approach distils the range of possibilities while simultaneously expanding the potential for individuation. In fact, there seems to be no limit to the variety of directions this approach can take: Swiss collector Uli Sigg focused on contemporary Chinese art; Los Angeles collectors Bill and Maria Bell have directed their attention towards a small but select group of artists whom they believe to be critically important in extending the ideas of Marcel Duchamp; New York collector Henry Buhl built a collection of more than 1,000 photographs and 100 sculptural works whose sole subject is the human hand; the Marli Hoppe-Ritter collection in Germany is devoted to works that have essentially square motifs (such as those by Kazimir Malevich, Josef Albers and Sol LeWitt); Valeria Napoleone, in London, collects only female artists; Berlin collector Matthias Döpfner concentrates on artworks of nude women; and fellow Berliners Siggi and Sissy Loch collected works that centred around the colour blue.

There is also the very individual approach taken by two Belgian collectors, the Brussels-based radiologist Herman Daled and his wife, Nicole Verstraeten, since divorced. They began collecting Conceptual art in 1966, with Marcel Broodthaers' *Robe de Maria* (1966) as their

'[An approach] favoured by certain collectors to novel and illuminating effect is to concentrate on a specific subject matter or conceptual framework.'

first purchase. The Daleds collected with set principles in mind: never purchase works by deceased artists; never purchase works on the secondary market; and never resell. Most atypically, they assiduously avoided installing works they owned in their home so as not to misuse them, in their view, as decoration. 'Je deteste le décor,'[5] said Herman Daled. In a combined purchase–gift arrangement, New York's MOMA acquired the Daled Collection, 223 pieces in all, in 2011. Included was an ensemble of sixty works by Broodthaers, and important works by Vito Acconci, Robert Barry, Daniel Buren, James Lee Byars, Dan Graham, On Kawara, Niele Toroni and Lawrence Weiner, among others.

Annick and Anton Herbert, the pre-eminent Belgian collectors mentioned in an earlier chapter, came at collecting in 1973 with a very specific conceptual approach: 'To take a creative position in the political discourse,' as they put it – to engage with the cultural and political upheavals that shook the world beginning in the late 1960s.[6] In building their collection the Herberts were especially influenced by particular artists, Marcel Broodthaers and Bruce Nauman being key among them. Though their collection happens to display a strong bent towards Minimalism, Conceptualism and Arte Povera, the Herberts eschew such rigid categorization of artists and stress instead the importance of the 'individual and individuality'. During their decades of collecting the Herberts maintained a regular dialogue with a select group of very knowledgeable, trusted dealers and curators and developed many deep and lasting relationships with various artists, which is itself a dynamic and efficacious approach to collecting that we'll discuss further shortly.

Patronage and philanthropy

'Buying contemporary art virtually underwrites the careers of living artists.'

Two additional, perhaps related approaches to collecting that also focus and define choices – patronage and philanthropy – deserve attention too. Broadly speaking, buying contemporary art, as we have already stated, virtually underwrites the careers of living artists; it enables many to pursue their art-making practices. But some art collectors take patronage to a different level, explicitly establishing or eventually turning to the support of specific artists and their projects as the primary directive of their collecting activity.

As an example, the art collection (not to mention the exemplary book collection) of New Yorkers Phil Aarons and Shelley Fox Aarons fills the couple's four residences, yet they prefer to be called 'supporters' rather than 'collectors', as their aim is to enable and assist in the realization of artist-initiated projects, exhibitions and

Art advisors Suzanne Modica (left) and Ashley Carr (right) in the library at Thea Westreich Art Advisory Services, 2012

Since the turn of the twenty-first century it has become much more common for collectors to retain professional art advisors than it was in the mid-1980s when TW started her advisory service. This trend has been fed to a large degree by the increasing size of the international art world, a world now so chock-full of exhibitions, art fairs and important galleries that it's virtually impossible for otherwise busy collectors with day jobs to cover it on their own. The fact is that anyone can call themselves an art advisor or art consultant, as standards for entry into the field are non-existent. The better art advisors are educated in art history, knowledgeable about the art market and objective in their counsel. The very best are also able to 'see' through their clients' eyes, to identify and vet outstanding works that will meet the collector's objectives. Our two colleagues pictured here, Suzanne Modica and Ashley Carr, belong with the best.

publications. With great enthusiasm, Shelley and Phil describe their activity in terms of putting money in the pockets of young and emerging artists; their collecting, they say, is '[about] supporting the work and not necessarily about objects' they come to own. They are true patrons, or as Shelley modestly said to us, 'We're cheerleaders for artists.'[7]

Anita Zabludowicz and her husband, Poju, are also art advocates with a history of enabling the careers of mostly younger artists; they support public institutions as well. In 2007 they opened an exhibition space in London, a converted Methodist chapel, to provide a public venue for the young and emerging artists in their large collection and to provide residencies for artists and curators.

Agnes (Aggie) Gund, President Emerita of New York's MOMA and Chairman of its International Council, is surely a collector who embodies a philanthropic disposition. Her passion for art and collecting is plain to see on inspection of her carefully chosen collection and can be gathered from any conversation with her. But her overriding impulse is to give her art, which she does regularly, making significant donations to public institutions of her choice.

From the first time we (TW) met Aggie in the mid-1980s, it was clear that the works she collected were eventually to be donated to a collecting institution – 'If they [meaning the works] were good enough' she explained in a later interview with us. As an example, she recounted, 'I have gone to curators and asked if they would like certain things, like I did with a Yayoi Kusama suitcase work that I bought, and it's a wonderful piece, but I didn't think it would be very easy to keep on the floor, so I asked Ann [Ann Temkin, a curator at MOMA] if she wanted it and she did.'[8] In countless other examples, works of interest to Gund have found their way to MOMA and other art museums that she generously supports.

In 2005, three art-collecting couples from Dallas – Marguerite and Robert Hoffman, Cindy and Howard Rachofsky, and Deedie and Rusty Rose – made a bequest to the Dallas Museum of Art of some 800 works from their collections and future works they may acquire. It's a large and significant gift, but especially unique in that these couples regularly consult with one another so as not to duplicate what is ultimately given to the museum. The Rachofskys, who travel widely and work with art advisor, Allan Schwartzman, also act as 'eyes and ears' for the museum curators and Texas collectors, alerting them to works that may be appropriate for the institution. We could just as readily name many other collector–philanthropists around the world who work with institutions of their choosing to help build and

shape permanent public collections – among them are Hans Rasmus Astrup, Marieluise Hessel, Henry and Marie-Josée Kravis, Ronald Lauder and his recently deceased wife Evelyn, and Helen and Charles Schwab.

Informed opinions

The various approaches discussed above can lead to singular collections, but it must be stressed that the vast majority of contemporary art collectors don't begin collecting with set boundaries in mind, though specific directions or areas of emphasis can evolve over time. Rather, most collectors usually pursue whatever interests or entices them, enjoying the full range of possibilities, with the only limiting factors being cost and maybe space to accommodate the art.

Yet no matter how collectors go about building their collections or how experienced they may be, the reality is that nobody goes about collecting in the talkative art world oblivious to the impressions, judgements and views of gallerists and dealers, curators, artists, advisors and other collectors. We are in no way suggesting that collecting with one's ears, so to speak, is preferable to relying on one's own eyes and personal feelings. Still, taking into account informed opinion has its uses and benefits.

Informed opinion can lead collectors, particularly those newer to the activity of collecting art, to exhibitions and specific artists that may prove to be of interest to them, and away from those artists who are merely producing derivative art. Furthermore, though surely at the most sophisticated level of collecting, informed opinion can help lead collectors to artists who are capable of making a lasting contribution to art history, as distinct from those who may have developed an appealing visual expression but don't have what it takes to expand on an idea over the long term, say ten or twenty years or even more. Admittedly it takes some doing to find people in the art world who can reliably offer this kind of informed, insightful opinion (as distinct from the 'blah, blah, blah' that Oslo-based collector Erling Kagge spoke of shunning in an earlier chapter). But over time most experienced collectors tend to form a coterie of art world players whose opinions matter to one another. These are opinions not necessarily to be followed unquestioningly, but are certainly worthy of consideration. Art world commentary, especially that which goes deeper than simply stating one's likes and dislikes, can be grist for the mill: thoughts and opinions to be considered and pursued through the scrim of one's constantly developing personal knowledge, taste and responses.

'The vast majority of contemporary art collectors don't begin collecting with set boundaries in mind, though specific directions or areas of emphasis can evolve over time.'

The lucky strike

'Choice is a common denominator of collecting, and certainly one of its utmost fascinations and thrills.'

Irrespective of how collecting is pursued, every collector ultimately faces decisions about which artists to follow and support and which work(s) of art to buy. Choice is a common denominator of collecting, and certainly one of its utmost fascinations and thrills. Most passionate, dedicated collectors go about making choices in very determined ways. When they visit galleries or attend auctions they typically do so with ideas about what they like, what interests them and what they want to buy. But interestingly enough, while much of the search for art is conducted in prescribed ways, with selling venues in mind, there are occasional moments when the unexpected occurs – 'the fortuitous circumstance of the lucky strike'[9], as Werner Muensterberger pegged it.

Call it serendipity or chance, or the 'lucky strike', it's happened to us, and we're sure to others, more than a few times. Once, while in Paris several years ago, we had a half hour to spare before meeting friends at the Centre Pompidou. We checked the gallery guide for something to do with the time and noticed a group show of interest at Galerie Nathalie Obadia, which is located a stone's throw from the Pompidou. Within seconds of entering the gallery we were both completely bowled over by the paintings of Martin Barré, an artist about whom we knew virtually nothing until that moment. The happenstance led to our collecting Barré's work, co-publishing a major monographic catalogue on his oeuvre (with Obadia, Daniel Buchholz and Christopher Muller, and Andrew Kreps) and, we must add, to the dearest of friendships with Michèle Barré, the artist's widow.

Another time, in what was an unplanned extra go-round on the last day of Art Basel in 1999 (made possible only by a last-minute cancelled appointment), we happened upon two of Mark Alexander's paintings on a back wall in the booth of London gallerist Anthony Reynolds. The purchase of one of those paintings, the first of several we've made of Alexander's work (now represented by Anthony Wilkinson's gallery in London), initiated an abiding interest in the artist and his remarkably idiosyncratic practice, and a close personal friendship with him as well.

On another occasion, our one and only visit to Luis Campaña's gallery while it was located in Cologne (it is now in Berlin), we happened to see a photographic work by Jan De Cock leaning against a wall just before it was put in storage. Had we not been there at that moment, ironically enough to discuss another artist's work, we're not sure when or even if we would have come to know De Cock's practice. For certain we would not have been

in a position to acquire some wonderful early pieces of his or soon thereafter co-publish his second artist's book and two subsequent volumes.

The importance of curiosity

It's been our observation that knowledgeable, passionate collectors are by their very nature curious, available to the moment and to the multitudinous possibilities that art collecting has to offer – wherever and whenever, anticipated or not. Countless collectors go about the adventure that is collecting with this mindset, compelled by their own interests, armed with information, certain of their likes and considered in their choices. Some are well known and regularly mentioned in art magazines and other publications as being among the world's 'top' collectors. Many others are less well known publicly, but nonetheless informed, committed and erudite in their collecting choices.

With museum groups and collectors from around the world regularly visiting their collection both at their San Francisco residence and the Napa Valley 'art cave' (see page 23), Norman and Norah Stone are among the more widely known collectors. They have been clients of ours for more than twenty years – and good friends, too. The Stones are curious and daring collectors who never let conventional opinions about what's hot and what's not get in the way of their collecting proclivities. As with several other San Franciscans, the Stones were motivated to collect by John Caldwell, the SFMOMA curator discussed earlier in the book.

In their early collecting years in the 1990s, the Stones acquired works by Sigmar Polke, Martin Kippenberger, and artists of the Pictures Generation, several of whom they've collected in depth. From time to time the Stones reach back in history to provide context and precedents for their collection, as they did when acquiring works by Joseph Beuys, Marcel Duchamp, Richard Hamilton and Hans Bellmer, but essentially they are focused on the art of their time, and they travel widely and enthusiastically in this pursuit. On occasion they commission works of art, as they have done with James Turrell, Rirkrit Tiravanija, Walid Raad and the musician–composer Alex Waterman, which adds to the individuality of the Stones' collection.

Developing relationships with artists

This brings us to the matter of developing relationships with artists, which is an approach to collecting that not only can be extraordinarily productive in helping a

'Knowledgeable, passionate collectors are by nature curious, available to the moment and to the multitudinous possibilities that art collecting has to offer.'

collector make refined, informed decisions, but also can infuse life with joy, excitement and cultural enrichment. When such a relationship is instigated the collector's initial experience is often not much different from being won over by a work of art: a belief in what the artist has to say takes hold. It's not necessarily a specific or empirically based belief but rather something less tangible and more elusive. Still, it's a feeling or response that is regularly triggered in passionate art collectors.

The purpose of developing relationships with artists is not primarily to have one artist recommend other artists, though that can occur and certainly to the collector's benefit. In fact, it was this way that we came to learn about the practices of a number of artists we admire and actively collect, including Ricci Albenda, Liz Deschenes, Sam Lewitt, Lucy McKenzie, Sean Paul and Blake Rayne. Yet even more vital and fundamental, relationships with artists can facilitate or lead to a better, more profound understanding of how they think about their own work, what they are striving to achieve, which works they consider important, and whether they are exploring new ground – the latter almost always a valid indicator of artistic significance. Dorothy Miller, the distinguished former MOMA curator and a bit of an art collector herself, put the matter of relationships with artists quite straightforwardly: 'If I hadn't known any artists I certainly wouldn't know a damn thing about art. You simply have to know the people and see them working and let them tell you about their pictures.'[10] It is said that Miller was in artists' studios as often as she was in museums.

Certainly some of the most important, noteworthy collections assembled in the twentieth century were

'Relationships with artists can lead to a better, more profound understanding of how they think about their own work.'

Pádraig Timoney working on one of his *Mirror* paintings in his studio, 2008

For avid collectors, visiting artists in their studios is an effective way to gain a deeper understanding of their praxis. In our experience, studio visits are usually more about conversation than about observing an artist at work. However, on one occasion we had the good fortune to watch as artist Pádraig Timoney made one of his Mirror *works in his studio in Naples, Italy. In realizing this body of work, Timoney employs a fascinating process of painting and alchemy, variously using gold, silver and copper to produce what he calls 'automatic portrait repetitors'. Timoney's* Mirrors, *like much of his work, manifest a connection between the work itself and the process and means of its representation.* ↦

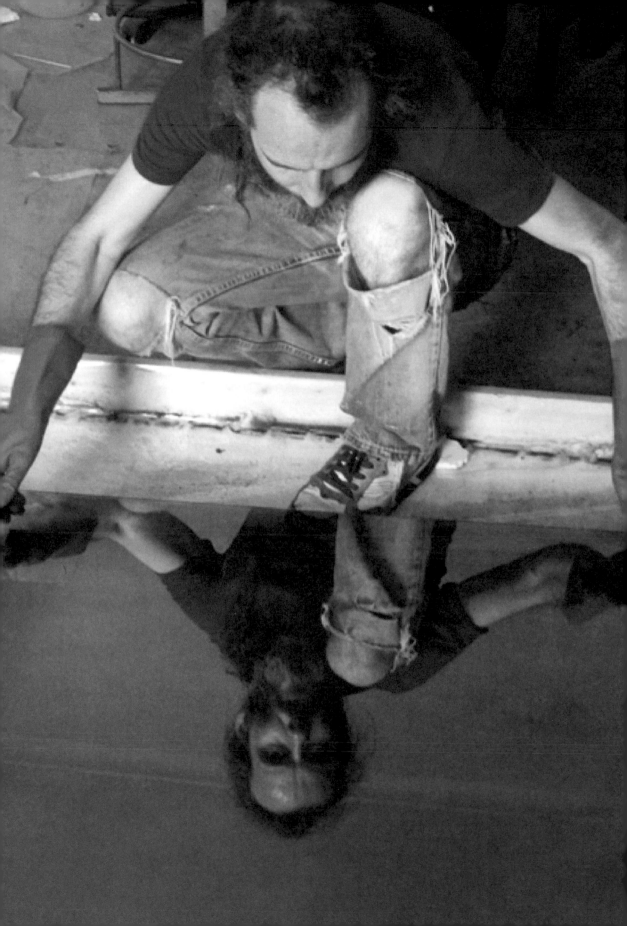

significantly affected, if not defined by the collectors' relationships with artists. One of the most colourful of these, and otherwise a remarkable story of modern art collecting, is that of Gertrude and Leo Stein. Soon after the Stein siblings moved from San Francisco to Paris at the turn of the twentieth century, they began developing friendships with artists – and buying historically important, radical pictures. The Steins were in the front rank of collectors by virtue of their intense curiosity, receptiveness to new ideas, intellectual vibrancy and very social natures. These traits led them to engage with and learn from some of the greatest, most creative minds of their time – arguably of all time.

The Steins were not alone in collecting cutting-edge art of the early 1900s or in being drawn to relationships with its makers. Two wealthy merchants from Russia, Sergei Shchukin (1854–1936) and Ivan Morozov (1871–1921), each also created fabulously important collections and frequently corresponded with and visited artists. Shchukin's collection of some 264 pictures, mostly assembled between 1895 and 1914, included eight Cézannes, sixteen Derains, sixteen Gauguins, fourteen Monets, seven Rousseaus and fifty Picassos. He had a long and close friendship with Henri Matisse, and owned thirty-seven of his works as well. Among them was *La Danse II* (1909–10), one of art history's iconic paintings, which Shchukin commissioned for his palatial personal residence in Moscow.

Morozov's collection, assembled over a period of eleven years, numbered some 278 paintings and 23 sculptures, mostly by the great Impressionists and Post-Impressionists. Included were seventeen Cézannes and works by exceptional Russian artists, such as Natalia Goncharova, Mikhail Larionov and Marc Chagall. Morozov was in regular correspondence with several artists, including Matisse, Pierre Bonnard, Edouard Vuillard and Maurice Denis; the latter once travelled to Moscow to visit the collector and install panels that Morozov had commissioned for his music room.

It is said that Shchukin and Morozov each started out seeking nothing more than to decorate their residences, at first buying easy-to-live-with pictures by popular Russian artists of the moment. But they were uncommon collectors, by virtue of their curiosity and openness to the avant-garde, and owing in no small part to their personal relationships with some of the key artists of their time. In fact their activities comprise a chapter in the history of art collecting. That remarkable chapter, however, ended abruptly in 1918 when the Russian state, through a decree signed by Vladimir Lenin, seized the two collections. Much of what Shchukin and Morozov had between them assembled was divided between the

Pushkin Museum of Fine Arts in Moscow and what would eventually become the State Hermitage Museum in St Petersburg.

Also counted among the outstanding collectors who were greatly influenced by their relationships with artists were Walter (1878–1954) and Louise Arensberg (1879–1953). Both of them came from wealthy families, were endowed with quite considerable intellects, and famously – sometimes raucously – enjoyed the company of artists and writers. During the years the Arensbergs lived in New York City, from 1914 to 1921, creatively accomplished individuals gathered almost nightly in their apartment to eat, drink, play chess and talk about art, poetry, music and literature.

Among the Arensbergs' many artist relationships, the one they maintained with Marcel Duchamp was the most renowned (and enviable to us): he was their friend and art advisor, they were his friends and patrons. As the story is told, it was Walter Arensberg, along with the painter Joseph Stella, who accompanied Duchamp to the J. L. Mott Iron Works to find the porcelain urinal that years later, bearing the signature 'R. MUTT 1917', would be proclaimed the twentieth century's most important work of art. The Arensbergs' eminent history continued through their later years in Los Angeles, and their great achievement as collectors is plain to see at the Philadelphia Museum of Art, where much of their seminal collection was bequeathed in 1954 and has been on view ever since.

Many other Americans and Europeans constitute the twentieth century's pantheon of great collectors; central to almost every one of them is their relationships with artists. In addition to those mentioned in this chapter, we would add John Quinn, Duncan Phillips, Katherine S. Dreier, Peggy Guggenheim, Albert and Mary Lasker, Count Giuseppe Panza di Biumo, Emily and Burton Tremaine, Dominique and John de Menil, Sally and Victor Ganz, and Herbert and Dorothy Vogel, among others.

Similarly disposed collectors are prevalent in the present-day collecting world; one of them is the generously spirited Greek-Cypriot businessman and collector Dakis Joannou. His collection consists of some 1,500 pieces by 400 artists, including more than forty works by Jeff Koons. In 1985, Dakis, the single name by which he is well known in the art world, came upon Jeff Koons's *One Ball Total Equilibrium Tank* (1985) while he was visiting galleries in Manhattan's East Village, and he and Koons have been close friends ever since.

Dimitris Daskalopoulos, Dakis's fellow countryman, has also amassed a large, well-regarded collection, at last count reportedly some 400 works by close to 200 artists. Though Daskalopoulos does not, at least to our

knowledge, nurture personal relationships with artists with the same ardour as does Dakis, his wont to collect large-scale, complex installations often requires getting close to the artist's thinking and intentionality. We vividly recall observing Daskalopoulos consider such a work, one by Keith Tyson, on view at the Kunsthalle Zürich in 2002. With chin in hand and eyes riveted on Tyson's installation, the collector listened as the artist explained the ideas embodied in his work. It was Daskalopoulos who, a few years earlier at auction, had bought what was said to be the last of the edition of Duchamp urinals in private hands. We knew that Tyson's practice had been influenced by Duchamp, so Daskalopoulos's interest in this particular artist certainly made sense to us.

We must add here that gaining understanding and perspective through relationships with artists is not for everyone. Many an artist and many a collector want no part of it. In fact, some collectors feel that such relationships get in the way of making objective choices. Yet when a collector is open and available to relationships of the sort we've discussed, and when there's mutual interest on the part of an artist, such relationships can take off. When they do, they can profoundly affect the nature, individuality and quality of an art collection. The natures of such relationships do not have to rise to the level of Gertrude Stein's with Pablo Picasso or Walter Arensberg's with Marcel Duchamp. Indeed, not every collector has as much time as did these two to devote to art world pursuits, and fewer still can claim intellects their equal. Nonetheless, in our experience, each relationship between a collector and an artist finds its own level, and almost whatever that is it can be fruitful and mind-expanding, certainly for the collector.

'[Relationships with artists] can profoundly affect the nature, quality and individuality of an art collection.'

Learning from artists

Over the years we've had many illuminating experiences conversing with artists we're interested in. In the mid 2000s, through Eileen Quinlan and Cheyney Thompson, two artists we admire, collect and are personally close to, we learned about a friend of theirs: an intellectually endowed young artist named Sam Lewitt, previously mentioned. On the first couple of visits to Lewitt's studio in Brooklyn we both left shaking our heads, not because we didn't like his work – we most emphatically did – but because, owing mostly to our own limitations, we couldn't fully grasp much of what he was saying about it. On the street following our third visit to Sam's studio, one of us (EW) said to the other in all seriousness, 'Wow, he must have really dumbed it down because this time I pretty much got it.'

Collector Dakis Joannou's yacht, *Guilty*, designed by Ivana Porfiri with exterior camouflage by Jeff Koons

Recalling his first meeting with Jeff Koons, Dakis Joannou said, 'From then on it was about meeting artists, developing personal relationships and collecting their work.' It is not surprising that when it came to the exterior motif for his 35 metre (114 foot) yacht, built in 2008, this mega-collector turned to none other than his close friend Jeff Koons. Koons's design (he worked with yacht designer Ivana Porfiri) was inspired by the 'Razzle Dazzle' camouflage used on warships in World War I, and by Roy Lichtenstein, who painted Young America, *a 1995 entry in the America's Cup race. Among the many artworks on Dakis's yacht is a text painting by Sarah Morris, titled* Guilty.

Set for Philippe Parreno's film *Marilyn*, 2012, Queens, New York

The Algerian-born French artist Philippe Parreno, widely recognized for his films, is self-effacing when discussing his work. Still, through the way he talks about his life, friends, and the books and films he's currently paying attention to, much can be gleaned about his practice. Pictured here is the set of Parreno's film Marilyn, which premiered at the Fondation Beyeler in June 2012. Much like visiting an artist in his/her studio, observers on Parreno's set could better appreciate and understand his artistic intention. About his film, Parreno said: 'I was interested in the idea of celebrating a dead person, of trying to portray a ghost. Why are ghosts interesting? Because they are unfinished, heterogeneous. Marilyn Monroe represents the first time that the unconscious killed a person – her image killed her. So we had to use an image to bring her back. The film is a portrait of a phantom incarnated in an image.'

Another example from our personal collecting experience is that of the British Conceptual artist Ryan Gander, whose practice can be difficult to grasp in its myriad permutations. Gander is not prone in conversation to offer up the ABCs of what he's doing, but there's something about spending time in his company that helps us vector in on his way of thinking and the meaning of his varied projects.

Yet another artist with whom we regularly get together, usually on his visits to New York City, is Toronto-based Scott Lyall. We always enjoy and learn from these conversations with Scott, but it's the artist's emails, in answer to our incessant questions, that allow us the time we seem to need to mull over and better understand his highly innovative methodology.

In the case of New York collectors Susan and Michael Hort, it was an experience with an artist that proved the genesis of their collecting. As Michael tells their story, 'The first piece we purchased was really key because it got us to collect contemporary art. It wasn't so much the art, which was nice, but the artist that got me excited especially.' Michael continues, 'I didn't really understand contemporary art at that point, but we had dinner with the artist. He was smart, interesting, and fun, and I said, "gee, this is good stuff".'[11]

Over the course of history, and especially since the beginning of the twentieth century, certain collectors have built distinguished collections by focusing on a specific art-making discipline or medium. Still more have pursued collecting by directing their attention to a particular subject matter or conceptual framework. Yet most collectors, especially in the wide-open field of contemporary art, collect what interests them and what they respond to, with no definitive boundaries in mind. Whatever approach is taken, from the very defined to the very general, collectors can benefit in any number of ways by developing relationships with artists. Many such relationships are spurred by a curiosity about art, which leads to curiosity about artists. In our experience that curiosity, endemic to dedicated, passionate collectors, is almost always rewarded – not only by knowledge gained but also by a life enriched. Artists are creators, many of them uncommonly interesting and highly intelligent. Getting to know them, and certainly developing friendships with them, provides one of the greatest joys that collecting contemporary art has to offer.

The collectors from times past who are mentioned in this book built singular collections, many of which are recognized as being among the greatest private assemblages of art in modern history. Many of the present-day collectors we mentioned are building or have built extraordinary collections as well. While they represent a wide variety of collecting approaches, they seem to share at least one trait: they did not or do not as a rule base their acquisition decisions on what is commonly embraced as popular or what the art market deems hot. Instead, they go their own way, based on their likes, desires and knowledge.

The book's final chapter is about building a 'great' collection – a common ambition among passionate collectors. If the objective were to be changed to, say, building a collection that will impress friends and other collectors, then buying with the market may indeed be an approach to take. Certainly, showing off a collection of art-market stars and signature works will be imposing in some quarters. But as many collectors learn, this sort of achievement can be fleeting, because what is popular at one moment in the ever-changing art market may not be so popular in the next.

If the final chapter were about assembling an art collection that maximizes financial return, just as one would construct an equities portfolio, then looking to the market might also pay off. The art market can also provide guidance for collectors who don't have an interest in or eye for art, or those who become involved in collecting because it seems to be the thing to do. We would note that collectors who begin collecting looking to impress, or gain financially, or do something socially cool, or decorate their homes may – and regularly do – change their outlook and develop a passion for the activity by dint of the joys that come from living with, learning about and above all responding to art.

To be clear, we do not take issue with any reason that compels someone to collect art – for that matter, we are not entitled to do so. As we've said throughout this book, art collecting stems from a wide variety of motives and offers all sorts of rewards, including personal gratification, social standing and financial profit. No single approach or mindset or reason for collecting is less legitimate than any other. Nevertheless, it is our view that the full range of satisfactions that can be derived from collecting – particularly experiencing art's emotional and intellectual stimulations – can best be realized by engaging with art's intent and meaning. Art stands apart, and in its own way so too does collecting – especially when pursued with passion and knowledge.

Endnotes

CHAPTER ONE

1 Steven A. Nash, 'Why Sculpture: An Interview with Raymond Nasher', in *A Century of Sculpture: The Nasher Collection* (New York: Solomon R. Guggenheim Museum, 1997), p. 36.
2 Judith Benhamou-Huet, *Global Collectors* (Paris: Editions Phébus, 2008), p. 59.
3 Werner Muensterberger, *Collecting: An Unruly Passion: Psychological Perspectives* (Princeton, NJ: Princeton University Press, 1993), p. 13.
4 Howard Rachofsky, interviewed by the authors, 2011.
5 Walter Benjamin, *Illuminations: Essays and Reflections* (New York: Schocken, 1969), p. 67.
6 Roy R. Neuberger, *The Passionate Collector: Eighty Years in the World of Art* (Hoboken, NJ: John Wiley & Sons, 2002), p. 32.
7 Muensterberger, *Collecting: An Unruly Passion*, p. 3.
8 Louisine W. Havemeyer, *Sixteen to Sixty: Memoirs of a Collector* (New York: Ursus, 1993).
9 Douglas Cooper, *Great Private Collections* (New York: Macmillan, 1963), p. 283.
10 John Paul Getty, *As I See It: The Autobiography of J. Paul Getty* (Los Angeles: J. Paul Getty Museum, 2003), p. 276.
11 In addition to Getty, over the course of the twentieth century many other collectors established public museums that have claimed their place in the cultural landscape. Among them are Henry Clay Frick, J.P. Morgan, Albert C. Barnes, Hans Rasmus Astrup, Lee Byung-chull, Peter Ludwig, Eugenio Lopez, Guan Yi, Joseph H. Hirshhorn, Ronald Lauder, Isabella Stewart Gardner, Sir Richard and Lady Wallace, Armand Hammer, Charles Saatchi, Dakis Joannou, Dominique and John de Menil, Norton Simon, Ingvild Goetz and Alice Walton.
12 'The Fine Art of Patronage', *Guardian*, 9 May, 2006.
13 'A "landmark" museum for Ukraine', *The Art Newspaper*, no. 228, October 2011.
14 Lucinda Bredin, 'Behind the scenes in private museums', *Financial Times*, 26 November, 2010.
15 Suzanne Muchnic, 'Broad won't hand off art', *Los Angeles Times*, 9 January, 2008.
16 Lisa Movius, 'Private Museums Bloom in Shanghai', *The Art Newspaper*, May 2012, 'China Focus' p. 9.
17 Javier Pes, 'To have and have not', *The Art Newspaper*, 16 June, 2011.
18 Pilar Corrias, email message to authors, 2012.
19 Simon Romero, 'The Keeper of a Vast Garden of Art in the Hills of Brazil', *New York Times*, 9 March, 2012.
20 Cristina Ruiz, 'Where dreams come true', *The Art Newspaper*, no. 218, November 2010.

CHAPTER TWO

1 Laura de Coppet, *The Art Dealers* (New York: CN Potter, 1984), p. 218.
2 Leonard Lauder, interviewed by the authors, 2011.
3 Charles Baudelaire, 'Exposition Universelle, 1855', in *Baudelaire as a Literary Critic*, translated by Francis E. Hyslop, Jr. (University Park, PA: Pennsylvania State University Press, 1964), p. 79.
4 Carol Vogel, 'Jane Meyerhoff, 80, Art Collector, Dies', *New York Times*, 19 October, 2004.
5 Barbara Levine, in discussion with the authors, 2011.
6 Aaron Levine, interviewed by the authors, 2011.
7 Ibid.
8 Ibid.
9 Meg Onli, 'Roberta Smith Answers the Question, "How Do Critics Experience Art?"' *Bad at Sports*, 2 October, 2008.
10 Duncan Phillips, *A Collection in the Making* (New York: Riverside, 1926), p. 4.
11 Benhamou-Huet, *Global Collectors*, p. 15.
12 Ibid., p. 109.
13 Patricia Marshall, interviewed by the authors, 2011.

CHAPTER THREE

1 Kirsty Bell, 'Open Eyes: Online or in person? The different ways of paying attention today', *Frieze*, no. 147, May 2012, p. 15.
2 Ibid.
3 Isabelle Graw, *High Price: Art Between the Market and Celebrity* (Berlin: Sternberg Press, 2009), p. 136.
4 Maria Lind and Olav Velthuis, eds., *Contemporary Art and Its Commercial Markets: A Report on Current Conditions and Future Scenarios* (Berlin: Sternberg Press, 2012), p. 91.
5 Martha Schwendener, 'An Art Expo on the Web, Virtual Fairgoer Included', *New York Times*, 6 February, 2012, p. C2.
6 Jackie Wullschläger, 'Lunch with the FT: Jay Jopling', *Financial Times*, 2 March, 2012, Life & Arts, p. 3.
7 Steven A. Nash, *A Century of Sculpture: The Nasher Collection* (New York: Solomon R. Guggenheim Museum, 1997), p. 32.
8 David Muenzer, 'A Real Problem of Materials: Gareth James in Conversation', *Artlog*, 2011.
9 Adam Lindemann, 'Cattelan at the Guggenheim? Are They Kidding?', *New York Observer*, 2 November, 2011.
10 Carol Vogel, 'The Modern Buys "Rebus"', *New York Times*, 17 June, 2005.

CHAPTER FOUR

1 The original price paid is cited in Judith Zilczer, *John Quinn: Patron of the Avant-Garde* (Washington, DC: Smithsonian Institution, 1978), p. 186.
2 B.L. Reid, *The Man from New York: John Quinn and His Friends* (New York: Oxford University Press, 1968), p. 652.
3 De Coppet, *The Art Dealers*, p. 103.
4 Ibid., p. 140.
5 The Vogels' collection included artists such as Dan Graham, Robert Barry, Sol LeWitt, Robert Mangold, Richard Tuttle and Lynda Benglis.
6 In Wachs' possession are Martin Puryear's widely exhibited *Big and Little Same* (1981); a Lee Bontecou sculpture made in 1964; Mike Kelley's *Pet Duplex* (1991); David Hammond's sculpture *Chicken Feet*; an early Richard Prince *Joke* painting; an early black-and-white Cindy Sherman *Film Still*, and the first work ever sold by Sherrie Levine.
7 From a letter dated 17 November 1920, quoted in Reid, *The Man from New York: John Quinn and*

His Friends, pp. 472–73.

8 Michael C. Fitzgerald, *A Life of Collecting: Victor and Sally Ganz* (New York: Christie's, 1997), p. 87.

CHAPTER FIVE

1 Jonathan Brown, *Kings & Connoisseurs: Collecting Art in Seventeeth-Century Europe* (Princeton, NJ: Princeton University Press, 1995), pp. 33–34.

2 Pierre Assouline, *An Artful Life: A Biography of D. H. Kahnweiler: 1884–1979*, trans. Charles Ruas (New York: Fromm International, 1991), p. 36.

3 S. N. Behrman, *Duveen* (Boston: Little, Brown and Co., 1972), p. 31.

4 Calvin Tomkins, *Duchamp: A Biography* (New York: Holt Paperbacks, 1996), p. 286.

5 Neuberger, *The Passionate Collector*, p. 78.

6 Leo Steinberg, 'Other Criteria', in *Other Criteria: Confrontations with Twentieth Century Art* (New York: Oxford University Press, 1972), p. 56.

7 Cynthia Saltzman, *Portrait of Dr. Gachet: The Story of a Van Gogh Masterpiece, Money, Politics, Collectors, Greed, and Loss* (New York: Viking, 1998), p. 249.

8 Anthony Haden-Guest, *True Colors* (New York: Atlantic Monthly Press, 1998), p. 17.

9 Sarah Thornton, 'Scene & Herd: Love and Money', *Artforum*, 11 May, 2006, http://artforum.com/. (Accessed 7 September 2012.)

10 Graw, *High Price: Art Between the Market and Celebrity*, p. 77.

11 Randy Kennedy, 'Lawsuit Describes Art "Blacklist" to Keep Some Collectors Away', *New York Times*, 12 April, 2010.

12 William D. Grampp, *Pricing the Priceless: Art, Artists and Economics* (New York: Basic Books, 1989), p. 152.

13 Graw, *High Price: Art Between the Market and Celebrity*, p.77.

14 Carol Vogel, 'As Koons Prices Balloon, His Dallas "Flower" Will Be Sold', *New York Times*, 23 May, 2008.

15 Emily Tremaine, 'Emily Tremaine: Her Own Thoughts', in *The Tremaine Collection: 20th Century Masters: Spirit of Modernism* (Hartford, CT: Wadsworth Atheneum, 1984), p. 25.

16 De Coppet, *The Art Dealers*, p. 103.

17 Aubrey Menen, *Art & Money: An Irreverent History* (New York: McGraw-Hill, 1980), p. 108.

18 'A New Prince of Wall Street Buys Up Art', *New York Times*, 13 January, 2012.

19 Christopher Green, *Art in France: 1900–1940* (New Haven: Yale University Press, 2001), p.54.

20 Noah Horowitz, *The Art of the Deal* (Princeton, NJ: Princeton University Press, 2011), pp.154–56.

CHAPTER SIX

1 Alan Solomon and Ugo Mulas, *New York: The New Art Scene* (New York: Holt Rinehart and Winston, 1967), p. 64.

2 According to data released, total sales for Christie's in 2011 were $5.7 billion; for Sotheby's, $5.8 billion. In a paper published by the European Fine Art Foundation, Clare McAndrew estimated the global art market to be valued at about $60.8 billion.

3 James Goodwin, 'How to start investing in art', *Money Week*, 16 March, 2006.

4 Kelly Devine Thomas, 'The 10 Most Expensive Living Artists', *ARTnews*, May 2004.

5 Menon, *Art & Money: An Irreverent History*, p. 5.

6 Parker, Robert. 'Tasting Notes and Ratings', *Robert Parker's Wine Advocate: The Independent Consumer's Bimonthly guide to Fine Wine.*

7 Jerry Saltz, 'Seeing Dollar Signs', *Village Voice*, 16 January, 2007.

8 Sarah Douglas, 'Through the Looking Glass: Behind Jacob Kassay's Meteoric Auction Rise', *Artinfo*, 24 November, 2010.

9 Other YBAs in Saatchi's collection were Jake and Dinos Chapman, Sarah Lucas, Jenny Saville, Chris Ofili, Tracy Emin, Rachel Whiteread and Sam Taylor-Wood.

10 Charles Saatchi, *My Name Is Charles Saatchi and I Am An Artoholic* (London: Phaidon, 2009), p. 6.

11 William Langley, 'Charles Saatchi: Britain's Silent Benefactor', *Telegraph*, 3 July, 2010.

12 Craig Robins, interviewed by the authors, 2011.

CHAPTER SEVEN

1 Leonhard Emmerling, *Jean-Michel Basquiat: 1960–1988* (Cologne: Taschen, 2003), p. 75.

2 Leonard Louis Levinson, *Bartlett's Unfamiliar Quotations* (Chicago: Cowles, 1971).

3 *Hans Ulrich Obrist Interviews: Volume I* is edited by Thomas Boutoux and was published by Edizioni Charta, Milano in collaboration with Fondazione Pitti Immagine Discovery, Firenze, 2003. This book, which includes 66 interviews, is the first part of Hans Ulrich Obrist's interviews project, which comprises more than 400 interviews recorded with some of the most prominent and influential thinkers and doers of today. The second set of interviews are contained in the book *Hans Ulrich Obrist Interviews: Volume II*, edited by Charles Arsene-Henry, Shumor Basar and Karen Marta and also published by Edizioni Charta, 2010. Graphic cover elaboration by Gabriele Nason, of the cover image of *Volume I*. This book, which includes 70 interviews, is the second part of Hans Ulrich Obrist's interviews project.

4 Rainer Maria Rilke, *Letters to a Young Poet* (Cambridge, MA: Harvard University Press, 2011).

5 Isabelle Graw and Daniel Birnbaum, *Canvases and Careers Today* (Berlin: Lukas & Sternberg, 2008), p. 59.

6 Christian Schaernack, in discussion with the authors, 2011.

7 Dominique de Menil, 'Foreword', *The Menil Collection* (New York: Abrams, 1987), p. 7.

8 Email correspondence with the authors, 2012.

9 Email correspondence with the authors, 2011.

10 James Elkins, *What Happened to Art Criticism?* (Chicago: Prickly Paradigm, 2004), p. 2.

11 Harrison C. White and Cynthia A. White, *Canvases and Careers: Institutional Change in the French Painting World* (New York: Wiley, 1967), p. 120.

12 Ibid., p. 119.

13 Tom Wolfe, *The Painted Word* (New York: Farrar, Straus and Giroux, 1975), p. 64.

14 Robert C. Morgan, ed., *Clement Greenberg: Late Writings* (Minneapolis, MN: University of Minnesota Press, 2003), p. 88.

15 Jerry Saltz, 'Why De Kooning Matters', *New York*, August 29, 2011, p. 100.
16 András Szántó, *The Visual Art Critic: A Survey of Art Critic at General-Interest News Publications in America* (New York: National Arts Journalism Program, 2002), p. 27.
17 Benjamin Buchloh, in 'Round Table: The Present Conditions of Art Criticism', *October*, vol. 100, Spring 2000, p. 202.

CHAPTER EIGHT

1 Michael Brenson, *Acts of Engagement: Writings on Art, Criticism and Institutions, 1993–2002* (Lanham, MD: Rowman & Littlefield, 2004), p. 126.
2 Daniel Birnbaum, 'When Attitude Becomes Form: Daniel Birnbaum on Harald Szeeman', *Artforum*, Summer 2005, p. 55.
3 Hans Ulrich Obrist, 'Mind Over Matter', *Artforum*, November 1996, p. 119.
4 Birnbaum, 'When Attitude Becomes Form', p. 58.
5 Among the early generation were Jan Hoet, Achille Bonito Oliva and Rudi Fuchs. Among the next generation, mostly born in the 1960s or a little later, and more diverse in countries of origin and gender, were Carolyn Christov-Bakargiev, Catherine David, Okwui Enwezor, Hou Hanru, Daniel Birnbaum, Bice Curiger, Gerardo Mosquera, Nicolas Bourriaud, Fumio Nanjo, Hans Ulrich Obrist, Jens Hoffman, Elena Filipovic, Rosa Martínez, María de Corral, Maria Lind, Francesco Bonami, Robert Storr, Massimiliano Gioni and Adam Szymczyk.
6 Press release for the 54th Venice Biennale 2011, press office of La Biennale di Venezi.
7 George Baker, 'The Globalization of the False: A Response to Okwui Enwezor', in Elena Filipovic, Marieke Van Hal and Solveig Ovstebo, eds., *The Biennial Reader* (Hatje Cantz, 2010), p. 448.
8 http://www.artberlincontemporary.com/en/2011/about.html
9 Press kit for Independent, p. 1.
10 Louisa Buck, 'The Verdict', *The Art Newspaper*, 14 June, 2011 (Art Basel daily edition).
11 Daniel Buren, 'Where Are the Artists?', in Filipovic, Van Hal and Ovstebo, *The Biennial Reader*, p. 216.
12 Jens Hoffman, 'John Baldessari: Documenta, …', *The Next Documenta Should Be Curated by an Artist*.
13 Melissa Milgrom, 'Behind the Scenes; Independent Curators: Have Art, Will Travel', *New York Times*, 24 April, 2002.
14 Kristine McKenna, 'Armed and Dangerous: An Interview with Hammer Director Ann Philbin', *LA Weekly*, 27 October, 2005.
15 Stefan Kalmár, email message to authors.

CHAPTER NINE

1 Johann König, email message to authors.
2 De Coppet, *The Art Dealers*, p. 194.
3 Assouline, *An Artful Life*.
4 Robert Hughes, 'Missionary of the New', *Time*, 9 April, 2001.
5 This list is limited to only those collectors who are now deceased or no longer in the business.
6 De Coppet, *The Art Dealers*, p. 88.
7 Ibid., p. 179.
8 Leo Castelli quoted in De Coppet, *The Art Dealers*, p. 105.
9 Kibo Njaro, 'Yuz Art Museum: Academic-Standard Contemporary Art', *C-Art* magazine.
10 Georgina Adam, 'Starting local, going global', *The Art Newspaper*, 15 June, 2011 (Art Basel daily edition).
11 Eileen Kinsella, 'Are You Looking at Prices or Art' *ARTnews New York*, May 2007.
12 Christopher Burge, interviewed by the authors, 2011.
13 Muensterberger, *Collecting: An Unruly Passion*, p. 246.
14 Christopher Burge, interviewed by the authors, 2011.

CHAPTER TEN

1 Peter MacGill, interviewed by the authors, 2011.
2 Raymond Nasher, interview by Jim Lehrer, 'News Hour with Jim Lehrer', PBS, 30 October, 2003.
3 The Nashers owned eleven works by Henri Matisse, seven by Pablo Picasso, eight by David Smith, seven by Raymond Duchamp-Villon, eight by Henry Moore, four by Joan Miró, thirteen by Alberto Giacometti, and the most sublime group of sculptures imaginable by Medardo Rosso.
4 Werner Kramarsky, interviewed by the authors, 2011.
5 'Less is More. Pictures, Objects, Concepts from the Collection and Archive of Herman and Nicole Daled 1966–1978', Haus Der Kunst website.
6 Annick and Anton Herbert, interviewed by the authors, 2011.
7 Shelley Fox Aarons, interviewed by the authors, 2011.
8 Agnes Gund, interviewed by the authors, 2011.
9 Muensterberger, *Collecting: An Unruly Passion*, p. 12.
10 'Mama MoMA', *New York*, 10 November, 2003.
11 *ARTnews*, September 2011.

Further reading

COLLECTING

Adams, Brooks et al, *Sensation: Young British Artists from the Saatchi Collection* (Thames and Hudson, 1997)

Allara, Pamela et al, *Possession Obsession: Andy Warhol and Collecting* (Andy Warhol Museum, 2002)

Arensberg, Walter and Louise, *Arensberg Collection* (Philadephia Museum of Art, 1954)

Auping, Michael et al, *Art of our time: the Saatchi Collection, volumes 1–4* (Lund Humphries and Rizzoli, 1984)

Barron, Stephanie et al, *Jasper Johns to Jeff Koons: Four Decades of Art from the Broad Collections* (Harry N. Abrams, 2001)

Benhamou-Huet, Judith, *Global Collectors* (Phebus, 2008)

Bishop, Janet et al, *The Steins Collect: Matisse, Picasso and the Parisian Avant-garde* (SFMOMA and Yale University Press, 2011)

Blom, Philipp, *To Have and To Hold* (Overlook Press, 2004)

Brown, Jonathan, *Kings & Connoisseurs: Collecting Art in Seventeenth-Century Europe* (Princeton University Press, 1994)

Coetzee, Mark, *Not Afraid: Rubell Family Collection*, (Phaidon Press, 2004)

Cooper, Douglas, *Great Private Collections* (Macmillan, 1963)

Deitch, Jeffrey, *Everything that's interesting is new: The Dakis Joannou Collection* (Hatje Cantz Verlag, 1996)

Fitzgerald, Michael C., *A Life of Collecting: Victor and Sally Ganz* (Christie's, 1997)

Frelinghuysen, Alice C., *Splendid Legacy: The Havemeyer Collection* (MOMA, 1993)

Gasslin, K. and Schröder, A., *Optik Schröder* (Walther König, 2007)

Giménez, Carmen and Nash, Steven A., *A Century of Sculpture: The Nasher Collection* (Solomon R. Guggenheim Museum, 1996)

Guggenheim, Peggy, *The Peggy Guggenheim Collection* (Arts Council of Great Britain, 1965)

Hunter, Sam, *Selections from the Ileana and Michael Sonnabend collection* (The Art Museum, Princeton University Press, 1985)

Janis, Sidney and Janis, Harriet Grossman, *The Sidney and Harriet Janis Collection: A gift to the Museum of Modern Art* (MOMA, 1968)

Kean, Beverly Whitney, *French Painters, Russian Collectors: The Merchant Patrons of Modern Art in Pre-revolutionary Russia* (Hodder & Stoughton, 1994)

Knight, Christopher et al, *Art of the Sixties and Seventies: The Panza Collection* (Rizzoli, 1988)

Moura, R. et al, *Through: Inhotim* (Brazil: Instituto Inhotim, 2009)

Muensterberger, Werner, *Collecting: An Unruly Passion* (Princeton University Press, 1994)

Neuberger, Roy R., *The Passionate Collector: Eighty Years in the World of Art* (Wiley, 2003)

Philips, Duncan, *A Collection in the Making* (Riverside, 1926)

Public Space/Two Audiences: Works and Documents from the Herbert Collection (Walther König, 2006)

Richardson, Brenda, *Dr. Claribel & Miss Etta: The Cone Collection* (Baltimore Museum of Art, 1985)

Stourton, James, *Great Collectors of Our Time* (Scala, 2007)

The Menil Collection (The Menil Collection, 1987)

The Tremaine Collection: Twentieth Century Masters (Wadsworth Atheneum, 1984)

Wilmes, Ulrich, *A Bit of Matter and a Little Bit More: The Collection and the Archives of Herman and Nicole Daled* (Walther König, 2011)

Zilczer, Judith, *John Quinn: Patron of the Avant-Garde* (Smithsonian Institution, 1978)

ART DEALERS AND GALLERIES

Assouline, Pierre, *An Artful Life: A Biography of D. H. Kahnweiler* (Fromm, 1991)

Behrman, Samuel N., *Duveen* (Little, Brown & Co., 1972)

Beyeler, Ernst, *A Passion for Art: Interviews by Christophe Mory* (Verlag Scheidegger and Spiess, 2012)

Buren, Daniel et al, *Konrad Fischer: Okey Dokey* (Walther König, 2008)

De Coppet, Laura, *The Art Dealers* (CN Potter, 1984)

Guggenheim, Peggy, *Out of This Century: Confessions of an Art Addict* (Universe Books, 1979)

Hall, Lee, *Betty Parsons: Artist, Dealer, Collector* (Abrams, 1991)

Kahnweiler, Daniel-Henry, *My Galleries and Painters* (Viking Press, 1971)

La Prade, Erik, *Breaking Through: Richard Bellamy and the Green Gallery, 1960–1965: Twenty-three Interviews* (Midmarch Arts Press, 2010)

Ryland, Philip, *Peggy Guggenheim & Frederick Kiesler: The Story of Art of This Century* (Solomon R. Guggenheim Museum, 2004)

Vollard, Ambroise, *Recollections of a Picture Dealer* (Hacker Art Books, 1978)

ART AND THE MARKET

Birnbaum, Daniel and Graw, Isabelle, *Canvases and Careers Today* (Sternberg, 2008)

Fitzgerald, Michael C., *Making Modernism: Picasso and the Creation of the Market for Twentieth-century Art* (University of California Press, 1996)

Grampp, William D., *Pricing the Priceless: Art, Artists and Economics* (Basic Books, 1989)

Graw, Isabelle, *High Price: Art Between the Market and Celebrity* (Sternberg, 2009)

Horowitz, Noah, *Art of the Deal: Contemporary Art in a Global Financial Market* (Princeton University Press, 2011)

Lind, Maria and Velthuis, Olav (eds), *Contemporary Art and its Commercial Markets: A report on current conditions and future scenarios* (Sternberg, 2012)

McAndrew, Clare, *The Art Economy: An investor's Guide to the Art Market* (Liffey Press, 2008)

Menon, Aubrey, *Art & Money: An Irreverent History* (McGraw-Hill, 1980)

Velthuis, Olav, *Talking Prices* (Princeton University Press, 2007)

Index

Figures in *italics* indicate captions.

Picture credits

Acknowledgements

A number of people were instrumental in helping realize this book, foremost Marci Kwon and Robert McKenzie. We are deeply grateful to Marci for her scholarly advice on any number of historical references, her fine editing touch and all the work she put in helping acquire photographic images. Rob has been of invaluable assistance by virtue of his art world knowledge, research capabilities, insights and unflagging attention to detail. Each was an absolute pleasure to work with. We also want to express our gratitude to our extraordinary partners at Art Advisory Services, Suzanne Modica and Ashley Carr. Their skilled service to our clients helped make it possible for us to devote the time necessary for writing.

We also wish to express our deep appreciation to all those who took the trouble to engage in lengthy interviews, including Phil and Shelley Fox Aarons, Christopher Burge, Jeffrey Deitch, Agnes Gund, Anton Herbert, Wynn Kramarsky, Leonard Lauder, Barbara and Aaron Levine, Patricia Marshall, Tobias Meyer and Mark Fletcher, Howard Rachofsky, Craig Robbins and Joel Wachs. A special note of thanks goes to Stefan Kalmár, Andrew Kreps and Christian Schaernack, whose insights pertaining to specific areas of the book were of inestimable value. Many thanks to those who graciously offered quotes, including Miguel Abreu, Pilar Corrias, Erling Kagge, Stefan Kalmár, Johann König, Peter MacGill, Christian Schaernack, Rob Teeters and Lorrin Wong, and to those who otherwise helped facilitate various information needs, especially Amy Cappellazzo, Timo Kappeller, Fergus McCaffrey, Hans Ulrich Obrist, Anthony Reynolds and Thilo Wermke. Of valuable assistance in sourcing photographs were Denise Bethel, Graham Domke, Lisa Franzen, Mizuho Kato and Gary McCraw. To those we somehow failed to thank, please know that after the book goes to print we will recall your contribution and forever regret not recognizing it properly.

To the outstanding professionals at Phaidon Press, most especially Amanda Renshaw, Victoria Clarke, Liz Jones and Alenka Oblak, we will always be grateful for all that you did to make the book better, and for the kind and considerate ways you went about your jobs.

Finally, for your thoughts and loving encouragement, we thank our dear Dana, our dear Deborah and Joe, our dear Lauren and Bob and our dear Ronald and Karol.

This book is dedicated to the artists in our life.

Phaidon Press Limited
Regent's Wharf
All Saints Street
London N1 9PA

Phaidon Press Inc.
180 Varick Street
New York, NY 10014

www.phaidon.com

First published 2013
© 2013 Phaidon Press Limited

ISBN 978 0 7148 4977 5

A CIP catalogue record of this book is available from the British Library.

Designed by Hans Stofregen
Illustrations by Josh Cochran
Printed in China